Women
and the
Unstable
State in
Nineteenth-Century
America

Number Thirty-three:
THE WALTER PRESCOTT WEBB MEMORIAL LECTURES

Women

and the
Unstable
State in

Nineteenth-Century
America

Edited by Alison M. Parker and Stephanie Cole

Introduction by Sarah Barringer Gordon

By Stephanie McCurry, Catherine Allgor,
Alison M. Parker, Janet L. Coryell,
Elizabeth R. Varon, and Lori D. Ginzberg

Published for the University of Texas at Arlington by
Texas A&M University Press
College Station

⊗ The paper used in this book meets the minimum requirements
of the American National Standard for Permanence
of Paper for Printed Library Materials, z39.48-1984.
Binding materials have been chosen for durability.

Library of Congress Cataloging-in-Publication Data

 Women and the unstable state in nineteenth-century America / edited by
Alison M. Parker and Stephanie Cole ; introduction by Sarah Barringer
Gordon ; by Stephanie McCurry . . . [et al.].
 p. cm. — (Walter Prescott Webb memorial lectures ; 33)
 ISBN 0-89096-930-2 (cloth)
 1. Women in politics—United States—History—19th century. 2. United
States—Politics and government—19th century. I. Parker, Alison M. (Alison
Marie), 1965– II. Cole, Stephanie, 1962– III. Series.

HQ1236.5.U6 w655 2000
306′.2′0820973—dc21

 99-054871

To Kathleen Underwood

Contents

Preface ix

Introduction: *Politics, Marriage, and the Texture of History*
SARAH BARRINGER GORDON 3

Chapter 1
"The Soldier's Wife": *White Women, the State, and
the Politics of Protection in the Confederacy*
STEPHANIE McCURRY 15

Chapter 2
"A Lady Will Have More Influence": *Women and
Patronage in Early Washington City*
CATHERINE ALLGOR 37

Chapter 3
"What We Do Expect the People Legislatively to Effect":
Frances Wright, Moral Reform, and State Legislation
ALISON M. PARKER 61

Chapter 4
Superseding Gender: *The Role of the Woman Politico
in Antebellum Partisan Politics*
JANET L. CORYELL 84

Chapter 5
Patriotism, Partisanship, and Prejudice: *Elizabeth Van Lew
of Richmond and Debates over Female Civic Duty in
Post–Civil War America*
ELIZABETH R. VARON 113

Chapter 6
Pernicious Heresies: *Female Citizenship and
Sexual Respectability in the Nineteenth Century*
LORI D. GINZBERG 139

List of Contributors 163

Preface

In the spring of 1998, Alison Parker organized the annual Walter Prescott Webb lectures at the University of Texas at Arlington. The essays that emerged from that conference and the accompanying essay competition follow. In planning the conference, Parker sought to bring together a group of historians involved in the latest research on women's participation in the political life of nineteenth-century America. Thus, this volume began with the premise that women were involved both implicitly and explicitly in the political process to a greater extent than historians had recognized. First, these essays address what possibilities were open for women's participation in nineteenth-century politics, as well as what limitations were placed upon them. They also investigate how the variety of political activities that women engaged in tell us about who they were as citizens, and in what ways the possibility of political action and a political voice affected citizenship. Finally, they ask how women's political activities helped to form the state and the eventual consolidation of a strong central government. As the essays discuss women activists and debates about women's citizenship, they transform our understanding of key moments of transition in American history when the state was being defined and redefined. The first half of the nineteenth century, in particular, was a crucial era of state formation. Throughout the nineteenth century, the possibility of women's suffrage shaped and was shaped by transformations within the state. As a part of exploring women's relationship to the state, this volume reorganizes our thinking about the ways in which the state was (and is) gendered.

Political, in this volume, is broadly defined. The essays successfully illustrate that women's lack of access to the ballot box did not preclude a variety of strategies for, or modes of, political activism. Their strategies ranged from direct participation in partisan politics to claiming access to public resources, thus assuming a new political identity, such as Confederate soldiers' wives. From the outset, we have assumed that women are a part of the larger

historical narrative, especially the narrative of American political history. In various ways, they are shown to be crucial to the development of the state. Their thoughts, desires, and voices inform debates about suffrage and citizenship, while they themselves embody the possibilities and paradoxes of nineteenth-century politics.

In editing this volume, we have benefited from the help of many people. Our fellow members of the Department of History, University of Texas at Arlington (UTA), have been supportive as usual, and we are especially indebted to Steve Reinhardt who assisted in planning the conference and with this volume. As in the past, we appreciate the kind words and careful readings offered by Geoffrey Hale and Chris Morris. Last, but certainly not least, we want to thank our erstwhile colleague and long-time friend, Kathleen Underwood. In 1974, a Center for Women's Studies was founded at UTA but was later disbanded. In 1983, Kathleen stepped into the breach to maintain interest in women's studies at the university. She helped to organize the Women and Minorities Research and Resource Center and under its rubric put on the Women and Work Conference at our institution, bringing together activists from both the community and the academy for seven years. In 1991, she was instrumental in garnering official recognition for an academic women's studies program, and she served as the first director of that program. Throughout this period she worked to heighten interest in women's history and in particular the nascent field of women in the west. Even after she relocated out of state, she aided in the selection of essays for this volume. For this assistance, but more especially for her guidance and exceptional effort in the cause of women's history at UTA, we dedicate this volume to Kathleen Underwood.

<div align="right">
Alison M. Parker

Stephanie Cole
</div>

Women
and the
Unstable
State in
Nineteenth-Century
America

Introduction

Politics, Marriage, and the Texture of History

SARAH BARRINGER GORDON

In March of 1998, the Thirty-third Walter Prescott Webb Memorial Lectures at the University of Texas at Arlington focused for the first time on women's history. Recent work in the field has bridged the traditional gap between political history and the experience of women. From both historiographical and ideological perspectives, the exclusion of women from political history narrowed the productive insights of historians. The reintegration of women and politics has alerted historians to the political resonance of gender in nineteenth-century America. Important work on the uses of gendered symbols in political rituals and campaigns, on changing concepts and practices of citizenship, and on the relationship of state laws of marriage to the federal government (especially after the Civil War) invigorates and complicates our understanding of the lives of women, and of the political systems of which they were always an integral part.[1]

The essays that follow build on (and in some instances challenge) this burgeoning political history that takes gender as a central organizing metaphor. This volume demonstrates the multiple and ineradicable layers of participation by women in political life, political debate, and the negotiation of political power throughout the nineteenth century. The gendered symbolism of political activity is only part of the story. The essays in this volume also highlight radical reform thought and conservative religious faith. Especially important, together these essays demonstrate the profound instability of American governments (state and federal) throughout the century. They also reveal the central role of marriage in the very maintenance of tenuous and changing political orders. With the Confederacy as the quintessential exemplar of

the strategic centrality of marriage inherent in a constitutional democracy that (arguably) provides for reworking at the most fundamental levels, this volume explores the experiences of women as they navigated turbulent times and changing political climates.

More broadly conceived than the (admittedly fascinating) subject of citizenship, the essays that follow trace subtle and less-traveled scholarly paths. They argue variously that the protection of women was the key to state formation in the Confederacy; that informal patronage work by influential women staffed the national government in the early republic; that the freethinker Frances Wright constructed an alternative state within the federal republic in the 1820s; that partisan rhetoric and allegiances drove activist women to intervene in debates those same parties argued should be reserved to men; that one woman's heroism and sacrifice in wartime were insufficient to sustain political credibility in peace; and, finally, that the assertion of women's political authority challenged (and eventually compromised with) an often overlooked—yet entrenched—equation between religious faith (and its social corollary, sexual respectability) and women's formal political incapacity.

Together, these essays highlight the central role of political change in the lives of women in nineteenth-century America. They also probe the integral relationship of marriage to the management of such change. Here is the lesson of this Webb volume: political instability in the nineteenth century was tolerable at crucial periods only because of a presumption of marital stability. And, as Lori Ginzberg's elegant concluding essay argues, political change for women depended, fundamentally, on the disaggregation of marriage and politics. The irony, and the key insight for historians, lies in the recognition that public and private structures of governance (that is, government and households) have been separated in part in the interest of women's increased political power in the public sphere.[2]

Women constantly positioned and repositioned themselves within systems of government—as supplicants demanding protection, patrons maneuvering for the political advancement of a male relative, radical critics of America's failure to live up to the mandate of real equality, partisan activists, embattled civil service employees, or advocates of woman suffrage. These stories make for fascinating reading in this volume, not only because they provide insights into women's history, but because they simultaneously highlight the contours of political history in ways that are otherwise elusive in historical scholarship. Here the precariousness of authority (private and public) in the nineteenth century reveals the struggles of political actors to link or

disentangle household and formal polities in potent new ways. For example, Stephanie McCurry's essay, the first in this volume, probes the intricate relationship between marriage and the allegiance of southern men, first to secession, and then to the Confederacy. This study provides substantial new insight into the coming of the Civil War and the difficulties of the Confederacy in sustaining the loyalty of soldiers whose wives suffered at home.

Taken together, these insights into political activity and debate in the nineteenth century require us to rethink the meaning and sweep of the traditional concept of women's political exclusion. They also complicate the understanding of formal inclusion as a transformative event. If, in other words, women were always there, always integral to the functioning of the state, then their ostensible "inclusion" is less the radical reworking of an actually exclusionary system than the acceptance of the presence of women without whom the system could not, and never did, function. Formal recognition and formal political rights are no mean feat, to be sure. Yet as Lori Ginzberg points out in the concluding essay, negotiation for inclusion took place within existing frameworks of private governance (that is, Christian faith and marriage). The potential and the limits of such frameworks marked the boundaries of strategic maneuvering.

Stephanie McCurry's essay makes clear that the very concept of the state was plastic, subject to radical alteration and redefinition in the nineteenth century. The stark quality of the state formation that McCurry deals with—secession and then civil war—throws the analysis of the political status of "domestic relations" into sharp relief. As McCurry deftly and convincingly shows, the rhetoric of protection, especially the protection of wives, daughters, and mothers, was for yeomen the key to allegiance to the Confederacy. The ethic of protection provided the justification and explanation for coverture as the political reality of the household (and for slavery, the other peculiar domestic institution sheltered with the household) before secession. This ethic became a means of retooling political loyalty to the Confederacy during the process of separation from the Union. As McCurry puts it, the relationship of white men to the state as rooted in the image of womanhood threatened—the state was "'the soil which gave him birth,'" the home itself as threatened by the insulting intrusion of northern soldiers and "hirelings." The sovereignty of the household, in this vision, and the sovereignty of the state, were not only mutually dependent, they were identical.

In the Confederacy, in other words, the legal and political structure of marriage was more than just a useful analogy; the relationship of the householder—the "free man" so central to southern politicians' description of

the mastery threatened by the election of a Black Republican to the presidency—was the axis on which all of political obligation turned. As McCurry describes it, "[t]he duty of the citizen-freeman reiterated the duty of the husband; the state reiterated the family or, more specifically, marriage, its foundational relation." The logic of obligation and protection such a reiteration commanded of white men was wildly successful, as soldiers answered the call to "'leave home and . . . defend the rights and interests of our mothers and sisters and homes.'"

And yet the very ethic of protection that generated the central political and social meaning of secession for yeomen (and, of course, their wives and "dependents") also complicated the dedication to serve the new state. The Confederacy was at once embroiled in a bloody and protracted war that necessitated the exposure of those same women to the vicissitudes of life without the protection of the men whose combat service was supposed to ensure the preservation of home and hearth. White women, not only elite but also poor women, were transformed from rhetorical subjects of political concern into political actors as the ravages of war and deprivation prompted them to call the new state to account in the absence of husbands, sons and fathers.

Women, especially soldiers' wives and widows, understood well their new place within the southern state and deployed the very rhetoric of the fire-eaters against them, as they petitioned for aid, for the release of their husbands, for the recognition that protection was their due. The label "soldier's wife" contained not only a traditional marital component but inevitably a profoundly political aspect. Soldiers' wives placed the sacrifice of women at the center of the southern political agenda and created an obligation on the part of the state that was invoked with strategic effectiveness, especially by yeomen and poor white women during the Civil War.

As McCurry's research into the political identity of southern women in the Confederacy demonstrates, the symbolic uses of marriage and the protection of the mastery of husbands in the construction of political loyalties simultaneously explained and invigorated the move to create a new government through secession. It also eventually weakened that same government as the real women whom the state claimed to protect suffered at home while their husbands fought and died for the "glorious cause," the defense of "wives, mother, and sisters" of the southern family.

Catherine Allgor's work, on the other hand, focuses on the gritty political work of elite women in early Washington City, which was essential to the construction of a working federal bureaucracy in the capital. This work was also vital to the plausible deniability of widespread male involvement in a sys-

tem of patronage. In this world, *women* protected *men* from exposure to corrupting influence. As Allgor points out in her essay, the traditional association of patronage with aristocratic rule dictated that political men in the young Republic distance themselves from the taint of influence peddling.

Such virtuous aloofness, however, hobbled the same political actors' effectiveness; without patronage, the networks and even the trust necessary to a functioning democracy cannot be established. Caught on the horns of the dilemma of disdain for patronage and simultaneous dependence on it (as Allgor puts it, "patronage was both the lifeblood of politics and the symbol of its corruption"), republican politicians left the real, gritty work to wives and other well-placed female relatives in the capital.

Margaret Bayard Smith, the central figure in Allgor's essay, pursued political power, to be sure, but on behalf of her male relatives and other worthy and deserving men. She understood her constant (and effective) manipulation of powerful men in the interests of the advancement of other men seeking power as an extension of benevolence—charitable action in the service of men whose claims on her allegiance were based in blood, marriage, and class.

Such activity, combined with Margaret Bayard Smith's tacit assumption that she and others of her class and political awareness were performing needed and appropriate work for men who would otherwise languish in obscurity, complicates the theory that the early Republic was characterized by male-only politics. To be sure, Smith, those she worked for, and those whose power she exploited understood that formal power was gendered—and that the cultivation of powerful men was best pursued by women in informal spaces. As Allgor makes clear, much official work was done in private houses, spaces where "social call[s] and family dinner[s]" both disguised and facilitated the exercise of female networks of political influence.

The uncovering of such a network, one in which women did the dirty political work of pleading and negotiation for actual positions while men remained conveniently offstage, inevitably raises questions of the embattled notion of "separate spheres." The daily routines of such women's lives included significant political work, which has become invisible to subsequent generations only because its existence is embedded in informal sources, such as Smith's letters and diary. The disappearance of such a world of women's political machinations (if indeed disappearance is the proper concept here) awaits further study.

The multiple possibilities for women in a climate of political uncertainty are also evident in the third essay. Formal, controversial, and highly public

political activity and theorizing in the early Republic (and beyond) were indeed the province of women, as Alison Parker's essay on Frances Wright documents. Wright, well known to historians for her free-love and free-thought views, was also a political thinker of some sophistication. Her attempt to construct racially neutral alternative governance and educational institutions complemented and compounded her opposition to the laws of marriage and the organized religion that sustained them. As Wright understood only too well, the political uncertainty and mobility that prompted her theorizing also implicated marriage.

Wright's utopian community, Nashoba, Tennessee, lasted only from 1825 to 1829. As Parker shows, Nashoba was designed as an exemplary model of the benefits of education and cooperative labor for slaves, leading (gradually, and only then with a mandate for colonization) to emancipation. Profoundly committed to a concept of state government as the embodied will of the people, Wright set about to change the slaveholding states by example. By creating a model of a right-thinking and right-living society, Wright concluded, she would capitalize on the "structural flexibility" of the decentralized, democratic American system of state government and its inherent potential for radical change.

Wright's primary targets—marriage and slavery—were creatures, she argued, of laws (and supporting religious doctrines) that denigrated women and labor. At Nashoba, practical demonstration through the lives of residents would illustrate the fallacies of such impediments to human happiness and self-worth. The reality was less elevating. Nashoba spiraled downhill, as "neither her black slaves nor the white idealists who joined [Wright] . . . were trained or prepared" to run a communal farm. Wright was unprepared too; the community disintegrated into an inhumane and untenable disaster.

Concluding that she had begun "at the wrong end," by focusing on slavery instead of the degradation of all labor, Wright turned to education as the source of radical change for the future. Only if raised and educated "as the children of a common family, and citizens of a common country," Wright argued, would Americans realize the goal of a classless society. The mandate for state-run boarding schools, Wright maintained, in which all children (no matter what their financial or social status) would be placed from the age of two, was contained in the Declaration of Independence, which immortalized the fundamental concept that "all men are free and equal." Trained in such institutions, removed from the deleterious influence of unenlightened parents, all children would grow into citizens whose reliance on external governance was negligible. Instead, they would monitor each other with a pre-

cision and focus that would, but for the maintenance of schools, allow the state to "wind up business." The starkly authoritarian qualities of such a scheme of mutual monitoring, of course, is what stands out to the historian, revealing the contradiction at the core of Wright's antistatism, here as in her Nashoba community.

The virulence of the opposition to Wright, while it may have been out of all proportion to the actual influence she possessed at any one time, testifies to the resonance of her ideas in an unstable, decentralized country. It also reinforces the insight, drawn from the earlier work of Lori Ginzberg, that the reaction against Wright narrowed possibilities for women, and for radical thought generally. Even as Wright's infamy eventually discredited her political agenda, her example made it more difficult for other women to act openly, and publicly.[3]

The difficulties and the persistence of partisan political work by women are the subject of Janet Coryell's essay. According to Coryell, women in the late antebellum period who were "actively engaged in politics and the affairs of national leadership but concerned more with the intricacies of partisan politics than the actual business of government" are properly understood as "woman politicos."

Anna Ella Carroll, the primary subject of Coryell's focus, was a writer, partisan theorist, and political opportunist, whose activism was expressed through "print and personal contact, through petitioning rather than confrontation or mass action." Like Smith and other elite women in the work of Catherine Allgor, Carroll was herself a member of a highly politicized and influential family. Other antebellum "woman politicos" also shared motives and strategies with Allgor's patronage-wielding women of the first quarter of the nineteenth century, including personal contact with powerful officeholders on behalf of male relatives. By the 1860s, however, Elizabeth Blair Lee's father was so shocked at her plans to importune senators for the promotion of her husband that Lee abandoned her scheme, even though she "was egotistic enough to think I could get things done he could not."

The erosion of a world in which women did the dirty political work while their husbands and fathers remained virtuously (and comfortably) on the sidelines is apparent in the constriction of Lee's activity. For even as women coming from similar backgrounds (and acting in the interests of the same objective—the political advancement of their male relatives) found new venues for partisan expression, especially in the burgeoning market for print, their political involvement was complicated by increasing and increasingly virulent resistance.

What could explain the difference between the unstated acceptance of the work of Smith in the early Republic and the restraint of Lee at mid-century? One explanation may lie in the backwash of the rhetoric of woman's rights, which by the 1850s had complicated all forms of political activity by women, and, arguably, by men as well. The open discussion of woman's rights, from which Coryell's authors nonetheless assiduously distanced themselves, gave a tinge of unrespectability to all women's political allegiances, even as the example of Fanny Wright gave their opponents a rhetorical trope that equated sexual radicalism with political (especially marital and racial) reform. So resonant was the equation that it stuck like a burr to activist women of all political stripes.

The strategic advantages of political instability for women, and the ubiquity of the cry of woman's rights as a disabling device, are nowhere more evident than in the work of Elizabeth Varon, whose essay is a study of the civil-service career of renowned Union spy "Crazy Bet" Van Lew. Appointed postmaster of Richmond by President Grant in 1869 in recognition of her wartime service in the Confederate capital, Van Lew was immediately and enduringly controversial. Her postmastership was evidence to southern conservatives not only of federal interference in the affairs of the former Confederacy. It also portended the incursion of dangerous radicalism—racial and sexual—into the very core of the system of partisan patronage. If the poor white women of McCurry's research into the Confederacy were strategically placed to take advantage of the racial and gender ideology of the secessionist South, Van Lew's presence was evidence of such ideology turned on its head. Her tenure as postmaster was a tangible consequence of defeat at the deepest and most painful level, and in the very capital of the defeated South.

Nor were southern moderates, northern Republicans, and even Van Lew's own appointees immune to the discomfort that such a challenge represented to the political order of both North and South. As Varon documents, Van Lew's struggles to retain her post were undermined ever more effectively as the postwar South stabilized along familiar, white supremacist lines. Her opponents claimed that she was undignified, that her "erratic" behavior and "obnoxious manner" meant that one of her white clerks was the "actual postmaster." This charge traveled alongside the charge that she hired and then paid African Americans "exorbitant salaries."

As Varon concludes, the bitter opposition to Van Lew and her policies was sculpted not only by her gender, which gave resonance to claims of lack of sufficient dignity and steadiness, for example, but also by her embrace of

racial equality. The combination was, as we have seen in Parker's study of Frances Wright, potent and provocative. Van Lew was removed in 1877, and withdrew into increasing isolation until her death in 1900, by which time she was remembered by white Richmonders for her "contrariness" and by (disfranchised) Afro-Richmonders as a "zealous and true . . . representative of the Union." Van Lew's stormy tenure as postmaster convinced her that her only hope lay in the ballot. She was caught in the maw, as Varon shows, of a political system in which "female impotence and incompetence" were the staples of an exclusionary logic that denied Van Lew the recognition she most sought—citizenship.[4]

The relationship between structures of formal governance (that is, the ballot) and private governance (marriage, and the religious mandate that sustained coverture and women's political marginality) are the focus of Lori Ginzberg's essay. Homing in on the resilient connections between political disability for women and traditional Protestant notions of sexual respectability, Ginzberg first documents the legal world of the antebellum United States, in which both political and jurisprudential truth was widely assumed to be based in explicitly Christian structures of faith, especially belief in eternal damnation.

Sexual respectability for women was also defined by Christian marriage. By the nineteenth century, as Ginzberg puts it, "only through marriage—not incidentally through marriage" were women "understood as citizens, a historical limitation on female independence with important implications for our own contemporary understanding of female citizenship." So tightly interlaced were concepts of religious and sexual conformity, Ginzberg argues, and so neatly did such notions presume the political disability of women, that to assert independence was to challenge not only the prevailing political order. Independence also called into question the marital and religious foundation on which the order itself was based.

And yet debates, especially those over the expansion of suffrage at state constitutional conventions, explored just these questions, even if only to conclude that the naturalness of marriage rendered woman suffrage ridiculous. The conviction that the vote was by definition gendered male was embattled by the 1870s, Ginzberg argues, demonstrated by the increasing bitterness of antisuffrage invective. But the cause was not won, Ginzberg maintains, by a successful retooling of the concept of suffrage as a gender-neutral right of all citizens.

Instead, the transformation in the thinkability of woman suffrage only took place "when politicians and woman suffrage activists could articulate a

notion of [the vote] that did not openly sever women's interests from those of their husbands—when they could keep in one frame the traditional representation of female religious and sexual purity with the newer one of the female [voter]." In other words, Ginzberg argues, by making peace with marriage, and with the religious ethic that underlies marriage, advocates of woman suffrage created a logic by which one could imagine a good wife, in the traditional sense, as a good voter.

The terms of this compromise, according to Ginzberg, are exemplified by the Woman's Christian Temperance Union, which campaigned for suffrage on the theory of what it called the "home protection" ballot. Women would use the franchise, in this view, to protect and promote the very institution that opponents of woman suffrage claimed would be imperiled by female political involvement. Without a serious challenge to marriage and "the constellation of values at the heart of the notion of female respectability," woman suffrage was itself a compromised achievement. The very reason for the ballot remained tied to the identity of every woman as wife: as maritally dependent, one might say, as the political identity with which Stephanie McCurry begins this volume—the "soldier's wife." Political change was achieved at the price of removing marriage from the equation.

Any embrace of "rights" that includes such implicit hierarchy and disability, Ginzberg maintains, is flawed. Expanding the availability of legal marriage to lesbian and gay couples, for example, re-creates (and revalidates) the very "notions of moral and sexual respectability that were designed to insulate women, to enforce middle-class domesticity, and to maintain categories of exclusion." The institution of marriage, in this view, has corrupted and compromised political activism.

What are we to conclude upon reading this volume of essays and pondering the state of women's history and its turn to politics? First and foremost is the insight that women have been crucial to American government in all its guises—from its initial workings in Washington, to the rhetoric and moral foundation of secession, and even to the men who ran Virginia, in Ginzberg's words, whose satisfaction with marriage and coverture was "not an invisible and never-discussed sexual contract" but "a source of much open pleasure and self-satisfaction." Second is the increasing difficulty of political activity for elite conservative women (that is, for those who did not identify with woman's rights activism by midcentury). Their tradition of informal power-broking was discredited, if not entirely undermined, not only by the presence of activists such as Elizabeth Cady Stanton and Susan B. Anthony but also

by the painful example of Frances Wright and the associated complex of sexual and religious danger that her very name implied.

Last but not least is the tenacity of marriage in the lives of women. Even Frances Wright, whose radical reputation was made on her outspoken critique of the institution of marriage, succumbed in the end, and married rather than give birth to an "illegitimate" child, as Alison Parker notes. The reintegration of marriage as the vital site of the intersection of political and women's history signals that legal structures that mediate gender and politics are fertile ground for important new research in the political history of nineteenth-century America. This volume, and the women whose lives are studied here, make the connections between politics and personal life that we have long known are central to women's history. As we are learning, one cannot understand political history without such connections either. The institutional structure that linked household and polity, and that ran like a seam through the lives of all the women in this volume, was marriage. Marriage by no means described the existence of all the women in this volume (Elizabeth Van Lew, for example, was never married), but it circumscribed their activity, and their ability to work and often even to envision change.

The problem of authority in the nineteenth century, which so profoundly destabilized governments at every level, did not dislodge the key institution of marriage. In this sense, the essays in this volume and the recent work of historians such as Hendrik Hartog and Nancy Cott and my own work into the history of debates over Mormon polygamy, all teach us to pay attention to the myriad threads that lead from household to polity, and back again, in unexpected and fascinating patterns.[5] Equally important for historians to remember as they work in the rich material of the nineteenth century, the political uses of marriage also lurk in the subtext of countless debates and strategic partisan maneuvering. And as Ginzberg reminds us, the political deployment of marriage is by no means a historical artifact, as debates over the relationship between marital structure and political stability roil through American law and society at the beginning of the twenty-first century.

Notes

1. To give just a sampling of the major work done in the field over the last decade, see Linda K. Kerber, *No Constitutional Right to Be Ladies: Women and the Obligations of Citizenship* (New York: Hill and Wang, 1998); Amy Dru Stanley, *From Bondage to Contract: Wage Labor, Marriage, and the Market in the Age of Slave Emancipation* (New York: Cam-

bridge University Press, 1998); Nancy F. Cott, "Marriage and Women's Citizenship in the United States, 1830–1940," *American Historical Review* 103 (Dec., 1998): 1440; Nancy Isenberg, *Sex and Citizenship in Antebellum America* (Chapel Hill: University of North Carolina Press, 1998); Elizabeth B. Clark, "Matrimonial Bonds: Slavery and Divorce in Nineteenth-Century America," *Law & History Review* 8 (fall, 1990); Mary P. Ryan, *Women in Public: Between Banners and Ballots, 1825–1880* (Baltimore: Johns Hopkins University Press, 1990); Lori Ginzberg, *Women and the Work of Benevolence: Morality, Politics, and Class in the Nineteenth-Century United States* (New Haven: Yale University Press, 1990).

2. This is an interesting twist on the insights of Linda Kerber in her article "Separate Spheres, Female Worlds, Woman's Place: The Rhetoric of Women's History," *Journal of American History* 75 (1988): 9.

3. Lori D. Ginzberg, "'The Hearts of Your Readers Will Shudder': Fanny Wright, Infidelity, and American Freethought," *American Quarterly* 46 (June, 1994): 195.

4. *Richmond Dispatch*, Sept. 25, 1900; *Richmond Planet*, Sept. 29, 1900.

5. Hendrik Hartog, *Husbands and Wives, A Legal History* (Cambridge: Harvard University Press, forthcoming); Nancy F. Cott, "Giving Character to Our Whole Civil Polity: Marriage and the Public Order in the Late Nineteenth Century," in *U.S. History as Women's History: New Feminist Essays*, ed. Linda K. Kerber, Alice Kessler-Harris, and Kathryn Kish Sklar (Chapel Hill: University of North Carolina Press, 1995), p. 107; Sarah Barringer Gordon, "The Liberty of Self-Degradation: Polygamy, Woman Suffrage, and Consent in Nineteenth-Century America," *Journal of American History* 83 (Dec., 1996): 815.

Chapter 1

"The Soldier's Wife"

White Women, the State, and the
Politics of Protection in the Confederacy

STEPHANIE MCCURRY

All legitimate government "rests upon the consent of the governed," Jefferson Davis asserted in his inaugural address as president of the Confederate States of America. Davis had clear ideas, too, about exactly whose consent mattered. Indeed he had already articulated them in addressing the crowd gathered to welcome him to Montgomery, Alabama, a few days previous. "Now we are brethren," he said on that occasion, "not in name merely, but in fact—men of one flesh, one bone, one interest, one purpose and of identity of domestic institutions." When Davis envisioned "the governed" he saw only the voters and the ties of race and manhood that he insisted (wishfully) bound them together. What he did not see was the great southern majority: the twice-governed free white women and enslaved men and women rendered invisible in his "domestic institutions." Jefferson Davis's vision of the new national body politic owed more to an antebellum world now lost than to the new world that lay ahead.[1]

Signs of the new world of politics were already evident in 1861. Just a few months after he spoke in Montgomery, Davis received a letter from an Alabama yeoman, William Lee, alerting him to two local problems that required state attention. "[i] havs to in form you," Lee began, "that thire is a good meny pore men with large famelys to susport An if they have to go in to the Army there famelys will sufer." "Thire is a Nother question to rise with us," he added, "the Negroes is very Hiley Hope up that they will soon Be free, so i think that you Had Better order out All the Negro felers from 17 years oald up Ether fort them up or put them in the army and Make them fite like good fells for wee ar in danger of our lives hear among them."[2]

William Lee was a good deal ahead of the game in suggesting the military deployment of slave men. But his concern about the politics of support and protection for poor soldiers' wives and about slaves' politics of freedom were destined to become two of the great considerations in the political and military contest of the Civil War. Indeed when Lee wrote, the antebellum South's foundational and linked dependencies—marriage and slavery—were already shaken, and the human beings they enclosed in protective embrace were already emerging into a new relationship to the state.

Lee's letter is only one indication of the new gendered and racial politics of nation making and war making, of the new and undesired constituencies Confederate politicians were in the process of acquiring. For as secession gave way to war, southern state and Confederate governments were forced into a growing recognition of the political relevance of the previously marginal: white women who were now soldiers' wives and slaves "Hiley Hope up" for freedom. However unlikely the prospect of success, securing the consent and allegiance of this diverse southern majority—not freemen, but their dependents—became an imperative of Confederate discourse and policy. The problem of consent in a slaveholders' democracy had become the problem of consent in a slaveholders' war.

Clearly this perspective leads in a number of directions, not least of which is to a full consideration of the meaning of slaves' politics of freedom to the political history of the Confederacy.[3] But it also suggests the existence of a critical politics of white womanhood in the Confederate South, and it is in this directions that the current essay heads. At the center of that subject, I contend in what follows, stands "the soldier's wife," both figure and actor in Confederate politics. For yeoman and poor white women especially, the war represented something new: a clear political identity and relation to the state as "the soldier's wife." Founded in a promise of protection made during the secession crisis and the attendant call of men to arms, the identity of the "soldier's wife" was turned into a legitimate claim of entitlement on and to the Confederate state. As such, it illuminates a great deal about the gendered politics of secession, war making, and state building in the Confederacy and about nonelite white women's role in that new politics.

That white women figured centrally in the politics of secession and nation making is evident in popular representations of "the glouris cose," as one yeoman farmer put it. "A call has been made upon the young, brave and chivalrous sons of Georgia and the South to leave home and the endearments that bind us to our families to defend the rights and interests of our mothers and

sisters and homes," young Edwin Bass puffed in the early days of April, 1861. "Tis glorious to die for one's country and in defense of innocent girls and women from the fangs of lecherous northern hirelings," William Plane wrote to his wife in June of the same year. Tulius Rice said much the same thing in 1863: "We have everything to fight for—our wives, children, land and principles." And so did a North Carolina colonel even later in the war: "Do you suppose," he wrote his wife, "we are going to submit to see our wives insulted for all future by brutes they would send among us? So long as we such have wives, mother, and sisters to fight for so long will this struggle continue."[4] The protection of women—by which they meant white women—was at the heart of the Glorious Cause.

But what are we to make of such sentiments? "If these phrases seem like cliches," James McPherson has written, "they nevertheless had real meaning to those who wrote them. . . . The conviction that they fought for their homes and women gave many Confederate soldiers remarkable staying power in the face of adversity." As McPherson treats it, soldier's "beliefs" about the necessity of protecting womanhood were "concrete and visceral," unmediated expressions of soldiers' motivation to military service, proof of their idealism, and partial answer to the critical question of "What They Fought For."[5]

James McPherson has surely done more than any other Civil War historian to probe the motivation and consciousness of ordinary soldiers and to urge those questions on the war's huge popular readership. But still, McPherson shares the tendency in the historical literature to reiterate, rather than analyze, soldiers' statements about the need to protect white women as reason for taking up arms. Whereas he treats the evidence transparently, as true expressions of individual soldiers' "beliefs," a different interrogation yields both more precisely historical and more problematic conclusions about "What They Fought For."[6]

For one thing, the analysis properly begins not with the war but with secession, not with soldiers but with politicians and voters. For in consistently linking their duty to the state with their duty to protect white women, Confederate soldiers literally echoed secessionist politicians' earlier call to arms. When scrutinized, talk about the necessity of protecting white women reveals its context in local politics. In this case it is the way the problem of consent—and the related problem of political obligation—presented itself in relation to voters, especially nonslaveholding ones: poor but first-class citizens invested with the right of the franchise, the power to decide the

question of nationhood and the obligation to bear arms in its defense should the necessity arise. Would voters embrace secession? Would they fight to defend the nation? Such were the preoccupations of radical politicians in the fall of 1860 and winter of 1861.

If we now understand "the extent to which the meaning of rights has been linked to gender," Linda Kerber has recently reminded us, we have hardly begun to consider that there is a "history of gendered obligation."[7] The specifics of the secessionists' case for political obligation are revealing of southern politics both past and yet to come: of the troubling class cleavages in the late antebellum southern body politic, of the way in which gender as well as race was used to breach them, and of the promise of protecting white womanhood, the case for political obligation embedded at the heart of Confederate politics.

Consider for a moment how radicals made their case to the people during the secession campaigns in South Carolina, the state that took the South out of the Union. The task, one planter politician instructed a gathering in November, 1860, was "to inform every man (nonslaveholder as well as slaveholder) of the deep and vital interests that are involved in our slavery institutions," to convince them "to strike as men strike, who strike for their hearths and firesides." "The election of a Black Republican President should be the signal for the dissolution of the Union," another put it to his crowd at a rural Charleston muster field. "Only under a southern Confederacy will we find security of our rights and the very safety of our hearths and firesides."[8] Long before federal troops set foot in the South, every "freeman's" personal domain was put in imminent danger of invasion.[9]

The political calculus is not difficult to discern. Enumerating the dangers to slaveholders' interest clearly would not do the job. The "circle of ownership" was just too narrow. On the stump and in the press, planter politicians chose their words carefully, worried, as one put it, about anything "calculated to widen the breach between the slaveholder and the nonslaveholder." By the fall of 1860 everyone spoke as and for "the people" and with rare exception the "rights of slavery" became the "rights of the South" or in planter-legislator Oliver Williams's expert phrase, "the rights of freemen" to the "constitutional protection of person and property" against the "tampering thieves of abolition." Nothing short of a redefinition of the "aristocracy of possession," as one editorialist put it in the *Charleston Mercury,* was at work in the radical representation of the Black Republican threat.[10]

But what exactly was that property on which abolitionists had designs?

What was the nature of the threat they posed to the ordinary yeoman voter? Certainly the property was racial, whiteness itself, as countless politicians and intellectuals rushed to point out. But something as fundamental as race—and inseparable from it—constituted the property rights at risk in Lincoln's election.

When Joseph Brown, the governor of Georgia, named sufficient justification for secession in his public letter of December 7, 1860, he pointed to the Republican Party's avowed "purpose to take from us our property, so soon as it has the power." Posing the question of why nonslaveholders should help defend slaveholders' property, he gave this answer: "[I]f our *right of property* are assailed by a common enemy, shall we not help each other? Or if I have a wife and children and a house, and another has neither wife and children nor house, will he, therefore, stand by and see my house burned and my wife and children butchered, because he has none?"[11] For Brown as for more radical men, property in women constituted the fundamental case of property rights themselves; a man had an obligation to protect what he by right possessed.

Cast in terms of property rights invaded, white men's protection of women appears in a new light indeed. It renders more problematic that central part of the "glorious cause," rescuing from nature and grounding in history the conventional gender script of protected and protector. It was the free (white) man's ability to claim a right of property in his wife's body—that is, exclusive sexual access—that distinguished him from a slave man or a dishonored one. Slave men had been routinely denied "the privilege of appropriating to themselves those of the other sex," a federal official would explain during the war in a bald admission of the propertied character of marriage and manhood both.[12]

In ubiquitous references to "invasion," "pollution," rape, and the protection of white womanhood, then, fire-eaters skillfully invoked the propertied and spatial arrangements of masterhood as yeoman farmers and planters alike understood them in the South. And in so doing they linked the violation of the state and its rights to the violation of the household and its master's rights. "I think I see in the future a gory head rise above our horizon," Thomas Cobb declared in the midst of Georgia's heated secession debate. "Its name is Civil War. Already I can see the prints of his bloody fingers upon our lintels and door-posts." In Georgia as in South Carolina, "the sovereignty of the state" and the sovereignty of the home were one and the same. When you vote, Cobb urged his fellow legislators, "remember the trembling hand of a loved wife. Recall the look of indefinable dread of the little daughter. And if

there be manhood in you, tell me is this the domestic tranquility which this 'glorious Union' has achieved." [13] Georgia, like the other women a freeman loved, now required protection.

"Georgia," "Mother Carolina," "[o]ur political mother," "insulted mother"—images of the state as chaste-woman-violated proliferated across the South. Here, as in other republican regimes, such "psychosymbolics" (to borrow Lynn Hunt's phrase) served quite transparently to root the political and martial duties of male citizens not in an abstraction, the state, but in the intimate body of the mother—"the soil which gave him birth," as one man put it—and in men's already acknowledged responsibilities to women closer to home. [14] It was in the pertinent and emotionally charged connection between political privileges and personal ones that radical discourse worked and the case for political obligation was made in 1860 and early 1861. [15] It was, then, in specifically gendered terms that the popular case for secession was made, that yeoman farmers and their planter neighbors were urged to prove their manhood in defense of vulnerable woman, symbolic and real.

Would-be Confederates were hardly the first to make recourse to a gendered politics of nation making and war making. [16] That all politics has a "family model" and every revolution its "family romance(s)," and that every state attempts to harness forms of deference, loyalty, and obligation customary to households and family relations, now seems entirely plausible; Lynn Hunt's argument about the French Revolution has applicability far beyond the particular case. But the Confederate case highlights one feature of this gendered politics not central to Hunt's analysis: that the family not only provides the model of state politics but provides the line of connection between the citizen and the state.

"The institution of heterosexual marriage," Nancy Cott has pointed out, is "the most direct link of public authority to gender formation, [is] the primary institution that makes the public order a gender order." As such, "marital status has, traditionally, not only defined individuals' household and sexual relationships but has also shaped their civil and even political status." So in the western political tradition, "a man's headship of a family, his responsibility for dependent wife and children, is what qualified him to be a participating member of a state." [17] But if that headship of a family endows a man with the full complement of citizen's rights—or excludes him from them, as the case of the slave man pointedly reminds us—it also constitutes the main means by which the state secures the individual citizen to the pursuit of its own political ends. [18]

Faced with the problem of political obligation in the secession crisis, politicians and the Confederate states and central government after them turned women into "objects of obligation," as Robert Westbrook aptly phrased it, and figured the state around the body of the woman—wife, daughter, mother.[19] The duty of the citizen-freeman reiterated the duty of the husband; the state reiterated the family or, more specifically, marriage, its foundational relation. By the time secessionists had finished it really could seem, as so many ordinary white soldiers would later say, that "the glouris cose" they fought for was the protection of woman.[20]

The success of this solution to the problem of political obligation is hardly in question: one voter and soldier after another reiterated its claims, sometimes verbatim. The mimetic quality of soldiers' wartime utterances about protecting women has not been recognized, however, nor have its consequences fully been considered by historians of the war. By articulating the relationship of individual citizens to the state through the constituent element of the family, for example, secessionists saddled Confederate officials with a never-ending struggle over local loyalties and national political authority.

Much certainly has been written about the conflict over states' rights in the Confederacy. Not much noticed in the discussion, however, is the way in which secessionists' gendered call to arms authorized a very local notion of defense—literally home protection—and rendered the task of nation making the more difficult.[21] Jacob Blount put it plainly to Joseph Brown in 1863: "I am willing to defend my country but I as well as other men want my wife and children protected."[22] The protection of womanhood and the defense of their "rights and interests" was soon at odds with military service, the private duties of husband and father antagonistic to the public political obligation of the citizen-soldier.[23]

The politics of protecting white womanhood has a long and complicated history in the American South, and I am certainly not suggesting that it originated with secession. To the contrary, I am trying to move away from arguments about "origins" and "legacies" to engagement instead with gritty substance and changing uses. In this respect the secession vantage point corrects a few mistaken impressions: promises to protect white women did not emerge de novo in the middle of the war, transparent articulations of soldiers' "beliefs"; nor did they gain discursive centrality only after the war in Confederate Memorial Associations' revisionist interpretations of why men fought.[24] Such arguments mistake as new unto the southern world something actually long part of it. The protection of white womanhood was

a central feature of the call to secession and subsequently to arms in the American South and also to the gendered politics of the war itself and the political history of southern women to which I now turn.

The gender and racial politics of nation making did not end with secession. Far from it. Secessionists' solution to the problem of political obligation—to mobilize male citizens in reference to their property in household dependents—left those dependents themselves beyond the direct reach of the state. Initially, that was not a matter of much political consequence. Nobody, including Jefferson Davis, was worried about securing the consent of white women or slaves. But as the now substantial literature on the homefront, Confederate "morale," and the destruction of slavery suggests, it was not long before individual state and Confederate governments were forced to contend with the political desires and actions of the dependent and disfranchised majority. In ways entirely different and by no means complementary, white soldiers' wives and slave men and women seized the opportunities the war offered to figure themselves as subjects, of politics and political history in the Civil War South.[25]

Secessionist and Confederate representations of white women as objects of political obligation were entirely consistent with conventional understandings of married women's legal and domestic identity in the mid-nineteenth-century United States. The state itself could not reach the married woman, Linda Kerber has reminded us, without disturbing coverture: marriage was woman's state, her husband the authority to which she owed duty.[26]

The South's variation of the national theme owed, of course, to slavery and found expression in the virulence of regional thinking about coverture: the depth of coverture's reach in white households and its utter irrelevance in black ones. The Presbyterian minister, Benjamin Morgan Palmer, put the matter plainly: In the family, that "model state . . . submission will yield all that is incumbent upon the wife."[27] Whatever their official legal status, then, adult white women were not really regarded as citizens: "This Constitution was made for white men—citizens of the U.S.," Thomas Cobb of Georgia proclaimed in November, 1860. In August, 1863, then, a group of men and women from Bullock County, Georgia, only reflected the common sense of the matter when, in a petition to the governor, they divided their signatures neatly into two columns: "Citizens names" and "Soldiers wives names."[28]

Clearly southern white women's political identity and status was defined through marriage. As such it reflected their own particular property in whiteness. Slave women's marital status had no legal or public meaning in the Civil War South, and even in federally occupied areas black soldiers fought a los-

ing battle to have their wives recognized, much less compensated, as "soldiers' wives."[29] White southern women made the most of their secondhand standing in relation to the state. Though conforming entirely to the substance of coverture and holding white women at a distance from the formal political sphere, "soldiers' wives" was a political identity with possibilities, and it was the one nonelite white women themselves privileged in attempts to shape and respond to social and military policy during the war. Confederate state governments had incurred a political debt to soldiers and the women they were mobilized ostensibly to protect. It was not long into the war before women, empowered now as "soldiers' wives," moved to redeem it.[30] Their loyalty, their allegiance, and their support for state policies—especially military service—had to be considered; individual state and Confederate governments had acquired a new and undesired constituency. The problem with consent was a dynamic one in Confederate politics.

Rejecting the passive role scripted for them by secessionist politicians —that women should "give up" their men and boys to the cause—white women, including yeoman and poor white ones, attempted to secure the substance of protection as they defined it. In doing so they turned a conventional ethic of sacrifice into a grounds of entitlement in relation to the state. In petitions and correspondence to state governors, to the Confederate Secretary of War, and to Jefferson Davis, they placed themselves on the political agenda empowered, as they usually put it, as "women [whose] husbands and sons are now in service or has died."[31]

Most adopted the conventional posture of women and petitioners while calling clearly on the state to live up to its promise to protect them. So "we the unsined Ladys" of Berrien County, Georgia, petitioned "Goviner Brown for a little assistance if you pleas sir." Requesting the detailing of a shoemaker to their neighborhood, they drew a pathetic picture of their circumstances. "We live in a flat low siction of the country and we have a grate chance of children in this section and the women and children has the work all to do and the wether is gitting cold." If Brown sent the shoemaker, they promised, "we will trie to attend to our affairs and let our Husbands trye to help drive back the enemy from off of our soil." Twenty-two women signed, all "Mrs" somebody.[32] One yeoman woman even appealed to Brown as wife to husband, rendering him state patriarch in a literal sense: "I wont you to think how yore wife would be in my situation," she wrote, begging him to "releas my husband fore a sort [sic] time."[33]

Like the Berrien County women, the great majority of Georgia women who appealed to their governor for help chose the more formal supplicant

posture of petitioner to the more fluid and empowered posture of constitu-ent correspondent. Fewer than 2 percent of the general correspondence Brown received was from women (fully 98 percent carried male signatures) while about 40 percent of the petitions he received were from women or mixed-sex groups that contained (often predominant numbers of) female signatures. Regardless of their class, women, it would seem, were more com-fortable in the posture of petitioner. Few (wise petitioners that they were), at least in communication to the Georgia governor, offered critical views of his war or conscription policy; they simply demanded relief from its burdens.[34]

A few women did step into public policy more aggressively, tapping pre-cisely the class anger so much discussed in histories of the Confederate home-front, but expressing its gendered dimensions as well. One group of "ladies" told Governor Brown to "call out the whole militia at once and give them [speculators in provisions] a whipping . . . Just go around these towns and see them men they don't know the war is going on . . . they can speculate of sol-diers wives make fortunes of them. Just look at ther woman and children that are begging bread husband in the war or perhaps dead." Their venting had a political point. "This has been an unholy war from the beginning, the rich is all at home makeing great fortunes," they offered by way of conclusion. Other southern white women shared the Georgia women's rage at the fat cats: "I wish you would have all the big leguslater men and big men about town ordered in to confederate serviz," one wrote Jefferson Davis. "[T]hey any no serviz to us at home."[35] For the first time in southern history, perhaps, as "sol-diers' wives," nonelite white women felt empowered to make claims on the state for "serviz."

The figure of the soldier's wife is not, of course, a new one to Confederate history; it can be discerned as a prominent trope in Confederate literary pro-ductions, as Drew Faust astutely pointed out a number of years ago. But the highly stylized, pathetic, and genteel figure of Confederate fiction bears only faint resemblance to the historical subjects who make their appearance in the public record. It is there, in the voluminous and messy record of petitions to and correspondence with state officials, that the class dimensions of the Con-federacy's gender politics come clearly into focus.[36]

Judging from the Georgia record, white women's demands on state offi-cials concerned a fairly narrow range of issues, most commonly about the fur-loughing, detailing, or exempting of men held to military service. This comes as no surprise, of course. The ability of the Confederate state (both central and individual state governments) to hold men to military service—and its increasing tendency to do so as the war progressed—made the state a much

more intrusive presence than formerly in white southern households and thus newly relevant to their dependent members. That point is confirmed, in fact, by the chronological concentration of women's petitions in the later war years. In Georgia, for example, fully 84 percent of women's petitions were dated 1864; with rare exception the substance of the demands contained in them recorded the connection to the governor's recently expanded conscription plan.[37] From such communications to state governors one can construct a more finely grained picture of how white women actively tried to shape the politics of protection in the Confederate South.

At first glance, white women's petitions confirmed the pattern established in William Lee's prescient communication of 1861. By 1864 a great many of the women's petitions directly linked the protection of women to more effective police control of slaves in demanding the detail or exemption of a particular man held to military service. When Mary Giles and seventeen other women from Stewart County, Georgia, petitioned Governor Brown to exempt fifty-two-year-old Robert C. Patterson, they made precisely that connection. There were, they said, "over five hundred negroes and no male white adult" in their neighborhood as a result of the "last proclamation of your Excellency," and they went on to explain that there were "more than twelve families of soldiers now absent or widows," and "that for assistance and protection the said families depended upon said Patterson almost exclusively." Patterson, they pointed out, was "a most efficient manager of negroes and that in his absence the negroes . . . have become insubordinate and unmanageable and constantly growing more." In the absence of Patterson, Mary Giles and the other women felt "great apprehensions for their personal security as well as for their property." In case that were not sufficient reason they added the assurance that Patterson, when previously exempted, had "contributed much to the relief of the indigent" and had exhibited nothing but "loyalty to the government during the present war." By 1864, in Georgia at least, police control of slaves was such a preoccupation of public policy that possession of "packs of Negro dogs" was regarded as sufficient, indeed excellent, qualification for exemption from military service, at least as far as neighborhood "ladies" were concerned. Mrs. David Shipp and her neighbors went right to the point: "Gov wee are all most left without any protection," they wrote, requesting the detail of Mr. James Goody to their Green Hill Settlement in Stewart County for the express "purpose of overseeing our negroes and controling them." Goody is "a good hand to control servants," they explained. "[H]e has a pack of negro dogs and the controle of the second pack." Goody was a valuable man to have at home: "[W]hen at home he can keep

all Deserters out of our comunity allso the servents to theare places." T. P. Neals, a local leading man, appended a letter to one such petition endorsing the women's desire to have detailed to their neighborhood a man "accustomed to keeping well trained dogs . . . and [to] keeping in subjection such Slaves . . . who have been disposed to disregard just and humane discipline and prove troublesome to their owners and the surrounding inhabitants." [38] The framework of protection clearly accommodated a host of white women's needs, including but not limited to personal safety.

There is a little-noticed aspect of this much-discussed concern of white women for personal and sexual protection from slave men. On closer scrutiny the connection between the protection of women and police control of slaves common in the pubic record reveals a particular class location. Recall that Mrs. Shipp and her friends wanted Mr. Goody at home to "oversee" the slaves as well as to "controle" them. Mrs. Giles and her friends too wanted Mr. Patterson sent home to alleviate their apprehensions about their "property" as well as their "personal security." The logic is laid bare in the petition Mrs. C. Clark and her neighbors submitted to Governor Brown. "We the assign Ladys are prinsipaly owners of slaves," they explained, and "as we cannot have our husbands and Sons to plan and manage and assist in controling our slaves we call on you to detail William G. Brian." Otherwise, they point out, they will not be able to plant crops to support their own families or "our army." The grammar of slaveholders often gave them away. Detail a man "to have our wheat cut and threshed," some "ladies" petitioned Brown, with the usual assurance of women accustomed to having things done for them (and not by them); "Attend to this as early as possible," Mrs. Clark and her neighborhood "ladies" concluded their petition to Governor Brown, a tone of instruction more appropriate, perhaps to the overseer than the governor. [39] Keeping slaves in subjection was clearly not exclusively a matter of ensuring the personal safety of elite women; it was also a labor issue. Like yeoman and poor white women, plantation mistresses felt the presence of the state most immediately in its ability to compel sons and husbands to military service and thus to disarrange the customary gender relations of their households. But the arrangements of planters' households were quite different from those of their poorer white neighbors and that difference is reflected in the substance of protection as it was delineated in the petitions. "Ladies" who were owners of slaves, it would seem, required protection from the necessity of managing slaves; ladies like Mrs. Giles, Mrs. Stafford, and Mrs. Clark required the protection only an overseer could provide. [40]

Keeping slaves in "theare places," as one petitioner had put it, was the cen-

tral concern of planter women in their petitions to Brown in 1864, and with one possible exception it was planter-class women who specifically linked the protection of women to the police control of slaves. In his letter endorsing the petition of one group of Georgia women T. P. Neals confirmed the elite basis of such claims of protection: "I am personally acquainted with your petitioners and assure you that they are of the first families of that Section," he wrote.[41] The particular petition Neals's letter accompanied has been lost, but the other "ladies" who linked the protection of women to the police control of slaves left one subtle but unambiguous clue to their class identity: the way they signed their names. Petitioners who linked police control of slaves to their own need for protection signed only their names, though sometimes in a fashion that indicated marital status: "Mary Giles," "Mrs. David Shipp," "Mrs. C. Clark," "Miss Alice Brown." They added no other social signifier, the significance of which point becomes clear in contrast to the signatory style of their poorer neighbors who justified their claims on the state in relation to their husbands' military service.

Alert to the openings created by the terms of public discussion, yeoman and poor white women did occasionally petition state officials for the exemption of male kin on the grounds of their own physical and sexual vulnerability. "[T]he negroes wile kile ale we women and children if they take ale the man away," Emily Jenkins wrote Governor Clark of North Carolina in November, 1861. Surely William Lee had been making the same point in linking the control or removal of slave men to the support and protection of poor white soldiers' wives. But Lee aside, references to fear of personal violation were far more common in the petitions of plantation mistresses or male kin allegedly on their behalf than in petitions filed by yeoman and poor white women. Of the Georgia petitions that linked police control of slaves to the protection of white women, only one was written by rough writers and apparently nonelite women, and they identified themselves not as ladies but as "soldiers wifes and famelys." "You pertisioners has ther husbans and sons now in the field . . . of our gloriou South," M. F. Bridges and thirty-five of her neighbors assured Governor Brown in requesting the detail of a man who owned a "pack of traned doges."[42]

So while elite women requested exemptions and details of men "for our protection in manageing negroes in our neighbourhood," as one group put it, nonelite women delineated the substance of protection in strikingly different terms. Mary C. Tisinger and twenty-two other women from her neighborhood in Upson County, Georgia, petitioned Governor Brown for the detail of "some male adult in the service." They were careful to establish their

identity at the outset and then went on to detail their circumstances. The undersigned "are the wives [and] widows of deceased soldiers and mothers of Soldiers in the Confederate Army," they informed him, explaining that "all of your Petitioners are very poor and dependent[,] that there are only a few slaves in the neighborhood not exceeding four or five slaves in their immediate neighborhood[,] that during peace or before the war began your petitioners were dependent on white labor for support," and that they are now "without protection or any one to gather our little crops of fodder, chinese sugar cane or go to mill for us." For Tisinger and her women neighbors it was the absence of slaves—not their numerous presence—that rendered them in need of "protection." Protection, moreover, was expressed as a need for white male labor to substitute for that lost by husbands and sons in military service. "We are a community of poor wimin and children in a helpless and unprotected condition," they reiterated, and "have a scanty supply of bread and very little meat." They needed "some male adult in the service" detailed to help them or they would lose their crop of sugar cane and "live the balance of the year with only scanty rations of bread." Mary Tisinger signed "Mary Tisinger with 6 chilrin Soldier wife"; Mary Stilwell signed after her as "Mary Stilwell soldiers widow 6 children"; "Mary Taylr" signed too "Mather of slder [unreadable] children"; "Sarah Kersy the mother of too soldiers"; "Elizabeth Kimbalt One syster and Brother died in the Army"; "Catherine Vaughan Solder wider Mother of 3 children"; and so on down the list. Every woman who signed—there were twenty-three of them—specified her identity in terms of family relation to men in military service and, presumably, to the sacrifice she had made to the cause.[43] For these women, sacrifice became a grounds of entitlement, the soldier's wife or widow a critical political identity in relation to the state.

The signatory style was not peculiar to Mary Tisinger and her Upson County neighbors. When Caroline Conner and other men and women from her Georgia neighborhood requested the exemption of a blacksmith, they justified their request on the basis of pressing neighborhood need, poverty, and, especially, the insufficiency of their crops for subsistence. The forty-three women who signed (there were also thirty men's signatures) all identified themselves in relation to the state through the military service of their husbands, even adopting a shorthand: Caroline Conner signed first as "Caroline Conner, Soldiers widow," but Charity Conner and every other woman who signed below her put simply "sw." Men, interestingly, identified themselves by occupation: "Daniel Wall, Farmer," for example.[44] If women like Mary Tisinger and Caroline Conner made their demands on the state in the

available and sanctioned language of protection, it is nonetheless clear that what they actually expressed was a driving need for male labor on their small farms. Sarah Woodall and her neighbors rendered the logic quite explicit in requesting the detail of a particular man whom they described as having "a large family dependent upon his labor for a support, he being the owner of but one field hand (a young boy)," and who had given service to "the Wives and Widows of Soldiers who are endeavoring with their own labor and what assistance they derive from their neighbors to raise provisions for themselves and families." In a neighborhood "entirely stripped of all the male residents," women needed protection not from slaves but from the sole burden of producing subsistence.[45]

So while elite women interpreted the substance of protection out of their historical experience, in terms of the sexual inviolability and leisure from labor that class privilege had customarily conferred (some even tried to turn Sherman's men into their protectors), few nonelite women put such faith in public talk about pure womanhood. Instead they defined the substance of protection historically and materially, in relation to what marriage and coverture had meant for them, as white women in small and often poor farm households in the slave South and in relation to the new legitimacy their husbands' military service conferred. Elite women might speak as "southern ladies," confident of their inclusion in public paeans to pure womanhood, but nonelite women spoke specifically as "soldiers' wives," discerning in the historical moment something that had never existed in the past, not at least for women of their class, in their region, in their lifetimes. They were, they said again and again, poor and deserving "soldiers' wives," women unable to make a family farm produce subsistence in the absence of male laborers.

"You nasty old whelp," Martha Sheets, a self-described "angry wife of a Confederate soldier" threatened the sheriff of her North Carolina county. "You have told lys to get your suns out of this war and you dont care for the rest that is gone nor for ther famelyes." Bring "that grain to my dore or you will sufer and that bad."[46] For women like Martha Sheets the operative political identity was the soldier's wife; the substance of male protection and state obligation was bread and board. Intended to obscure class difference among southern whites, the discourse of protecting white womanhood instead marked it in the historical record.

It ought to be clear by now that "the soldier's wife" was not, in any simple sense, a description of women's marital or social status; that it was, rather, a political identity occasioned by the war, and of considerable strategic value to yeoman and poor white women and their families. When Martha Allen, a

self-described "soldier's wife and mother of three children," complained about the distribution of food relief in her Georgia county, the governor ordered an investigation. The relevant commissioner subsequently defended himself by adverting to the local knowledge of which Allen's complaint was evidence. There is "very little if any suffering" in Orange County, he assured the governor. "She has herd of some women writing to you and getting help and no doubt thats the main cause of her letter." One factory superintendent in North Carolina claimed that a woman had "presented herself to [him] as a soldier's wife and a mother" but that he recognized her "as a single woman, with no husband or children . . . [who] had borrowed the children to enable her to get the yarn" she wanted from the factory. Whatever the truth of either officials' claim, it is clear that the "soldier's wife" was and knew herself to be a woman newly entitled in relation to the state.[47] It is clear, too, that state officials felt constrained to respond, alert to the new constituencies the war produced.[48] The incurred debt to soldiers' wives could never be fully redeemed, but its promise of protection framed much of the popular politics of the Confederate South.

Indeed, so legitimate was the claim of the "poor soldier's wife," so useful the identity, that white men, including elite ones, attempted to inhabit it. In one petition after another, they offered service to poor soldiers' wives as justification for details, exemptions, and discharges, and the signatures of "many ladies" to evidence the legitimacy of their requests. When poor men spoke, family sacrifice was the measure of entitlement; when elite men spoke it was service to soldiers' wives in their vicinity. One planter who began his petition for a furlough on the moral high ground (explaining that he would serve his country better at home "supplying soldiers' needy families" and controlling local "negroes") soon revealed his real interest—in complaints about impressing officers who "are taking advantage of me in my absence from home to rob me of my property." However inauthentically, the soldier's wife's claim on the state became a powerful card in the petitioner's hand, a dimension of popular politics in the Confederacy missed in the usual emphasis on class conflict.[49]

The soldier's wife had put herself on the political agenda, invited there by politicians' promises of protection. But the terms of mobilization only deepened the problem of consent and political obligation in the Confederacy. White women's new wartime relation to the state had been defined through marriage, the Confederate soldier's wife asked to sacrifice her husband and sons to defend the only right to which she was entitled: the right of protection. The assumptions of coverture and the exclusion of women from the full

load of citizens' rights left the state with little, other than the ethic of sacrifice and promises of protection by which to secure white women's support for a war to which their right quickly fell victim. "[My husband's] devotion to our country caused him to neglect his more sacred duty to his family," one woman wrote the Confederate secretary of war, begging her husband's discharge.[50] White women, and especially nonelite ones driven by the starkest need, would continue to make decisions not as full citizens but as private members of a household defined by marriage and their own distance from the state's claims. Coverture exacted its own price in the course of the war. White women had no political obligation to the Confederate state: the consent of these "governed" had not been solicited and could not be secured. The politics of protection had proven unexpectedly demanding in the hands of the Confederacy's white women.

Notes

The author would like to thank the editors of the collection, Alison Parker and Stephanie Cole, for their careful readings and timely production of the volume, the other participants at the conference for their insistence on clarity, and Steven Hahn for his critical readings and intellectual company.

1. Jefferson Davis, *Gentlemen of the Congress of the Confederate States of America, Friends, and Fellow Citizens, Montgomery, February 18, 1861*, in *The Papers of Jefferson Davis*, 7 vols. to date, ed. Lynda Lasswell Crist and Mary Seaton Dix (Baton Rouge: Louisiana State University Press, 1992), vol. 7, p. 46; *Frank Leslie's Illustrated Newspaper*, Mar. 16, 1861, quoted in Gary Gallagher, *The Confederate War: How Popular Will, Nationalism, and Military Strategy Could Not Stave Off Defeat* (Cambridge: Harvard University Press, 1997), plate following p. 111.

2. William H. Lee to Jefferson Davis, Monroe County, Alabama, May 4, 1861, in *Freedom: A Documentary History of Emancipation, 1861–1867*, series 2: *The Black Military Experience*, ed. Ira Berlin, Joseph P. Reidy, and Leslie S. Rowland (New York: Cambridge University Press, 1982), p. 282.

3. This project is well under way. For key contributions, see Robert F. Durden, *The Gray and the Black: The Confederate Debate on Emancipation* (Baton Rouge: Louisiana State University Press, 1972); Clarence Mohr, *On the Threshold of Freedom: Masters and Slaves in Civil War Georgia* (Athens: University of Georgia Press, 1986); *Freedom: A Documentary History of Emancipation*, series 2, *The Black Military Experience*, esp. pp. 279–302, and series 1, vol. 1, *The Destruction of Slavery*, ed. Ira Berlin et al. (New York: Cambridge University Press, 1985), esp. pp. 661–818.

4. Milton Barrett to Dear Brother and sister, Camp Mcdonel, Aug. 2, 1861, reprinted in *"The Confederacy Is on Her Way Up the Spout": Letters to South Carolina, 1861–1864*, ed. J. Roderick Heller III and Carolyn Ayres Heller (Athens: University of Georgia Press,

1992), p. 22; Edwin Bass to "Dear Sister," Dawson, Ga., Apr. 22, 1861, reprinted in Mills Lane, *"Dear Mother: Don't Grieve About Me. If I Get Killed, I'll Only Be Dead: Letters from Georgia Soldiers in the Civil War* (Savannah, Ga.: Beehive Press, 1977), p. 4; William F. Plane to his wife, June 1, 1861, in "Letters of William F. Plane to his Wife," ed. S. Joseph Lewis, Jr., *Georgia Historical Quarterly* 48, no. 2 (June, 1964): 217; Tulius Rice, Richmond, Feb. 17, 1863, in Lane, *"Dear Mother,"* xii; Dorsey Pender to Fanny Pender, June 6, 1862, quoted in James McPherson, *What They Fought For, 1861–1865* (Baton Rouge: Louisiana State University Press, 1994), p. 20.

5. Here, of course, I am borrowing James McPherson's title, *What They Fought For.*

6. McPherson, *What They Fought For,* pp. 18–20. See also Gallagher, *Confederate War,* esp. pp. 57–58. Gallagher uses McPherson's evidence of soldiers' "beliefs" to counter the "materialism" of social historians of the war and their emphasis on class and gender lines of dissent in the Confederacy.

7. Linda K. Kerber, "'A Constitutional Right to Be Treated Like American Ladies': Women and the Obligations of Citizenship," in Kerber, Alice Kessler-Harris, and Kathryn Kish Sklar, *U.S. History as Women's History,* pp. 19–20.

8. *Charleston Mercury,* Nov. 12; Oct. 5; Nov. 13, 1860. I have used the *Mercury* rather than the more moderate *Charleston Courier* because the federal threat was given earliest and sharpest form in radical (or fire-eater) discourse.

9. Secessionists' language had popular currency: "Our country is invaded—our homes are in danger—we are deprived of . . . that glorious liberty for which our fathers fought and bled," Augusta, Georgia, area plantation mistress Ella Gertrude Clanton Thomas wrote in her diary in July, 1861. "We are engaged in a war which threatens to desolate our firesides. Our men are fighting for liberty and homes," she wrote a few months later. Virginia Ingraham Burr, ed., *The Secret Eye: The Journal of Ella Gertrude Clanton Thomas, 1848–1889* (Chapel Hill: University of North Carolina Press, 1990), pp. 184, 195.

10. *Charleston Mercury,* July 28, 1858; May 10; May 25, 1860. "You will find a great element of weakness in our own nonslaveholding population," Daniel Hamilton, U.S. marshall for Charleston, S.C., wrote to his friend, U.S. senator William Porcher Miles in Jan., 1860. "I mistrust our own people more than I fear all of the efforts of the abolitionists," he added a few weeks later. D. H. Hamilton to William Porcher Miles, Jan. 23, 1860, Feb. 2, 1860, William Porcher Miles Papers, Southern Historical Collection, University of North Carolina, Chapel Hill.

11. Joseph E. Brown, *The Federal Union,* Dec. 11, 1860, in *Secession Debated: Georgia's Showdown in 1860,* ed. William W. Freehling and Craig M. Simpson (New York: Oxford University Press, 1992), pp. 147, 155.

12. United States Senate, *Report of the Secretary of War,* Executive Document No. 53, 38th Congress, 1st Session (Washington, D.C., 1864), American Freedmen's Inquiry Commission Report, pp. 2, 4, 5. On slave marriage see Margaret A. Burnham, "An Impossible Marriage: Slave Law and Family Law," *Law and Inequality* 5 (July, 1987): 187–225.

13. Thomas R. R. Cobb, *Substance of Remarks Made by Thomas R. R. Cobb, Esq., in the Hall of the House of Representatives, Monday Evening, November 12, 1860* (Atlanta, 1860), in Freehling and Simpson, *Secession Debated,* pp. 29, 6, 11. "Abolitionists cannot contend with men combined for the sole purpose of guarding the sovereignty of their state—of defending their families and protecting their home" (*Charleston Mercury,* Nov. 23, 1859).

14. Lynn Hunt, *The Family Romance of the French Revolution* (Berkeley and Los Angeles: University of California Press, 1992), p. 13; *Charleston Mercury,* Sept. 28, 1860.

15. For one powerful example, see John Townsend, *The South Alone Should Govern the South and African Slavery Should Be Controlled by Those Only Who Are Friendly to It,* 3rd ed. (Charleston: Evans and Cogswell, 1860), pp. 40, 9. Townsend's piece was distributed as pamphlet no. 1 of the 1860 Association. It sold out in one month after its September publication.

16. Even their particular tactics—the symbolic representation of the state as woman, invocation of rape, and the necessity of protecting womanhood—are strikingly like those in evidence before (in revolutionary France, for example) and after (World War I Britain, for example). From a comparative perspective, then, the very sameness of the images becomes meaningful, pointing up the power of women, gender, and male sex-right to fabricate unity in moments of political crisis. On France see Hunt, *Family Romance;* Joan Landes, *Women and the Public Sphere in the Age of the French Revolution* (Ithaca, N.Y.: Cornell University Press, 1988); Maurice Agulhon, *Marianne Into Battle* (Cambridge, England: Cambridge University Press, 1981). On Britain see Susan R. Grayzel, "Women, Culture, and Modern War: Gender and Identity in Britain and France, 1914–1918" (ms. in possession of the author; published as *Women's Identities at War: Gender, Motherhood, and Politics in Britain and France during the First World War* [Chapel Hill: University of North Carolina Press, 1999]), esp. ch. 2. On the late-nineteenth-century South, see Jacquelyn Dowd Hall, *Revolt Against Chivalry: Jesse Daniel Ames and the Women's Campaign Against Lynching,* rev. ed. (New York: Columbia University Press, 1993), and "'The Mind That Burns in Each Body': Women, Rape, and Racial Violence," in *Powers of Desire: The Politics of Sexuality,* ed. Ann Snitow, Christine Stansell, and Sharon Thompson (New York: Monthly Review Press, 1983), pp. 328–49; and Glenda E. Gilmore, *Gender and Jim Crow: Women and the Politics of White Supremacy in North Carolina, 1896–1920* (Chapel Hill: University of North Carolina Press, 1996).

17. Lori Ginzberg in this volume also illustrates the centrality of marriage to the debate over women's suffrage. Nancy F. Cott, "'Giving Character to Our Whole Civil Polity': Marriage and the Public Order in the Late Nineteenth Century," in Kerber, Kessler-Harris, and Sklar, *U.S. History as Women's History,* pp. 121, 110, 119.

18. For a thoughtful treatment of the "politics of slave marriages," see Laura F. Edwards, "'The Marriage Covenant is at the Foundation of all Our Rights': The Politics of Slave Marriages in North Carolina After Emancipation," *Law and History Review* 14, no. 1 (spring, 1996): 81–124.

19. Robert B. Westbrook, "'I Want a Girl, Just Like the Girl That Married Harry James': American Women and the Problem of Political Obligation in World War II," *American Quarterly* 42, no. 4 (Dec., 1990): 589.

20. The long history of this particular construction of the glorious cause throws considerable doubt on LeeAnn Whites's recent argument that it was in fact a revisionist production of postbellum southern white women. See Lee Ann Whites, *The Civil War as a Crisis in Gender, Augusta, Georgia, 1860–1890* (Athens and London: University of Georgia Press, 1995), pp. 160–98.

21. Edwin Bass to "Dear Sister," Dawson, Ga., Apr. 22, 1861, in Lane, *"Dear Mother,"* 4; Shephard Pryor to "My Dear Penelope," Travellers' Rest, Va., Aug. 17, 1861, in Lane,

"*Dear Mother,*" p. 51; William Stillwell to his wife, Fredericksburg, Va., Aug. 13, 1861, in Lane, "*Dear Mother,*" pp. 260–61; William Moore and others, Bullock County, Ga., Aug. 2, 1864, Executive Department, Petitions, RG 1-1, Box 1, Georgia Department of Archives and History (hereafter GDAH).

22. Jacob Blount to Governor Brown, Attapulgas, Ga., Aug. 12, 1863, Governors Incoming Correspondence, Joseph E. Brown, RG 1-1-5, Box 24, GDAH.

23. It is interesting to note that although Confederate military historian Gary Gallagher generally takes issue with the emphasis placed on desertion in social histories of the war, he does acknowledge the salience of this aspect of the problem: men deserting, sometimes temporarily, to lend labor support and physical protection to women at home, especially when Yankee troops were in their home localities. See Gallagher, *Confederate War,* pp. 30–34.

24. For the first position see, for example, McPherson, *What They Fought For,* pp. 18–20; for the second, see Whites, *The Civil War As a Crisis in Gender,* pp. 160–98, esp. 176, 181.

25. Despite the massive revision in understandings of slave emancipation produced by the documentary work of the Freedmen and Southern Society Project, the political history of the Confederacy continues to adhere to fairly narrow definitions of political subjects and political history. See, for example, the recent book by George Rable, *The Confederate Republic,* in which he acknowledges that much of the pressure driving Confederate policy debate originated in popular politics outside the Confederate Congress but in which he focuses, nonetheless, almost exclusively on matters internal to that body. "Political pressures (including legitimate concern about civilian morale) greatly influenced strategic and even logistical decisions," he points out (p. 116), but the concern remains parenthetic. See Rable, *The Confederate Republic: A Revolution Against Politics* (Chapel Hill: University of North Carolina Press, 1994). For an introduction to the work on slave emancipation see Ira Berlin et al., *Slaves No More: Three Essays on Emancipation and the Civil War* (New York: Cambridge University Press, 1992); on "morale" and the ideological necessities of the war, see Drew Gilpin Faust, *The Creation of Confederate Nationalism: Ideology and Identity in the Civil War South* (Baton Rouge: Louisiana State University Press, 1988).

26. See Kerber, "'A Constitutional Right to Be Treated Like American Ladies.'"

27. Benjamin Morgan Palmer, *The Family in Its Civil and Churchly Aspects: An Essay in Two Parts* (Richmond, Va.: Richmond Presbyterian Committee of Publication, 1876), pp. 69, 49. Women "had no more right to political or economic power than a slave or a child," one southerner editorialized in 1851, "while the husband is vested with a property in her labor and may dispose of it at his pleasure, because it is thought the best arrangement for her well being." *Albany Patriot,* July 11, 1851, quoted in Susan E. O'Donovan, "Transforming Work: Slavery, Free Labor, and the Household in Southwest Georgia, 1850–1880," (diss. in progress, Univ. of California, San Diego), pp. 46–47.

28. Cobb, *Substance of Remarks,* pp. 8–9; and A. B. Briggs Sr. and others, Bullock County, Ga., Aug. 8, 1863, Executive Department, Petitions, RG 1-1, Box 1, GDAH.

29. Thavolia Glymph, "'This Species of Property': Female Slave Contrabands in the Civil War," in *A Woman's War: Southern Women, Civil War, and the Confederate Legacy,* ed. Edward D. D. Campbell, Jr., and Kym S. Rice (Richmond: Museum of the Confederacy,

and Charlottesville: University Press of Virginia, 1996), pp. 55–72; Burnham, "Impossible Marriage," pp. 187–225; Edwards, "'Marriage Covenant.'"

30. George Rable notes that after only a few months in the army at the beginning of the war, "Irish soldiers in Dorsey Pender's regiment were already receiving letters from home telling of starving wives and children." George Rable, *Civil Wars: Women and the Crisis of Southern Nationalism* (Urbana: University of Illinois Press, 1989), p. 63.

31. M. H. Bray and others, Banks County, Ga., Jan. 26, 1864, Executive Department, Petitions, RG 1-1, GDAH.

32. Mrs. Margaret Tucker and others, Berrian County, Ga., Oct. 10, 1864, Executive Department, Petitions, RG 1-1, Box 1, GDAH. It is interesting to note that even during the war white women used the formal petition more frequently than informal "correspondence" in communications to Governor Brown. I would like to thank Margaret Storey, a graduate student at Emory University History Department for her research assistance with the Joseph E. Brown Papers. The fullest description and analysis of these sources is in Rable, *Civil Wars,* pp. 50–90.

33. Frances Bolton to Governor Brown, Milidgivell [*sic*], Ga., July 22, 1864, Governors Incoming Correspondence, Joseph E. Brown, RG 1-1-5, Box 24, GDAH.

34. The wartime papers of Governor Joseph E. Brown are divided into two categories: 1) Governor's Incoming Correspondence, and 2) Executive Department, Petitions. The statistics offered in the text are derived from a sample consisting of one box each of Incoming Correspondence and Petitions, randomly selected and compared for the sex of signatories.

35. Anonymous, From the ladies of Spaulding County, Griffin, Ga., June 15, 1864, Governors Incoming Correspondence, Joseph E. Brown, RG 1-1-5, Box 22, GDAH; Mrs. L. E. Davis to Jefferson Davis, Aug. 22, 1864, Confederate Secretary of War, Letters Received, RG 109, M437, Roll 125, National Archives, quoted in Rable, *Civil Wars,* p. 107. More elite women took the opportunity of the war to advance moral crusades against licentious men, complaining to Governor Brown of Georgia about drinking, horse racing, and fast young men. See, for example, Anonymous to Governor Brown, n.p., n.d [1864], Governors Incoming Correspondence, Joseph E. Brown, RG 1-1-5, Box 22, GDAH.

36. Faust, *Creation of Confederate Nationalism,* pp. 48–55.

37. Based on a sample of one box of petitions (Q-R, alphabetical by county) addressed to Governor Brown during the war. The box contained 104 petitions, 42 of which included women signatories. Of the dated petitions signed by women (38) 32, or 84 percent, were dated 1864. See Executive Department, Petitions, RG 1-1, Box 3, GDAH.

38. Mary Giles and others, Stewart County, Ga., Aug. 15, 1864, Executive Department, Petitions, RG 1-1, Box 3, GDAH; Mrs. David Shipp and others, Stewart County, Ga., July 21, 1864, Executive Department, Petitions, Box 3, RG 1-1, GDAH; T. P. Neals, Camp Hamilton, May 17, 1863, Executive Department, Petitions, RG 1-1, Box 3, GDAH.

39. Mrs. C. Clark, Washington County, Ga., n.d., Executive Department, Petitions, RG 1-1, Box 3, GDAH; Mrs. S.A. Stafford and others, The Rock, Ga., June 16, 1864, Executive Department, Petitions, RG 1-1, GDAH.

40. This point is entirely consistent with the reading of slaveholding women's aversion to disciplining slaves offered in Drew Faust, *Mothers of Invention: Women of the Slaveholding*

South in the American Civil War (Chapel Hill: University of North Carolina Press, 1996), pp. 53–79.

41. T. P. Neals, Camp Hamilton, May 17, 1863, Executive Department, Petitions, RG 1-1, Box 3, GDAH.

42. Emily Jenkins quoted in Victoria E. Bynum, *Unruly Women: The Politics of Social and Sexual Control in the Old South* (Chapel Hill: University of North Carolina Press, 1992), p. 117; M. F. Bridges and others, Stewart County, Georgia, May 22, 1864, Executive Department, Petitions, Box 3, GDAH.

43. Sarah Bridge and others, n.p., Aug. 13, 1864, Executive Department, Petitions, RG 1-1, Box 3, GDAH; Mary C. Tisinger and others, Upson County, Ga., Aug. 15, 1864, Executive Department, Petitions, RG 1-1, Box 3, GDAH.

44. Caroline Conner and others, Tatnall County, Ga., July 20, 1864, Executive Department, Petitions, RG 1-1, Box 3, GDAH.

45. Sarah A. Woodall and others, n.p., n.d. (Aug. 22, 1864), Executive Department, Petitions, RG 1-1, Box 3, GDAH.

46. Martha Sheets quoted in Bynum, *Unruly Women,* p. 148.

47. Quoted in Bynum, *Unruly Women,* pp. 126, 127. It is interesting to note that Bynum quotes a lot of poor white North Carolina women who, in correspondence to state officials, identify themselves specifically as "soldiers' wives"; that construction is not, however, subject to analysis in her book.

48. That much, of course, can be inferred from the North Carolina officials quoted above. But see also Paul Escott's analysis of Governor Joseph Brown's regime in Georgia and of Brown's enthusiastic embrace of the populist politics of protecting soldiers' wives and families. Paul Escott, "Joseph E. Brown, Jefferson Davis and the Problem of Poverty in the Confederacy," *Georgia Historical Quarterly* 61 (spring, 1977): 64. Brown boasted that he had "labored day and night" to send clothes and food to suffering families when "they could get none from the Confederacy." Escott notes that Brown and the Georgia legislature appropriated nearly ten million dollars in 1864, explicitly declaring their intention "to feed and clothe the suffering wives and widows and orphans and soldiers" (p. 69).

49. Captain John Bragg to Brown, Scriven County, Ga., Mar. 13, 1863; Anonymous to Governor J. E. Brown, Linton [Hancock County], Aug. 5, 1864; M. A. Brantly to Brown, Augusta, Ga., Feb. 5, 1864; James M. Brantley to Brown, White Bluff [near Savannah], Jan. 16, 1864, all in Governors Incoming Correspondence, Joseph E. Brown, RG 1-1-5, Box 24, GDAH. Paul Escott's article on Joseph Brown is a good example. Escott astutely analyzes Brown's construction of himself as the people's governor—that is, the class appeal—but while documenting his services to "soldiers' wives," fails to consider that gender vehicle of class politics in his analysis. See Escott, "Joseph Brown."

50. Virginia Thornton to Jefferson Davis, quoted in Rable, *Civil Wars,* p. 74.

Chapter 2

"A Lady Will Have More Influence"
Women and Patronage in Early Washington City

CATHERINE ALLGOR

In 1801, Thomas Jefferson rode into the brand-new capital of the United States, determined to construct a government and seat of power based on "pure republicanism," a task with which he, his followers, and presidential successors struggled for the first three decades of the nineteenth century. Translating republican ideology into a working federal structure, while securing the future of Washington City (as the capital was called), proved a complicated and often contradictory exercise as theoretical ideals clashed with political necessity. The only models for amassing and implementing political power the founding generation knew originated in the Old World—in the very monarchical and corrupt structures that they had fought in the Revolution.

In European cultures, it had always made good political sense to award jobs, titles, lands, and sinecures as rewards for loyalty or to secure a regime, as well as to establish reciprocal power relations on both central and local levels. This association with aristocratic rule made patronage a major political challenge for early republican politicians; patronage was both the lifeblood of politics and the symbol of its corruption. In the American republic, politicians and critics of every stripe scorned and reviled this base "Old World" system, with the opposition exercising vigilance lest those in power be contaminated by its use. However, when elections and new administrations brought these same watchdogs into power, the new officials discovered that surrounding themselves with appointed friends and like-thinkers provided the surest way to effect political action and build coalitions.[1] Being a politician in the early federal city required walking a fine line; even the virtuous

Jefferson, who wrote more about patronage than any other issue, was accused of cronyism.[2]

Republican theorists and observers also feared another highly visible component of aristocratic privilege, one intimately connected with patronage practices. Elite European women had always been an important part of court life, serving both as actual participants and as rhetorical lightning rods, symbolizing all the dangers of aristocracy. Associated with lavish display and elite material culture, they embodied the decadence and luxury feared by republicans. Even more seriously, women (though unelected and unappointed) had long exercised power over personnel and policies, answering to no official body. Kings justified their rule by mandates from God, but aristocratic women in the European courts claimed their ruling privileges through unregulated relations of marriage, kinship, and sex.[3]

During his tenure as minister plenipotentiary to France in the 1780s, Jefferson himself was appalled by the degree to which women in Paris involved themselves in the upheavals of the times. Everything about female participation in politics shocked Jefferson—the conversations of the elite men and women, the speeches and marches of the female lower orders—but above all, he abhorred women who "mix promiscuously in gatherings of men." French women dominated social events, and in their capacities as social leaders they exerted a powerful and (to Jefferson's mind) deleterious effect on the French government's decisions, "their solicitations bid[ding] defiance to laws and regulations." In a 1788 letter to George Washington, Jefferson detailed the Notables' plans for reform, adding, "In my opinion a kind of influence, which none of their plans of reform take into account, will elude them all; I mean the influence of women in the government." Women were allowed to "visit, alone, all persons in office" in order to obtain jobs for their "husband, family or friends." Jefferson feared that female influence would prove so powerful that it would negate any attempts at official reform. He could only rejoice that American women's "omnipotent influence" restricted itself behind the "domestic line," thereby saving America from a similar "desperate state."[4]

For all that such fear of women in the polity can be viewed as the projection of a patriarchal culture, Jefferson and other observers were correct in their perceptions of women's power. Women exercised enormous political leverage in French and English gentry and court life, and, given the chance, American women would do the same. The republicans saw too clearly what kind of system female politicking engendered and determined that by eliminating

women they might avoid a government based on personal relations. With hindsight, however, we may see that the critics of female political action erred in perceiving these women's efforts as a *challenge* to the public world of men and official documents rather than an integral part of the system.

In early federal Washington City, women of the new ruling classes used the familiar aristocratic practices—especially patronage—to further their families' interests, as elite and gentry women in Europe and colonial America had long done. However, their efforts assumed even greater importance in the contradictory condition of the infant capital. The new government badly needed structures and cooperative relationships between branches and individuals. Unfortunately, the ruling rhetoric of republicanism espoused by public men prohibited the politicking practices that could build such a political machine. While virtuous republican men struggled to reconcile an unworkable ideology with political necessity, women used patronage and personal relations to pursue political power. A closer look at the career of a Washington woman illustrates how a parallel political culture functioned to facilitate the workings of a burgeoning democracy.

In November, 1800, a young bride, Margaret Bayard Smith, wrote enthusiastically to her family of her new home in Washington City, the infant capital of the United States. She and her husband, Samuel Harrison Smith (who was also her second cousin), had set off on a ramble, and, she informed her Philadelphia clan, "I seldom enjoyed a walk more than this and had scarcely resolution to return, although the sun had set." On another "delightful day," she had "sallied forth," with a group of new friends: "I will not say we walked along. . . . the elasticity of the air had given such elasticity to my spirits that I could not walk." The ramblers dropped in on a neighbor and stayed the day, socializing, "putting up curtains," and enjoying a turkey dinner.[5]

Thus began a remarkable confluence of person, place, and circumstance. Margaret Bayard and Samuel Harrison Smith came to Washington City from Philadelphia under Thomas Jefferson's personal patronage. He wanted Samuel Smith to become the editor of a new paper, the *Daily Intelligencer* (precursor to the *Annals of Congress* and the *Congressional Record*), and Samuel Smith justified his patron's trust. He attended Congress every day, recording its proceedings faithfully for his newspaper's pages. Though historians owe this hardworking publisher a great deal for his stenographic thoroughness, it was Margaret Bayard Smith who became the historian's dream. First and foremost, she was consistently *there,* no mean feat in a city known for the transience of its inhabitants. Though by the 1840s Washington City boasted

a core of longtime residents who made up a political/social elite, no one could match the Smiths' forty-four-year residence.[6] Not only her proximity but also her social position assured Bayard Smith a front-row seat at the events of the day. She quickly became a community leader; as her husband rose in prominence, she became enmeshed in the community networks of the town, and her entrée to places and people proved unparalleled. Moreover, Margaret Bayard Smith was a talented writer, rendering descriptions of scenes and assessments of people with a few choice words or phrases, much as a good painter can give a sense of movement and life with a few well-chosen brush strokes.

In 1906, over sixty years after Bayard Smith's death, Gaillard Hunt edited a volume of her letters and sketches, *The First Forty Years of Washington Society*, which represents only a small fraction of her papers and remains her sole claim to general fame. Hunt did a very thorough job sifting through Bayard Smith's voluminous correspondence with her two sisters, Jane Bayard Kirkpatrick and Maria Bayard Boyd, as well as with members of her husband's natal family. He included the mentions of "Great Men" that he knew would interest his readers and tried to eliminate all the tedious details of the relentless social round that dictated the lives of the Smiths and their neighbors. As Laurel Thatcher Ulrich points out, however, it is the very "dailiness" that reveals the rich particularity of history, and Bayard Smith's writings prove the point irrefutably.[7]

A close reading of the "dailiness" of Bayard Smith's life reveals many political narratives, the uncovering of which requires new analytic constructs about gender and power. The hunt for hidden political stories in women's writings demands more complex detection than a similar quest in, for example, the diary of John Quincy Adams. The cultural prohibition on "politicking women" guaranteed that women's political work developed in an atmosphere of denial. To trace this political history, one must follow women's stories as they understood them, as contained within traditional female frameworks of love, family, and charity. Charity, in fact, provides a good starting point for one of Bayard Smith's particular political stories.

From the start of her residence in Washington City, Margaret Bayard Smith, like many middle-class white women in American cities and towns, became involved in charitable work. Washington proved as different from other towns in the growth of its underclass as in other urban evolutions. Poverty arrived early and spread rapidly in the barely settled capital.[8] Bayard Smith first approached the problem of poverty as a private individual, inter-

esting herself in the poor families near her home on the outskirts of the city. Though she firmly believed that education granted the only "beneficial influence" for the poor, Bayard Smith also responded quickly and often to the relief of "present wants."[9]

Supplying destitute families with food, fuel, and clothing, she did not hesitate to involve friends and family in tending to the immediate needs of those around her. At the same time, as Washington's middle-class female population grew, Bayard Smith became part of an informal network of like-minded citizens who tried to provide relief beyond such immediate needs. In an 1802 letter to her younger sister, Maria, Bayard Smith describes one of her efforts: "You recollect of my telling you of a handsome, genteel-looking woman that called one morning while you were out for some work." When Bayard Smith later sought the woman out in her own home, she found a residence "perfectly clean," though revealing recent destitution. Surrounded by her five daughters, "all lovely looking children," one a small infant, the brave widow made the very picture of genteel poverty. Though she "sighed that I had not the power to relieve them," Bayard Smith went straight from the humble dwelling to Mrs. Madison, the wife of the secretary of state and the White House hostess, and to Madam Yrujo, the wife of the Spanish ambassador, asking their assistance in providing work for the destitute woman, which they promised to do.[10]

Reflecting her commitment to offering more than the bare necessities, Bayard Smith often acted as a broker for poor families as they struggled to support themselves. She urged her circle to buy produce or craft items from them, even acting as an informal employment agency in finding domestic work for the women and work in building projects for the men. Though Bayard Smith felt sorry for the poor she aided, she was absolutely horrified by the situation that befell another desperate group—middle-class families fallen on hard times. In the days before insurance, the removal of the working male through death or desertion could reduce a family to destitution. The economic climate of the time could, with a sudden blow, doom even an intact family to poverty as well. The Smith family, and other friends, took widows and children of their set into their own homes, often straight from the auction that had disposed of their houses and goods, offering a refuge until they could make a new start. Bayard Smith assisted them in this as well, seeking employment for the widows and their daughters as governesses, companions, or teachers.

Scholars of women's lives have studied the development of benevolent and

charitable associations in nineteenth-century America, tracing the growth and scope of female involvement. In many ways Bayard Smith's personal history mirrors their findings—specifically, her change in strategy from solely individual efforts to groups; her role in establishing a network of women working together; even her philosophical shift from regarding indigence as emerging from a deficiency in character to an awareness of poverty's structural nature.[11] Though scholars like Paula Baker argue that female activities and institutions such as benevolent societies changed the very definition of "political," most historians specify carefully that this was a female world, only occasionally intersecting with the male "sphere" of what has traditionally been considered politics.[12]

Though some of Bayard Smith's activities support this model, a closer look at her actions blurs any line drawn between the female world of the benevolent association and the male world of business and politics. As long as Bayard Smith urged her friends to buy produce from the underprivileged and solicited jobs for newly poor women, her activities fell safely within the rubric of "women's work," "private sphere," or "benevolence." Even when male civic leaders asked her to find a teacher to start a school for children of the residential and political elite in 1816, she could still be seen as performing within strictly female limits, much like the politically active women in other towns. But Margaret Bayard Smith's letters reveal that, in addition to finding places for the mothers and daughters of the genteel poor in middle-class households, she and her friends found government jobs for the *fathers* and *sons.* These occasions challenge all assumptions about "spheres" and the separation of male public life and female domesticity. Bayard Smith and her friends may have understood their efforts as extensions of female benevolence, but these practices clearly crossed the line into the powerful world of political patronage.

The law of supply and demand influenced the extent of this power considerably. Federal offices available for distribution included jobs outside of Washington (like postmaster appointments and judgeships), but the Washington-based government posts (clerks and bureaucrats of the various departments) generated the most competition. Historians have traced the professionalization of medicine and law to a need for employment and advancement for the sons of the growing middle class.[13] Politics, long the domain of a leisured, elite class, also became professionalized, as middle-class parents and children of both sexes realized government's economic and prestige potential. An "entry level" position as a clerk in a federal department could lead to a long, profitable career in national politics.[14] The competition

was brutal, not only from young men who wished to start a career but also from men of all ages who had failed in business or agriculture, a likely prospect in the volatile economic climate of the early nineteenth century. Moreover, a post in the federal government was a family acquisition, enabling a young man to support his natal family and an older one to establish his children with jobs and marital alliances.[15]

Not surprisingly, patronage issues and office seeking emerge as one of the most discussed topics in the correspondence of politicians and political families. Washington observers, official and unofficial, seemed dazed by the spectacle of competition prompted by these posts. As Margaret Bayard Smith described it: "In fact, no sooner does a vacancy occur, than it is instantly supplied and for this plain reason, that hundreds of candidates for every place, from the highest to the lowest, are registered on the office books—waiting often for years for a vacancy to be made."[16] Many descriptions of the overwhelming crush of office seekers on the Washington scene appear as complaints from besieged legislators and cabinet members; but even they, along with outside observers, express deep sympathy for the applicants and their mostly futile efforts.

Stories of hopeless cases abound in the literature, tales of well-qualified applicants, with every reason to hope for success, defeated by sheer numbers. John Smith, representative from Virginia, sent a report home in 1808 designed to "prevent a repetition of such numerous applications" as he had experienced when the government granted his state military positions. Smith related that though the call was for one troop, twenty thousand men applied. He concluded that the "chance of success is too small to countenance the application."[17] In another incident, recounted by Harriet Otis in 1812, "Poor Mr. Melville" had just left Washington "hopeless and penniless," after "four months dancing attendance on the members and having hopes of success that seemed justly grounded." Mr. Melville felt so beaten down that he "said that he had been so long unfortunate that success would have seemed to him miraculous."[18]

Many applicants waited so long that they ran out of money and could not get home. A "Mr. H.," referred to by James M. Varnum, was therefore lucky to have a horse and gig to sell for his fare, "having been disappointed in getting his contemplated $1,250.00 salary."[19] Job Durfee, representative from Rhode Island, no doubt spoke for many when he declared: "This office seeking is too low a business for any person who has the spirit of man." Nevertheless, Durfee added, "I cannot help having some pity for those who must go home disappointed and mortified."[20]

In the face of such dismal prospects, many acknowledged that success did not lie in following official procedures. Customarily, to obtain a post, one submitted a letter of application accompanied by as many recommendations from important personages as one could muster. Many a candidate was dismayed to discover that credentials and official recommendations that would garner respect and attention anywhere else in the Union were lost in a sea of similar applications.[21] "Yesterday, I went over in the dusk of the evening to have a confidential chat with a young man, but an old friend of mine, Eugene Vale, about the best means of procuring employment in one of the departments," wrote Bayard Smith to her sister Jane. Her conversation with Mr. Vale revealed that "[w]ritten applications or recommendations were worth nothing—seldom read but amid the multiplicity of letters loading the department table, overlooked and thrown aside."[22] Vale, who had just enjoyed a promotion in the State Department, "gave [Bayard Smith] a great deal of information, but all concluding that personal favor conferred and personal presence was by far the best means of obtaining that favor."[23] Another friend of Bayard Smith's confirmed this information: "[A]s Judge Southard stated on a former occasion, an individual who has powerful friends within the government has a better chance of success than those long registered expectants."[24]

The successful applicant had to have "a friend at court," and often that "friend" was a woman from a powerful political family. In 1821, Bayard Smith reported that "this Florida business," the acquisition of the territory, "has filled our city with strangers" seeking appointments: "I am told above a thousand persons are here seeking for some place." Only very few appointments were to be had, which stimulated much public discussion by women and men. "No one seems yet to have the least idea who they are to be," Bayard Smith recounted. "I have seldom known such absolute silence observed. Not even a conjecture is formed, although it is known from good authority that there have been above a hundred applications from persons of great respectability." According to Bayard Smith, some of the public discussion among the capital elite centered around the part played by Floride Calhoun, wife of South Carolina senator John C. Calhoun: "Mrs. Calhoun has done her very best to obtain the clerkship of the board for Mr. Tasslet. She went herself to the President and others, but I fear there is no chance for a poor man and a foreigner."[25] Even in a culture that forbade talk of politics to proper women, Washington City society's evaluation of Mrs. Calhoun's aggressive involvement and public efforts on her protégé's behalf centered not on her personal character but on whether or not she succeeded.

Like other Washington women, Bayard Smith frequently reported on her own career, providing valuable information on how the all-important patronage game worked. By the late 1810s, Bayard Smith had become a powerful person in Washington political circles, already well established in her long career as an influence peddler.[26] In this field of operations she displayed certain characteristics shared by other women who wielded similar influence. One- or two-term congressional wives might obtain a modest post here or there for a constituent, but it took women like Dolley Payne Todd Madison, Hannah Nicholson Gallatin, Martha Jefferson Randolph, and Bayard Smith to enjoy repeated successes. They had lived in the capital city for years, had husbands or fathers who served in government for long periods of time and in high capacities, and had grown up in elite, politically connected families. In addition, Bayard Smith's expertise in working the unofficial channels may have been sharpened because her own fortunes depended on the patronage system. After selling his newspaper in 1808, Samuel Harrison Smith relied on government jobs to support his family.[27]

Bayard Smith was able to find places for both male relatives (the sons of her sister Jane Bayard Kirkpatrick, for example) and nonkin candidates who presented themselves to her. Many of her notable successes took place in the years 1815–24, though she would continue to participate at least until the 1830s. Despite Samuel Harrison Smith's unpopularity with the presidents (he had opposed both James Madison and James Monroe), Margaret Bayard Smith succeeded many times in placing a friend or relation in office. Part of her success lay in her close relationships with influential members of Congress, particularly William Crawford and his family and Henry and Lucretia Hart Clay. Another reason for her success during Samuel's eclipse may lie in the structure of the patronage system itself; because patronage was women's work, a family could retain their power to get jobs and favors even as they suffered official isolation.[28]

The clientele of a business often reflects the effectiveness and reputation of the enterprise. Similarly, one particularly illustrious mother's request demonstrates not only how capable Bayard Smith was but also how highly her contemporaries regarded her skill. Martha Jefferson Randolph was a woman of impeccable pedigree. Not only Thomas Jefferson's sole living daughter, she was also known to have been her father's favorite, his confidante and occasional White House hostess. In addition, she married into the Randolph family, a politically powerful Virginia clan, and her husband served as an influential member of Congress. Occupying the highest pinnacle of the social ladder whenever she was in the capital, Mrs. Randolph became the head

of whatever occasion she attended. No matter what the social skirmish, no one disputed her right of precedence.[29]

She, of all people, should have had no trouble calling in a favor, and in her time of need, Mrs. Randolph could have turned to any Washington lady or gentleman for help, but she chose Margaret Bayard Smith. By 1828, Mrs. Randolph and her family lived on the edge of poverty in Monticello. Her father had left her nothing except a debt so large that it consumed several generations' and families' fortunes, including her husband's. Her only hope for support was to get a male relative into a government job that would provide the means and opportunity to leave Monticello and its expenses and live in Washington. Her daughters and sons would profit from a residence in the capital, with its opportunities for employment and good marriages. Out of the loop of everyday political activities, Jefferson Randolph turned to Margaret Bayard Smith, Washington insider.

It was a good choice. In 1828, Margaret Bayard Smith was at the peak of her political power. In October, Bayard Smith wrote to her sister Maria Bayard Boyd that she "had a most affecting letter . . . from Mrs. Randolph. She made no complaints and expressed no anxiety but the simple narrative . . . needed nothing to touch any heart."[30] Martha Jefferson Randolph appealed to Bayard Smith for a clerkship for her son-in-law Nicholas Trist (who had married Virginia Jefferson Randolph in 1824), "without which it would be impossible to come to Washington."[31]

Bayard Smith's motive for helping Jefferson Randolph may have sprung from a warm heart, but her assessments were coldly professional as she spoke of a recently deceased officeholder: "The moment I heard [of] Mr. Forest's death—I went to Mr. Clay—showed him her letter and added to it every argument justice or benevolence could. If ever I was eloquent it was then." Speaker of the House Henry Clay sympathized but told Bayard Smith that the clerks in his department expected the vacancy to be filled by promotion. However, he ended the interview by telling Bayard Smith that "his feelings were one with me, and he would do everything justice would allow."[32] Bayard Smith did not work alone, enlisting Dolley Payne Todd Madison herself (and her kinswoman, "Miss Cutts") to urge the same suit. Internal departmental pressure notwithstanding, Nicholas Trist got the job and went on to a long and distinguished career in public service.[33]

Four years later, Randolph again turned to Bayard Smith for help in placing a member of her large family in a position. This time, Bayard Smith took her cause to Letitia B. Porter, wife of General Porter, with whom she often collaborated on these missions. Mrs. Porter came through, appealed to jus-

tice and feeling, and obtained a place through her husband's connections. She wrote to Bayard Smith that if Mrs. Randolph had a son of suitable age, General Porter agreed to get him a cadet's commission and advance him so that the young man would have "almost all the advantages as if he had entered" at the proper time, some five months before.[34]

These particular missions proved unqualified successes, but Smith did sometimes fail. The significance of her work, however, should not be judged by the success or failure of a particular object or campaign. Rather, it lies in the reactions of those around her, the general assumption that she acted quite reasonably and rightly. A female network underlies Bayard Smith's patronage stories, an important clue that far from being unique, her influence peddling constituted acceptable, desirable behavior for a group of influential women. On one occasion, when Bayard Smith hoped to succeed where her husband had failed, she reminisced: "Ah, when my good Mrs. Porter was here, with what freedom would I go to her on such occasions with a certainty of success, where circumstances admitted it."[35] A closer look at another episode in Bayard Smith's career illustrates the action of the female networks and the milieu in which they took place.

On several occasions both Bayard Smith and her husband tried mightily to procure appointments (including a seat on the Supreme Court) for Andrew Kirkpatrick, chief justice of New Jersey and husband of Jane Bayard Kirkpatrick. In spite of their best efforts, they could not deliver. However, failure breeds justification and, most pertinent for this examination, *detail*. After failing several times, in 1826 Bayard Smith defended yet another attempt with a long account of her unsuccessful venture. In a letter filled with news of family health and activities, she interrupted herself, "[A]nd now, my dear sister, for the business mentioned in your last letter," clearly indicating that these transactions, though for the benefit of Judge Kirkpatrick, were conducted in "personal" correspondence between the sisters. "[B]eing aware of the necessity of promptitude in such affairs," Bayard Smith and her adult daughter Susan went into the city the day after receiving Bayard Kirkpatrick's letter and called on "Mrs. ———," who "with her usual kindness, immediately asked me to stay to dinner, which invitation I accepted, having ever found gentlemen more good humored and accessible at the dinner table than when alone."[36] One can scarcely imagine a more succinct summation of the assumptions behind the dinner table strategy! The success of this tactic depended upon the cooperation of the lady of the house, who had issued this invitation upon learning of Bayard Smith's mission.

Over dinner, Bayard Smith did her best to "dissipate the coldness and

reserve common of late to Mr. ———— and succeeded pretty well, he became as amicable and gracious as when I first knew him." Though Bayard Smith is not forthcoming on the reasons for this "coldness and reserve," her awareness and attempts to overcome it indicate a professional attitude, which does not let pride stand in the way of a goal.[37] After the servants had cleared and with-drawn, "Mrs. ———— rose to leave the table," an indication that the other fe-males in the room should retire with her. "I asked her if she could trust her husband tête-à-tête with me—she, (knowing my object) laughingly con-sented and withdrew with my Susan and her son." The presence of Susan and the son of the house reminds us how this "official" transaction looked like a social call and family dinner.

Alone with Mr. ————, Bayard Smith, using her "very best manner . . . broached the subject," adding two interesting disclaimers. First, she would not be requesting a job if "not prompted by affection," and second, "Mr. Smith as he well knew had always declined such interposition." By in-voking the pull of "affection," Bayard Smith was indulging in the ritual de-nial many women of this era used before embarking on political actions or discussions. Her second demur implies, ironically, that in an antipatronage culture, patronage was, and could only legitimately be, women's work. Ba-yard Smith's account continued: "After this preface, I said all I could think of to interest him in our friend." One might conclude that Mr. ———— did not want to be involved, since he immediately suggested "a more proper per-son to apply to." Bayard Smith cannily told him that she hoped to have the influence of the man Mr. ———— suggested but "that I annexed much more importance to his influence, knowing it to be much more powerful than of any other individual."

No doubt flattered, but still reluctant, Mr. ———— "modestly disclaimed having any influence, or at least but little"; but Bayard Smith had not come so far to have him wiggle off the hook. "'Give us that *little* and I will be con-tented and indeed sure of success,' said I, adding some compliments." Re-lenting, Mr. ———— promised that, though he made no guarantees, he would "certainly remember all I had said, would give due weight to the cir-cumstance I had mentioned and to whatever misrepresentations might be made by others." He cautioned Bayard Smith that much had to pass before the matter was settled and advised that "our friend" should "obtain letters from the most influential characters in the state and throw into his scales so great a weight of public opinion as he could obtain." Bayard Smith stressed to her sister that in her report she had condensed the high points of a "long and desultory conversation," throughout which Mr. ———— "evidently

avoided committing himself," although she hastened to assure Jane, "It was obvious his feelings were kind and friendly."

Bayard Smith's concluding explanation of why Samuel Harrison Smith could not intercede for Jane's husband is equally instructive about the process of patronage. Noting that "What he will not do for himself, will not be deemed unfriendly not to do for another," Bayard Smith claimed that her husband "keeps himself wholly aloof from the present administration, and [would] feel it an indelicacy in him to ask any favor from those who he has opposed." Because of his political stance, "he never visits," demonstrating the close connection between calling and politics in the capital. In other words, Samuel *could not* call, because his actions would be interpreted politically. His wife, however, led a separate existence, and whatever intercourse existed between the Smiths and official society "arises from my personal friendships with the ladies." Bayard Smith then ended her letter: "I most sincerely and affectionately interest myself in everything that interests you and should rejoice in any or the best degree, to prove by something more than words the interest I feel." [38]

This account not only confirms the centrality of women to the business of patronage but also establishes that such transactions took place in women's spaces, like parlors and dining rooms, during social activities usually considered "private," like calling and visiting. In 1815, ten years before Bayard Smith's efforts on Andrew Kirkpatrick's behalf, Samuel Smith brought up his name at the president's dinner table, only to have the strategy backfire. A man Samuel thought friendly proceeded to disparage Kirkpatrick in front of the president.[39] Perhaps this disastrous incident convinced Samuel to implement his policy of noninterference and leave these matters to his wife. He certainly made no time for a future brother-in-law of one of Jane's daughters, who arrived in Washington in 1814 with a letter of introduction from Margaret Bayard Smith's brother, Samuel Bayard. No matter that her husband would not involve himself—his future "Aunt Smith" invited him to a round of parties, teas, and dinners, where "I took pains to introduce him to all the members." A list of some seven men follows, including Henry Clay, and "two dozen more of the most distinguished members." Through Bayard Smith's intercession, this young man immediately found himself moving in high company indeed.

During her own party for her future kinsman, Bayard Smith improved the opportunity by "mention[ing] him particularly" to those with whom she was "very intimate." Though Samuel Harrison Smith had been too busy to initiate occasions to help this young aspirant to office, Bayard Smith's party

allowed her husband the opportunity, without much effort, to "sp[eak] of his [the candidate's] business in a way that might turn their attention to it," and to introduce the young man to the chairman of the Ways and Means Committee. Margaret Bayard Smith followed up on her husband's efforts by inviting the chairman to dinner, along with other influential men.[40] In addition to her direct efforts to aid her young kinsman, then, Bayard Smith provided the social space that multiplied opportunities and efforts for and by others.

In politics, private spaces have often served public purposes. Diplomats have long recognized that the business of diplomacy is rendered most effective with trust and confidence between government officials.[41] This is not easy to establish, and the most efficient way lies in using homes and social settings to make the process seem "natural" and easy. A home setting shifts the focus from the "official" males to the "unofficial" women, which allows the "officials" room for maneuvering and negotiating. Wives, daughters, and other female kin create an atmosphere that makes officials feel they are truly getting to know each other on terms of intimacy.[42] Like homes of foreign ambassadors in Washington City, the homes of politicians became places to establish trust. In a diplomatic context, then, Washington parlors constituted one more type of political space.

Women cut off from official channels develop a keen sense of the nuances of the unofficial, such as the insistence on personal presence that emerges from women's correspondence on patronage. A large percentage of those unread applications, piled in department offices, came from men who placed too much confidence in the power of official documents. In contrast, Bayard Smith and other female patronage players insisted that the candidates present themselves personally. Though the $800-a-year post she obtained for her nephew Samuel Todd was not as lucrative as she had hoped, Dolley Payne Todd Madison explained that "the advantages of your being in this place will be considerable towards your obtaining something better."[43] Bayard Smith offered the same advice to Jane Kirkpatrick on the various occasions she helped find employment for Jane's sons and other male kin: "So, let me repeat, let our friend come and make himself known. I intended using the privilege of old acquaintance."[44] The reasons were obvious: "If he were here on the spot, that would be a great point gained—a very great one—he might make acquaintance and others might become acquainted with his qualifications and personal merit and would feel a much livelier interest for one whom they knew, than for one who they never saw."[45]

In addition to blurring the lines dividing "public" and "private" events and spaces, women's accounts of their patronage work also confuse the his-

torical construct of the "separate spheres," in which women supposedly retired to the home, leaving the corruption of the marketplace and smoke-filled rooms to men. In one way, the business of patronage neatly reverses this paradigm; while women engaged in the nuts and bolts of politicking, men remained aloof and "pure." When they did participate, men employed "feminine wiles" in social situations, as Samuel Smith did by introducing the topic of Andrew Kirkpatrick over the dinner table. In contrast, Margaret Bayard Smith discussed salaries, conditions of employment, and opportunities for advancement with her candidates at social occasions. She also approached nonkin males in their official capacities as employers and couched her requests not in the Esther-like style of war widow petitions but with open discussions of money and qualifications. Gendered behavior prescriptions blur with reality, as both sexes employed whatever strategy they needed to get what they wanted.

Perhaps most significantly, in these crucial matters, women and men worked together.[46] Rather than presiding over sex-segregated areas, women and men approached each other, discussed, proposed, and negotiated. Men and women did not conduct business identically, but perhaps less differently than historians have argued.[47] An official male always had to be the end point of a patronage process, since he had to make an official appointment, but males, of course, were also the supplicants. Men supplied the "official documents," including not only the jobs but also the letters of recommendation. Women helped make the system work on the ground.

Males as well as females were part of a patronage seeker's network. For Bayard Smith, they were colleagues, connections, and sources of information, as her visit to the successful aspirant Eugene Vale indicates. On one occasion, Bayard Smith, who often presented herself as a world-weary, home-loving domestic creature, railed at being housebound and thus prevented from information gathering and calling in some important chips. "Had it not been for her [daughter Susan's] increased indisposition, I should have seen and conversed with a gentleman in office who has always shown me much regard about the affair of an appointment and another gentleman, who is somewhat indebted to me for the place he holds and who is now in high favor and on the most confidential terms with the president." Far from the stereotype of the True Woman avoiding the public sphere, Bayard Smith knew that being out and about in public, or inviting the male public home, was crucial to her interests: "If I was not thus detained at home, I should have been going about seeking for information. Now we invite no company to the house, so I have no chance of seeing gentlemen who might aid in researches."[48]

Given early republican American culture's oft-expressed and universal horror of "petticoat politicians," these women's actions in political business may seem improper or even radical. On this point, Bayard Smith's documents prove most revealing, especially in their articulation of what may have remained unspoken in other women's lives. These elite white women certainly did not see themselves as lone feminists or radicals breaking barriers. Paradoxically, Bayard Smith, as well as Dolley Payne Todd Madison and others, saw their political activities as extensions of two of the most important and most womanly duties of their lives—caring for the family and charity toward others. The righteousness of her causes, such as aiding fatherless males with mothers and siblings to support, may have allowed Bayard Smith full rein to be aggressive and therefore effective. By the mid-1810s, when her own kin came of employment age, she had a system in place and the confidence to aid not just her relatives but any young man or family she deemed worthy.

By framing her efforts in the language of benevolence and emotion, Bayard Smith could assure herself (and her correspondents) that she was only doing what her "heart" deemed proper. People in nineteenth-century middle-class culture viewed women as creatures of the heart; as long as they followed its dictates (within the limits of male desires and anxieties, of course), they could do no wrong. A letter from Jane Bayard Kirkpatrick reveals a way of thinking that would allow women of the era to contain their patronage dealings within psychologically and socially acceptable boundaries. After Bayard Smith succeeded in placing Littleton Kirkpatrick in a highly advantageous position, his mother wrote to her: "Seldom, my dear Margaret, in the course of my whole life have I from any circumstances been rendered so happy as by the intelligence contained in your last letter. By the blessings of providence and your kind exertions our plan for L. is completed."

Though she cited her sister's "kind exertions," Bayard Kirkpatrick continued by describing how her "heart is overflowing with gratitude to my Heavenly Benefactor," crediting God not only with "providing" but even with actually placing her son in a situation "so favorable to exertion, so calculated to every generous sentiment of his nature." Couched in these terms, Bayard Smith appears as an angel of personal happiness (and Divine assistance) for her sister, and places employment in the realm of personal improvement rather than in the crass arena of the marketplace. Kirkpatrick's letter flows on in the same vein, full of the softest sentiments, lauding her sister's "generous heart" for obeying the "law of love" and predicting "ample recompense"— from the "hands of a just and beneficent providence."[49] Little would the uninformed reader know that the writer's sister had acted as an influence ped-

dler, negotiating terms and salaries with an employer. Bayard Kirkpatrick's language preserved her own pride of place as eldest sister and presented Bayard Smith's efforts in terms acceptable to the two well-bred women and their world.

Bayard Smith and other women undertook this work in the context of overlapping "families," which reminds historians of the importance of seeing historical actors both male and female not as "great" or "exceptional" isolated individuals but as embedded in complex kinship networks. In later decades, the ideal of the nuclear family in retreat from the world and pursuing self-sufficient privacy would dominate, but during this period the ideology and myth of individualism was not an important part of elite and middle-class culture. Natal and marital connections told the upper and middle classes who a person *was.* Individual merit was not insignificant, but background controlled and indicated personality and capabilities.

On the simplest level, Bayard Smith and her counterparts understood their efforts to obtain employment for male family members as an extension of their duties as loving, responsible mothers. However, they also justified obtaining jobs for nonkin men (as Bayard Smith did for Nicholas Trist) as benevolent aid to deserving families in need, using the "bonds of womanhood" to benefit anxious mothers or to protect innocent sisters.[50] They also worked within the institution of family in the process of carrying out their missions, appealing to wives and mothers, using family homes (their own and others') as their forum, making their requests during a social call or at a dinner table. Bayard Smith and other elite white women worked within the assumption that it was better to see a candidate personally than to read about him and that it was best of all to know a family, rather than just an individual.[51] These assumptions may seem like common sense, but they have only rarely been taken seriously as factors in political analysis.[52]

Beyond all of this selfless rhetoric, it is also clear from reading Bayard Smith's papers that at least some women knew the significance of their work and that they took pleasure in their success. Preceding an account of a successful patronage foray, Bayard Smith exulted, "I write with more pleasure now, as I have more pleasing intelligence. I know of nothing more delightful than to succeed in plans in which we are much interested," adding playfully, "I have had this pleasure in so great a degree this morning, that I feel unusually exhilarated."[53] Though sometimes acting as men's voices, speaking when and where their husbands dared not, these women knew they were not tools or intermediaries or even "deputy husbands." They acted as independent agents, pursuing their goals in forthright and focused ways.

Possessing power imparts a sense of self-importance; Bayard Smith was not above boasting about her capability, as in an acerbic comment concerning a young man who, once a frequent and pleasant visitor, had become corrupted by the *"usage du monde,"* thus neglecting his old friends: "What trifles influence the destiny of men—Little does he suspect the influence I have had in his present condition." "Unknown to him," she revealed she had obtained a place for this young "Mr. Ward" in a traveling party bound for the West, "consisting of western members [of the House], Governor Cass, Governor Clark and family, Mr. Lyon." The "intimate acquaintance" Ward formed with these "respectable and worthy people who are now among his best friends" thereafter ensured his success. Even before the young man left Washington City, Bayard Smith continues, "I likewise took an opportunity of interesting Mr. Clay for him." This she accomplished in the most traditional of social ploys: "I maneuvered to place him . . . alone on the sopha by Mr. Clay." "The maneuvering" worked, and "an interesting conversation took place. Mr. Clay, I hear, is his constant correspondent and a patron of his paper."[54] However, in a cultural climate that did not allow even men to express ambition openly, Bayard Smith did not indulge in too much preening. Note that she precedes the relation of her part in the young man's success with a disclaimer, presenting her influence as a "trifle." For all of the obvious pride and pleasure Bayard Smith expressed on the occasions she discussed her efforts, she understood her work, or at least spoke of it, in ways very different from our twentieth-century conceptions.

In this discussion of the crucial role women's relationships and activities played in obtaining jobs and favors for men, it is worthwhile to stress again that patronage provided the foundation for the structure of the early federal government. Placing "friends" in highly desirable places ensured constituent satisfaction, thus securing a return engagement at the center of power. As important, the process of making contacts and deals, of learning political systems, of indebting oneself to powerful people, of enmeshing oneself and one's family in the national power structures, also contributed to creating oneself as a personal political force.

Patronage's long history stems partly from its neat, reciprocal quality. Being a successful "friend at court" ensured that one's family would itself gain a new "friend" in a position of power. Being in the debt of someone more powerful was a good thing; having someone powerful in your debt was even better. An effective influence peddler acquired both kinds of debts, the first while working *for* a candidate and the second *from* a grateful candidate who

might, through one's efforts, leapfrog up the political ladder. The process of networks became richer and more complex when connections were being made not just between individuals but among whole families. In a time of unprecedented growth in Congress, with a relatively weak executive, these networks of kith and kin, of personal and professional favors, provided the federal government with a system by which to grow and thrive. With so much at stake, no wonder that disruptions of the social scene and violations of the social rules caused what Washington women called "heartburnings."

The discoveries provided by a close reading of Margaret Bayard Smith's activities challenge the general assumption that politicking activities could only be the business of official men. On the contrary, in Euro-American political systems, elite men and women both politicked in unofficial space. This proves especially true for democratic politics in an age before organized parties became the dominant political units. Transactions in the unofficial space privilege face-to-face, personal interactions over speeches to audiences, official procedures, and exchanges of documents. In a democracy, where successful legislation depends upon a majority and decisions are necessarily by consensus, personal relations prove crucial. These relations always provide the base of the political, in a democracy or a republic perhaps even more than a monarchy. On the simplest level, a working democracy includes increasingly large groups of interested people, and the layers and levels of relations multiply. The failure to understand this aspect of democratic politics explains lawmakers' conflicted attitude toward politics during the early republic. Having eschewed a system of monarchy based on "corrupt" personal power, the founding generation could not yet recognize that the alternative system they embraced also had to rely on personal relations.

And no wonder Jefferson and the other early republicans were obsessed by patronage, a risky, unrepublican, and crucial practice. Politics and patronage provided the keys to making a government run. An absolute monarch can unapologetically display his or her power over these areas, while a republic, which also needs connections and self-interest in order to function, must dissemble. Ironically, the growth and stability of the first modern democracy depended heavily on these "aristocratic" practices and deployed the same personnel to implement them—women. As in a larger political and cultural context, women became the repository for aristocratic practices, desires, and longings, so here they facilitated politics as usual.[55] The austere republican man could remain pure and uninvolved in patronage, as "Mr. Madison" did while "Lady Madison" employed patronage and networking to build

congressional consensus and support for her husband's administration and policies. In an ironic twist on the separate spheres, women performed the "dirty work" of politics to ensure their husbands' political purity.

Notes

The author wishes to thank the following for their skill and generosity: Nancy F. Cott, John Demos, Rose Barquist, Joseph J. Ellis, Joanne B. Freeman, Jan Lewis, Jonathan Lipman, Mary M. Wolfskill, Rosemarie Zagarri, and the editors, Alison M. Parker and Stephanie Cole.

This essay is based largely on the papers of Margaret Bayard Smith (hereafter MBS Papers) at the Library of Congress (hereafter DLC). The following is a list of the correspondents of Margaret Bayard Smith (hereafter MBS): Samuel Harrison Smith (SHS), husband; Jane Bayard Kirkpatrick (JBK), sister; Maria Bayard Boyd (MBB), sister. Some correspondence is from the Massachusetts Historical Society (MHS).

Biographies have traditionally referred to female subjects by their first names—e.g., "Dolley"—granting the patronym to the male as the central actor—e.g., "Madison." This essay offers an alternative naming pattern, utilizing natal and marital patronyms as kin markers for its many female subjects while referring to males by full or first name.

1. For the revolutionary focus on royal patronage as a major issue and the problem of Federalist abuse of patronage, see Gordon S. Wood, *The Radicalism of the American Revolution* (New York: Knopf, 1992), pp. 80–81, 174–79, 263–64. This ambivalence about patronage is a symptom of a larger unease in early republican politics. Joanne B. Freeman's work presents a political culture in which ideological tenets existed in clear disjunction with political realities. The early republican politicians feared the fusion of the "personal" and the "political," as in "political friendships." They refused to see politics as a fundamental human activity and could not accept that private interest could intersect with public good. Joanne B. Freeman, "Slander, Poison, Whispers, and Fame: Jefferson's 'Anas' and Political Gossip in the Early Republic," *Journal of the Early Republic* 15, no. 1 (spring, 1995): 40.

2. Wood, *Radicalism,* p. 361; and Joseph J. Ellis, *American Sphinx: The Character of Thomas Jefferson* (New York: Knopf, 1993), p. 197. Jefferson, a man fond of stark dichotomies, found no easy solution to the problems of wanting to appear conciliatory to his old enemies on one hand and having an overwhelming desire for harmony and control on the other.

3. Joan B. Landes, *Women and the Public Sphere in the Age of the French Revolution* (Ithaca, N.Y.: Cornell University Press, 1988), pp. 17–18, 27, 36; Dena Goodman, *The Republic of Letters: A Cultural History of the French Enlightenment* (Ithaca, N.Y.: Cornell University Press, 1994), pp. 53–54, 74–76, 89; Gordon S. Wood, *The Creation of the American Republic, 1776–1787* (New York: Norton, 1969), pp. 52–53, 418.

4. Thomas Jefferson to George Washington, Dec. 4, 1788, *Papers of Thomas Jefferson,* vol. 14, ed. Julian P. Boyd et al. (Princeton, N.J.: Princeton University Press, 1950), p. 330.

5. MBS to JBK, Nov. 16, 1800, MBS Papers, DLC.

6. There were local Maryland and Virginia families who built houses in Washington City, so they, too, claim long residences. But Margaret Bayard and Samuel Smith's longevity is remarkable among those who came to Washington to follow the government.

7. Laurel Thatcher Ulrich, *A Midwife's Tale: The Life of Martha Ballard, Based on her Diary, 1785–1812* (New York: Knopf, 1990), p. 9. Recent scholars have turned to Smith's vast collection of unedited papers to address new historical questions concerning the intersection of class, race, and gender in early Washington City. Her fiction and professional writings are also receiving new scrutiny for what they reveal about social and cultural practices. See: Fredrika J. Teute, "'A Wild, Desolate Place': Life on the Margins in Early Washington," in *Southern City, National Ambition: The Growth of Early Washington, D.C., 1800–1860,* ed. Howard Gillette, Jr. (Washington: American Institute of Architects Press, 1995), p. 51, and "In 'the gloom of evening': Margaret Bayard Smith's View in Black and White of Early Washington Society," *Proceedings of the American Antiquarian Society* 106, no. 1 (1996). In addition, two full-length studies are forthcoming by Teute and Rose Barquist.

8. David R. Goldfield, "Antebellum Washington in Context: The Pursuit of Prosperity and Identity," in *Southern City, National Ambition,* ed. Howard Gillette, Jr., pp. 15–16; Constance McLaughlin Green, *Washington: Village and Capital, 1800–1878* (Princeton, N.J.: Princeton University Press, 1962), p. 101.

9. Margaret Bayard Smith, *The First Forty Years of Washington Society,* ed. Gaillard Hunt (New York: Ungar, 1906), p. 251. Smith's novel, *A Winter in Washington; or Memoirs of the Seymour Family* (New York: E. Bliss and E. White, 1824), devotes many pages to the efforts of the mother and oldest daughter of the Seymour family to provide relief for the families ignored or rejected by the city fathers and visiting politicians of Washington City. Fredrika J. Teute provides a brief history of Margaret Bayard Smith's benevolence work among the poor in an essay about Bayard Smith's fiction. Teute, "'Wild, Desolate Place,'" pp. 54–55.

10. MBS to MBB, Apr., 1802, MBS Papers, DLC.

11. Lori D. Ginzberg, *Women and the Work of Benevolence: Morality, Politics and Class in the Nineteenth-Century United States* (New Haven, Conn.: Yale University Press, 1990); Nancy A. Hewitt, *Women's Activism and Social Change: Rochester, New York, 1822–1872* (Ithaca, N.Y.: Cornell University Press, 1984); Mary Ryan, *Cradle of the Middle Class: The Family in Oneida County, New York, 1790–1865* (Cambridge, England: Cambridge University Press, 1981); and Anne Firor Scott, *Natural Allies: Women's Associations in American History* (Urbana: University of Illinois Press, 1991).

12. Baker does argue that the skills and techniques developed by the women would become the accepted political tools for citizens of both sexes, but not until the twentieth century. Paula Baker, *The Moral Frameworks of Public Life: Gender, Politics, and the State in Rural New York, 1870–1930* (New York: Oxford University Press, 1991), pp. xvi–xvii, 89.

13. See Ryan, *Cradle of the Middle Class,* pp. 184–85; Burton Bledstein, *The Culture of Professionalism: The Middle Class and the Development of Higher Education in America* (New York: Norton, 1976), pp. 4–6, 13–21.

14. Leonard White, *The Jeffersonians* (New York: Macmillan, 1951), p. 83.

15. Harrison Otis visited his friends from Boston, the Bulfinches, newly moved to Washington, and noted approvingly of the couple: "She is, I think, much more eligibly situ-

ated than in Boston and is herself of that opinion. His chances for establishing his children are certainly multiplied." Harrison Gray Otis to Sally Foster Otis, Nov. 25, 1818, Harrison Gray Otis Papers, MHS.

16. MBS to JBK, Nov. 24, 1831, MBS Papers, DLC.

17. John Smith to ?, Mar. 10, 1808, John Smith Collection, DLC. Though the number of men required cannot be precisely known, forty is a customary number.

18. Harriet Otis, Diary, Apr. 13, 1812, Harrison Gray Otis Papers, MHS.

19. James M. Varnum to J. B. Varnum (father), May 7, 1814, Varnum Family Papers, MHS. For more such tales of stranded job seekers, see Francis J. Grund, *Aristocracy in America: From the Sketchbook of a German Nobleman* (New York: Harper, 1959), pp. 249–50.

20. Job Durfee to Judith Borden Durfee, Feb. 7, 1824, Job Durfee Papers, DLC.

21. This was the experience of Margaret Bayard Smith's brother, Samuel Bayard.

22. MBS to JBK, Feb. 15, 1832, MBS Papers, DLC.

23. MBS to JBK, Dec. 15, 1831, MBS Papers, DLC.

24. MBS to JBK, Nov. 14, 1831, MBS Papers, DLC.

25. MBS to Susan H. Smith (sister-in-law), Mar. 19, 1821, MBS Papers, DLC.

26. By 1818, Delaware senator Louis McLane acknowledged Smith as a "very important personage in the city," presiding in "great state," as a dispenser of vital information. Louis McLane to Kitty McLane (wife), Jan. 24, 1818, McLane Papers, DLC.

27. Actually, Samuel Harrison Smith benefited from a powerful patron before that. During Jefferson's first term, as Jefferson's unofficial "editor," Samuel received a prize "plum"— contracts to print all House documents. In 1813, President Madison appointed him commissioner of the revenue of the Treasury Department and, in 1814, secretary of the treasury ad interim. Smith records her extensive efforts to find him a new place, using her "particular friend," William Crawford. Her efforts to obtain for him the job of postmaster general, a very profitable patronage post, or employment in the land office, were unavailing.

28. The practice of using women's second-class status to the family's advantage was not uncommon; husbands utilized the debt laws and "hid" money in their wives' names. In this volume, Janet Coryell also discusses the ability of women to sustain a role in politics even when not officially connected to an officeholding husband.

29. For more on this politically powerful woman, see Linzy Brekke, "Martha Jefferson Randolph and the Politics of Family in the Early Republic" (senior thesis, Mount Holyoke College, 1998).

30. MBS to MBB, Oct. 24, 1828, MBS Papers, DLC.

31. Martha Jefferson Randolph to MBS, Oct. 5, 1828, MBS Papers, DLC.

32. MBS to MBB, Oct. 24, 1828, MBS Papers, DLC.

33. Trist's notable posts included, among others, private secretary to Andrew Jackson (1831), assistant secretary of state (1845), and special agent to negotiate the peace treaty with Mexico (1847–48). For Martha Jefferson Randolph's grateful acknowledgment of Smith's services, see Martha Jefferson Randolph to Margaret Bayard Smith, Nov. 10, 1828, MBS Papers, DLC. This transaction is truly intriguing and worth deeper study than the brief consideration here. Many thanks to Margaret Bayard Smith biographer Rose Barquist and to Mary Wolfskill, head of the Reading Room, Manuscript Division, for plumbing the depths of the DLC to obtain the crucial letters for me.

34. MBS to Letitia B. Porter, Oct. 25, 1828, MBS Papers, DLC. A post as cadet or midshipman was widely considered as an important stepping-stone into the ruling elite on the military track.

35. MBS to JBK, Nov. 24, 1831, MBS Papers, DLC.

36. Smith frequently uses guarded language and initials in her discussions of patronage, a caution that reflects the subterranean nature of the topic. I find the word "subterranean" particularly accurate in describing patronage and women's political activities in general. It not only carries the connotations of "secret" and "underground," but also (as in "cellar") that of "foundation."

37. It is less likely that Smith herself would consciously have agreed with this "professional" interpretation. More likely she would have seen herself as Eleanor Parke Custis Lewis did: "The fear of refusal will never deter me from attempting to serve my friends, I have no idea of that kind of pride. We must risk something, before we can be certain of success in anything." Eleanor Parke Custis Lewis to Elizabeth Bordley Gibson, Mar. 19, 1826, cited in *George Washington's Beautiful Nelly: The Letters of Eleanor Parke Custis Lewis to Elizabeth Bordley Gibson, 1794–1851,* ed. Patricia Brady (Columbia: University of South Carolina Press, 1991), p. 174.

38. MBS to JBK, Sept. 25, 1826, MBS Papers, DLC.

39. MBS to JBK, July 2, 1815, MBS Papers, DLC.

40. MBS to JBK, Jan. 29, 1814, MBS Papers, DLC.

41. Rosemary Foot, "Where Are the Women? The Gender Dimension in the Study of International Relations," *Diplomatic History* 14 (fall, 1990): 621.

42. Cynthia Enloe, *Bananas, Beaches, and Bases: Making Feminist Sense of International Politics* (Berkeley and Los Angeles: University of California Press, 1990), p. 97.

43. Dolley Payne Todd Madison to Samuel Todd, Mar. 31, 1809, Dolley Madison Papers, DLC.

44. MBS to JBK, Dec. 15, 1831, MBS Papers, DLC.

45. MBS to JBK, Nov. 24, 1831, MBS Papers, DLC.

46. Barbara Carson concurs, stating: "[T]his concept of twin spheres does not provide an adequate model for the lives of husbands and wives who were part of the very small but very visible Washington high society." Barbara Carson, *Ambitious Appetites: Dining, Behavior, and Patterns of Consumption in Federal Washington* (Washington, D.C.: The American Institute of Architects Press, 1990), p. 87. I would go further and question the "strictness" of separation between "work or family life."

47. Some historians, however, have presented a world men and women made together. Laurel Thatcher Ulrich describes the lives of men and women as being like a check weave, in which, though there are two distinct colors, the occurrences of intersection are more numerous than solid squares of any one color. *Midwife's Tale,* pp. 73–76.

48. MBS to JBK, Dec. 20, 1831, MBS Papers, DLC.

49. JBK to MBS, Sept. 22, 1816, MBS Papers, DLC.

50. Nonkin petitioners also played on the trope of mothers and motherly concerns in their requests for intercession. Phebe Morris, Dolley's "adopted" daughter, approached her patron with a request for a foreign appointment for her father on the grounds that his health demanded a change of scene.

51. A candidate did better to meet not just his future benefactor but also the family of the

benefactor, as indicated when Smith offered to take nephew Bayard under her wing, assuring her sister, "[I]t would be my study in every way in which I possibly could to advance his interest and comfort. I would make it a point to introduce him into two or three families." MBS to JBK, Jan. 8, 1815, MBS Papers, DLC.

52. See for instance, Sidney H. Aronson, *Status and Kinship in the Higher Civil Service: Standards of Selection in the Administrations of John Adams, Thomas Jefferson, and Andrew Jackson* (Cambridge: Harvard University Press, 1964). This work is still cited thirty years after publication because no new work has followed up on Aronson's findings.

53. MBS to JBK, Sept. 16, 1816, MBS Papers, DLC.

54. MBS to JBK, n.d., MBS Papers, DLC. Though this letter is undated, internal clues and handwriting indicate that it was written later in Smith's career, which can explain the tone of open pride.

55. Early republican Americans both feared and longed for the distinction imparted by aristocratic practices, and women often occupied a mediating position between aristocratic and democratic impulses in the culture. Catherine Allgor, "Political Parties: Society and Politics in Washington City, 1800–1832," (Ph.D. diss., Yale University, 1998).

Chapter 3

"What We Do Expect the People Legislatively to Effect"
Frances Wright, Moral Reform, and State Legislation

ALISON M. PARKER

From the 1820s through the 1840s, Frances Wright explored the relationship between individual conscience, legislation, and the effort to create a better society. Wright's solutions for American social problems were bold: she created a radical antislavery commune and supported mandatory boarding schools for all children. Her critiques of the institution of marriage, rejection of organized religion, support for racial miscegenation, and arguments against stigmatizing children born outside of marriages as "illegitimate" were even more disruptive and unconventional.

Yet her ideas did not simply challenge mainstream values, for she also drew on popular concerns and priorities of the Jacksonian era. Her interest in utopian experiments, for instance, reflects their wider popularity; there were more than one hundred secular and religious utopian communitarian living experiments in the first half of the nineteenth century. Her own antislavery commune at Nashoba, Tennessee (1825–29), moreover, was based in part on a Christian, perfectionist model of reform whereby individuals' values would be transformed by moral example. Experiments like Nashoba, she believed, would lead Americans to ensure social justice by eventually passing new antislavery laws at the state level.[1]

Wright's career as an antebellum female moral reformer illustrates the instability of the political moment and the development of a unique social vision. Her embrace of state legislation and the Working Men's Party in New York shows one woman's comfort with political debates and campaigns. But Wright's ideas about government (both state and national) were complicated. She was persuaded by the Jacksonian vision of a democratic state that

represents and is formed by the people. Viewing the federal government as more distant and less responsive to the average citizen, Wright supported legislation at the state rather than national level. Other antebellum activists, such as perfectionists and many women reformers, began their careers ignoring the state as much as possible, believing that moral suasion would change society; by the 1840s they had generally shifted toward advocacy of *national* legislation to promote their goals. Although Wright was attracted to perfectionist ideas whereby superior leaders would determine what was morally right—what the people need—and then set a moral example that would produce change, for Wright this process did not translate into support for national legislation that could mandate change before the people were ready for it.

Wright's ideas about reform, legislation, and state power can tell us much about the Jacksonian era. But neither Wright's ideas about the use of state legislation nor her similarities and connections to her world have been fully analyzed. Ignoring her pragmatism and popularity, most historians have dismissed her ideas as too radical to be of any broader historical relevance. Her biographers have focused on the drama of Wright's volatile relationships with family, friends, and romantic partners. They have also lamented the discontinuity between her public speeches against marriage and male tyranny and her own unsuccessful marriage leading to her loss of property rights and legal autonomy.[2]

Although many of her ideas were indeed radical, I argue that Wright was less of an aberration of the antebellum era and Jacksonianism than has been thought.[3] In fact, Wright embodied the spirit of boundlessness and the volatility that characterized antebellum America. She embraced, exploited, and sometimes personified the Jacksonian era's weak federal government, its stronger state and local governments, its political conflicts and social turmoil, as well as its democratization and visionary plans. Her emphasis on state rather than national legislation found a sympathetic audience with Jacksonian democrats who wanted to limit the power of the federal government. Widespread utopian ideals and communes, along with a radical working-class movement, inspired Wright's plans for Nashoba and her subsequent career as a lecturer. Wright's plans reflect the openness of her time. In particular, her calls for universal equal education were given serious consideration by the working classes and reformers during the Jacksonian era. Even her ideas about race were embedded in her time. Although she supported miscegenation, Wright's language and actions betrayed her commonality with most white Americans who believed in a racial hierarchy in which whites were, in

her words, "the master race."[4] The social turmoil of the 1820s and 1830s gave her the opportunity and encouragement to plan her utopian society at Nashoba, promote education reform legislation at the state level, launch lecture tours, and openly participate in the political struggles of the era.[5]

Wright's political ideas about the centrality of the Constitution and the meaning of nationhood were shared by other antebellum Americans.[6] Moreover, her notions about moral suasion and the role of legislative reform reflect the nature of governmental power, at both the state and federal level, as it evolved. Specifically, during the early and mid–nineteenth century, the federal government was not as large, bureaucratic, or pervasive as it became by the twentieth century but was still new and decentralized.[7] After the American Revolution, rather than creating an administratively centralized state, the founders of the New Republic set up a system whereby politics and legislation became the means by which public welfare was debated and decided: "U.S. citizens refuse[d] to designate any concrete body as sovereign, but instead attribute[d] sovereignty to the law and the Constitution."[8] Thus, the Constitution allowed power to be located in politics and state laws rather than in a strong central state.[9] For these reasons, Wright consistently invoked the Constitution and the Declaration of Independence as her models for significant change.

Although Wright never met with approval from traditionalists, it was not until the tenor of the age became more ordered and conservative that she was finally marginalized.[10] A consolidation of Protestant conservatism began in the 1830s; the 1840s and 1850s brought a decline in utopian socialism, a new concentration by workers on "pure and simple" unionism, and increased immigration and urbanization. As the nature of American society and politics began to change, more Americans joined with the already alarmed conservatives to push for governmental intervention and assistance at the national level.[11] Significant moves toward consolidation and ordering of the central government occurred during these decades.[12] As radical and reform movements declined, and as the central state gained greater stability, the possibilities for someone like Frances Wright diminished. Wright drifted into obscurity as early as the late 1830s, finding it impossible to attract large audiences or attention from the public and media.

Wright's challenges to America's laws and politics derived from her profound faith in their potential to represent the will of the people. The structural flexibility and democratic potential inherent in the Revolution and its founding documents inspired Wright. *Views of Society and Manners in America,* a travel account of Wright's first visit from Scotland to the United States

in 1818, lauded America's revolutionary possibilities. From her original vantage point as a European intellectual and radical, and because of her sympathy for the democratic ideals of the French Revolution of 1789, Wright was deeply impressed by the promise of the American Constitution. She adopted America as her country because it had the necessary elements to make up a successful government by and for the people: "[W]e should distinguish the advantage we possess over other nations, to be—*not that our form of government is republican, or democratic, or federative, but that it possesses the power of silent adaptation to the altering views of the governing and the governed people.*"[13] Wright understood a main tenet of the constitution: the central and state governments existed purely as the representatives of the will of the people, acting only on their behalf and in their interest.[14]

In a later speech of 1836, Wright elaborated on what she saw as the crucial differences between England and the United States. In England, Parliament had too much power and control over the people. In contrast, the American Congress was limited by the constitutional principle of states' rights. The citizens of each state could determine the laws that would effect them. (Taking this further, Wright agreed with Jacksonian political activists who wanted United States senators to be selected directly by all citizens in each state in order to ensure that they represented state rather than national interests.) In contrast to England, she noted that the founders of the United States had devised a more balanced organization of their political system:

> America's first political fathers had evidently deeply studied the machinery of British government, and distinguished where the shoe pinched. The Puritans of New England . . . determined to establish popular power in its substance; and to them we are indebted for that first organization or systematic division of the parts of government, together with the sectioning of the territory so as to facilitate the action of the population, which, in its whole, will constitute, in the progress of its development and sound action, the definitive state of human society.[15]

The division of the country into separate states, she argued, brilliantly ensured a balance of powers. The right to vote and participate in politics was a vital way to restrict the power of the central government. Wright celebrated Americans as "a people voluntarily submitting to laws of their own imposing, with arms in their hands respecting the voice of a government which their breath created, and which their breath could in a moment destroy!"[16] The Constitution could become the basis for more profound and radical change

because it guaranteed that the people could both amend it and pass new laws in their own states.

When Wright returned to the United States in the company of her friend General Lafayette on his triumphal tour of 1824, her observations of conditions across the country left her disappointed with its failure to achieve its promise. In particular, she criticized those state laws that affected women and slaves. Most laws that affected women, she noted, were not the work of this newly liberated people but were instead based on English common law. Asking Americans to rid themselves of the evils of the English legal system, she implied it had been thoughtlessly adopted in full: "Every part and parcel of that absurd, cruel, ignorant, inconsistent, incomprehensible jumble, styled the common law of England . . . is at this hour the law of revolutionized America."[17]

An early proponent of the notion that marriage was a form of coercive bondage for women, Wright tried to create an ideology for and a language adapted to the needs of women.[18] One of her principle objections was that married women were denied the right to inheritances, wages, and joint guardianship of their children. Like many antebellum reformers, Wright focused on marriage because it was simultaneously a legal institution, a religious commitment, and a powerful site of human emotions. Organized religion was irrational, she argued, and helped prop up the unfair legal institution of marriage. Wright favored replacing current laws on marriage and illegitimacy (equally biased against women, in her opinion) with what she termed nonlegalized bonds of "generous attachments."[19] Partnerships based on mutual respect as well as love, she insisted, need not be officially regulated or sanctioned by either legal or religious authorities.[20] By attacking organized religion and the revivalism sweeping the United States, as well as by attacking marriage and prescribed sex roles, Wright epitomized to her critics the dangerous instability of her era.[21]

But marriage was not the only problem. Wright found that the ideals of the Declaration of Independence, its promises of equality and freedom, were blatantly denied to all black people, most glaringly to those who were enslaved. Like Christian perfectionists, Wright believed in moral suasion and did not seek the immediate legal emancipation of all slaves. Whereas more mainstream antislavery supporters used legislation and politics, antebellum radical perfectionists were convinced that they should end slavery through the tactics of education and persuasion rather than through force or legislation.[22] Perfectionists argued that since individuals were free agents in the

deepest sense, they could immediately improve. They could virtually perfect themselves through an act of will and eventually make their society perfect as well. Based upon their Christian certainty in the possibility of individual perfection, they believed that by appealing to fellow Americans' moral consciences, they could convert those Americans (including slaveholders) into abolitionists who would free their slaves.

Wright was a part of this milieu and had much in common with these religious thinkers conceptually, for she drew on the perfectionist belief in the need for individual moral change before broader social change would be possible. Yet she departed from them substantially in ideology by opposing what she perceived to be the irrationality and emotionalism of the Second Great Awakening of the 1790s through the 1830s.[23] Wright separated the primacy of individual conscience from the process of religious conversion and, instead, appropriated moral certitude for secular causes. In this case, her secularism is what distinguishes her; nearly all other perfectionists were religious activists. Indeed, to her contemporaries, Wright was best known for her assaults against the "priestcraft" and her rejection of organized religion, which she considered a tool to subdue the mass of the population, particularly women.[24] She challenged conventional thought by arguing that religion was merely a belief, while virtue was a practice, and that the two were not inherently connected.

So like perfectionists, she pinned her hopes on the persuasive power of moral example, yet she applied it in a unique way—to an antislavery commune. Once white southerners objectively observed her antislavery experiment, they would see that slavery was unnecessary. She concluded that the only effective way to produce change was to act upon her moral beliefs and expect other citizens eventually to join her. Speaking of herself in the third person, Wright explained that she "had observed that the step between theory and practice is usually great . . . mankind must reasonably hesitate to receive as truths, theories, however ingenious, if unsupported by experiment. . . . She determined to apply all her energies . . . to the building up of an institution which should have those principles for its base, and whose destinies, she fondly hoped, might tend to convince mankind of their moral beauty and practical utility."[25] She admitted that such an experiment was "opposed to all existing opinions and practice," yet hoped that her antislavery ideas would seem less threatening and more of a real possibility for the future if she tried to enact rather than just assert them.[26]

Although she insisted that "the founder of Nashoba looks not for the conversion of the existing generation; she looks not even for its sympathy," she

clearly anticipated that in spite of any initial resistance, people would follow her lead and move toward antislavery once they saw the success of her experiment. While not necessarily expecting sympathy, she explained that she expected tolerance from a country that guaranteed free speech. Nashoba, she insisted, was founded "not in a spirit of hostility to the practice of the world, but with a strong moral conviction of [its] superior truth and beauty."[27]

During the 1820s, when Wright planned and established her experiment, most emancipation societies were still in the South, not the North, and attracted those white planters who questioned slavery as a permanent labor solution for the South. Colonization, or the removal of blacks from America, was promoted as the ultimate solution to the problem of slavery. Yet since the Revolution, southern antislavery ideas had not translated into widespread emancipation or colonization for slaves. In 1825, Jefferson Davis's older brother, Joseph, met Wright in Natchez, Mississippi. As she shared her vision of Nashoba with him, she attempted to learn how to run her commune as a farm with slave/farm workers who would earn their own freedom. Davis listened to Wright's antislavery ideas with interest; while he determined to keep plantation slavery, he aspired to make it both profitable and more humane. His paternalistic plantation was a financial success, yet he never once emancipated any of his slaves.[28]

Wright had initially wanted to try her experiment in race relations with free blacks and whites, but since few free African Americans had joined her at Nashoba, she explained that she had decided to use enslaved African Americans instead. Wright shared the conviction of most white southern reformers that slaves could not immediately be freed because they needed to be schooled in liberty.[29] Even if some planters were ready, she claimed, slaves themselves were not prepared for freedom. "Human enfranchisement," she explained, "is but another name for civilization." Slaves, therefore, would have to be civilized before they were freed.[30] Freed slaves could not automatically be given political citizenship, in her estimation, because the first generation would lack moral and mental elevation. An "apprenticeship" like that at Nashoba would teach them to be civilized. They would be guided, Wright determined, by the white "master race" which was "superior in knowledge" and "therefore necessarily the sovereign disposer of their destinies."[31] Since she agreed with slaveholders that slaves were "unfit" for free citizenship, even education and training at Nashoba could not significantly improve the existing generation. Once her slaves were ready to leave Nashoba, she acknowledged that they would have to be colonized: "the founder judged that she should best conciliate the laws of the southern states and the popular feeling

of the whole union, as well as the interests of the emancipated negro, by providing for the colonization of all slaves emancipated by the Society."[32]

Wright's acceptance of and immersion in the political philosophies of her era shaped the expression of her radical hope for change. Americans could hear her critiques because she often spoke in terms they understood, using concepts they shared. In an article entitled "Nashoba: Explanatory Notes," written in 1827, Wright outlined her vision of her antislavery experiment. Consistent with her support of states' rights and in an overture to white southerners, Wright argued that slavery could only be abolished by "the future decision of our southern fellow-citizens themselves acting constitutionally within their own states' jurisdictions."[33] Significantly, Wright noted that southern slavery was (and should remain) "removed . . . by good sense and by compact" from the sphere of national legislation. Therefore, it would be impossible to impose antislavery on a section of the country. She explained: "I have stated southern slavery to be, at this existing point of time, without the pale of effective and beneficent legislation. . . . [B]efore legislation may be effective and beneficent in its action, public opinion must be in unison with its statutes. . . . Where and when constitutional law doth not speak, but the public mind is prepared to make it speak, the people have to supply its deficiencies or to rectify its errors."[34] Because each slaveholder must come to understand that slavery is wrong, only legislative change at the state level would show that "human opinion" had changed and was now "righteous."[35]

Since the end to slavery was an issue that would be decided by white southerners, she believed that she herself had to become a "southern citizen, and, even, a slaveholder" in order to effect change.[36] Wright declared herself unwilling to violate existing state laws on slavery: "As it was the object of the founder to attempt the peaceful influence of example, and silently to correct the practice, and reach the laws through the feelings and the reason of the American people, she carefully forebore from outraging any of the legal provisions in the slave state in which she ventured to attempt her experiment, or those of any of the slave states with which she is acquainted."[37] Before beginning her experiment, therefore, she carefully read "all the laws of the slave states, bearing directly upon the labor and the government of the negro."[38]

The suspicions of Wright (and other Americans) about the efficacy of federally mandated change twisted the radical possibilities of her Nashoba experiment. Because the "public mind" must make its own laws, a national emancipation imposed on the South, she believed, would lead to violence.[39] Indeed, the tensions Wright outlined between states' rights and the central government were not fully resolved by the Constitution. As historian John

Murrin notes: "Vigorous policies by the central government always threatened to expose the underlying differences that could still tear America apart." [40] Wright herself "readily admitted" the "absurdity, the danger" of immediate emancipation. [41]

Wright's own arguments sometimes implied that experiments like Nashoba could have little effect. Specifically, she suggested that slavery would not cease until the price of cotton dropped: "But when the bankrupt fortunes of the southern planters shall have put an end to the *internal slave trade of the United States;* and Maryland, Virginia, and Kentucky, the *Guinea* of the states farther south, shall have lost their *last staple commodity of profit,* the principles avowed at Nashoba may then attract the national attention." [42] Such contingencies—which depended on fundamental economic changes—left a fairly marginal role for the example of Nashoba and moral suasion more generally.

Once the profit motive for continuing slavery was removed, Wright predicted that southern planters would abandon colonization schemes and favor the emancipation of slaves within the borders of the United States. It would take this scenario, where colonization of blacks would be unnecessary, to make the example of Wright's experiment at Nashoba truly useful. Thus, in the same 1827 "Explanatory Notes," when Wright envisioned this future, she found it possible to step back from her contention that reformers should not offend the sensibilities and laws of the white South. Although she reiterated that "the emancipation of the colored population cannot be *progressive thro' the laws.* It must and can only be *progressive through the feelings;*" she continued with a surprising conclusion that "through that medium [the feelings], be finally complete and entire, involving at once political equality and the amalgamation of the races." [43]

Whereas Wright's ideas about immediate emancipation and colonization matched those of some southern slaveholders, her open advocacy of miscegenation makes Wright quite unique in her time. The great majority of whites were obsessed about maintaining clear distinctions between the races and insisted on labeling as "black" all children who were the products of interracial unions (often in the form of the rape of black female slaves by their white masters and overseers). [44] Wright's support for racial amalgamation in her "Explanatory Notes" led to great public censure and attacks upon her sexual morality and upon Nashoba, but she did not flinch. [45] Insisting that the already large number of mixed-race children showed how easily miscegenation could take place, she believed that "the olive [branch] of peace and brotherhood [will] be embraced by the white man and the black, and their

children, approached in feeling and education, gradually blend into one their blood and their hue."[46] Wright's free-thought compatriot, Robert Dale Owen, continued this argument in a later article on Louisiana quadroons where he pointed to the hypocrisy of white Southern men who kept black mistresses (and had children with them) while also having white wives and owning slaves.[47] The eventual erasure of visible racial differences into one new race of "Americans" would, Wright claimed, finally end the divisive issue of race in the United States.

Wright further isolated herself from mainstream society and made it difficult for Nashoba to be accepted by declaring in her "Explanatory Notes" that "without disputing the established laws of the country, the institution recognizes *only within its bosom,* the force of its own principles." Specifically, she announced that "the marriage law existing without the pale of the Institution, is of no force within that pale."[48] Wright wanted to affirm sexual experience as a source of human happiness, even *outside* of marriage. By defying marriage laws, she most certainly disputed "the existing laws of the country." Her willingness to defy state laws (while ultimately hoping to change them) drew on the intellectual tradition of Scottish common sense philosophy, which stressed that the only valid laws were those that upheld each individual's moral sense.[49] Problematically, whereas she summarily rejected the arbitrary power of marriage laws at Nashoba, she accepted the arbitrary power of slavery laws. It is difficult to reconcile her uncompromising, assertive, and openly defiant stance on marriage with her explanations for why she became a slave owner and did not, for example, buy slaves and immediately free them. The difference seems to be that, in Wright's mind, white women were already prepared for their freedom, whereas black slaves were not. Yet in practice, Wright found it difficult to flaunt laws affecting women—even those she disagreed with. When she found herself pregnant, she felt obliged to enter the institution of marriage although she understood clearly the risks involved for herself and her property.[50]

Wright's observation that the "step between theory and practice is usually great" certainly held true for her own experiment at Nashoba as well as her later decision to marry.[51] Both practically and ideologically, Wright and Nashoba had many flaws. In practice, Wright was not prepared for the difficulties of setting up and maintaining a utopian experiment.[52] Neither a farmer nor a businessperson, Wright had hoped to create a communal farm that would sell its excess crops. Neither her black slaves nor the white idealists who joined her at Nashoba were trained or prepared to do this work. Ill-

ness, malnutrition, and economic crisis were the results. More significantly, Wright exploited her slaves at Nashoba: whereas the white residents could exempt themselves from physical labor by contributing money, the labor of the slaves was required. Overworked, disciplined, and still enslaved, they were unconvinced by Wright's utopian promises. Furthermore, she adopted some of the American slaveholders' most damaging customs. Wright had agreed in principle that ostensibly intractable slaves could be punished by their white managers. When she and Robert Dale Owen exercised the privileges of their race and class by leaving for a trip to Europe to recover her health and gain more converts, two female slaves were whipped while they were away.[53] Wright's free utopia became, in the words of one biographer, "deeply inhumane."[54]

Wright later identified her problems at Nashoba with her optimism and lack of information, claiming that she was "ever prone to underestimate difficulties . . . partly (and there I believe lay the main root of the error) to my then imperfect acquaintance with the character and condition of the American people, and to my ignorance of the immense distance between the theory of American government and its development in practice."[55] The United States was farther from its revolutionary potential than she had hoped—in practice, her exploitation of her slaves demonstrates that she was as well. Furthermore, her white neighbors in nearby Memphis, Tennessee, were actively hostile and tried to sabotage Nashoba's chance of success by publishing frequent attacks on it in the local newspapers. When a white man and a free black woman at Nashoba decided to live together openly as a couple, the fervor of the attacks against Wright and her community became overwhelming.[56] After only four years, Wright dissolved the experiment in 1829 and fulfilled her promise to colonize the former slaves; she accompanied thirty-one freed slaves to the new black republic of Haiti, where they were offered asylum and liberty, as well as cabins, gardens, water, tools, and provisions.[57]

In retrospect, Wright decided that she had begun her experiment "at the wrong end." It was the "degradation of [all] human labor" that was the real problem. Slavery was simply the institutionalization of that degradation; it would be eliminated once all labor was elevated and rewarded.[58] Wright's support for colonization was connected to this idea. By the 1830s and 1840s, she imagined that the removal of black slaves could make way for the elevation of manual labor by white agricultural workers. The "African race" would be "leaving behind it a country prepared for facile cultivation by the white race."[59] Less crowded conditions in the North would raise the status of

industrial laborers, while white workers who moved south would bene-
fit from healthy farm work. Just as her support for miscegenation reflects
both her radicalism and the experimentation and boundlessness of her age,
Wright's acceptance of racial hierarchies reinforces her connection to racially
divisive Jacksonian politics. Although she did not pursue this particular pro-
posal, it shows how and why Wright could comfortably turn her attention
from slavery towards the plight of white urban working classes as Nashoba
fell apart.[60]

Thus, in the late 1820s and then throughout the 1830s, the problems and
needs of the white working classes were at the forefront of Wright's con-
cerns.[61] The Jacksonian era's political volatility, economic boom and bust,
class conflict, and changing concepts of citizenship (especially those pertain-
ing to race and to a broadening of democracy in the United States) were
all fuel for her fire.[62] Wright became the first woman in the United States
to speak to large audiences of men and women on secular and political top-
ics. Her public speeches were the most significant source of her fame; her
most devoted followers were working-class men. Thousands of people came
in part for the novel and "sensational" phenomenon of hearing a woman
speaker and in part because of the attraction of her utopian rhetoric and free
thought. Speaking to the fears and desires of those artisans and mechanics
whose skilled jobs were threatened, Wright was rewarded by strong support
from the working classes who often made up the majority of the audience at
her speeches. Wright criticized lawyers and members of the clergy for undue
influence. This critique was likely to be viewed favorably by her working-
class audiences.[63]

Placing her hopes in the process of democratization, she argued for a po-
litically involved citizenry.[64] During her lectures, Wright would flourish a
copy of the Declaration of Independence, maintaining that it and the Con-
stitution provided a practical basis for changing the nation.[65] Her references
to the Constitution enabled Wright to draw upon a long-established tradi-
tion. In the early republic, as historian John Murrin points out, both Fed-
eralists and Antifederalists "accepted the Constitution as their standard, a
process that kept the system going and converted its architects into some-
thing like popular demigods within a generation."[66] Similarly, in her very
first public address before a mixed audience of men and women at Robert
Owen's New Harmony society on July 4, 1828, Wright reminded Americans
of their revolutionary heritage.[67] Appropriating the meaning of the Fourth of
July, the celebration of which many Americans considered "a reenactment

of republican faith," Wright warned that the Revolution had been left incomplete.[68] She encouraged her audiences to work for profound social change through constitutional means—the ballot box and, particularly, new state laws.[69]

Legislation at the state level, always part of her antislavery solution, now became a more vital part of Wright's plans. Legislative reform was consistent with her continued insistence on the need for individual moral transformation. If legislation was passed in any state, she believed, it would be because the people had taken the necessity of change to heart. Enacted legislation directly reflected the changed beliefs of the citizens. She urged her audiences to "firmly [adhere] to the constitutional principle, of effecting wholesome changes *peacefully through their legislatures,* and that, not by hastily subverting the existing *forms* of society, however unwise or unjust, but by preparing a change in the *very soul* of society."[70] Thus, Wright embraced a conception of legislation as the embodiment of the will of the people.

Education reform was Wright's primary focus. If citizens supported legislation for equal education, this would prove they had already undergone the necessary moral changes and were simply enacting their will. For Wright, only education reform could guarantee equality for all: "What we *do expect the people legislatively to effect,* and what we do think, for the honor of the nation, for the realization of its republican professions and for the salvation of the human race, they *ought* and *must* so effect, is to organize a system of education as shall facilitate that universal correct training of the human mind from which all things may be expected, without which nothing."[71] Individual independence and the common good would not be in conflict but rather in harmony: "*The American people shall present, in another generation, but one class, and, as it were but one family—each independent in his and her own thoughts, actions, rights, person, and possessions, and all cooperating, according to their individual taste and ability, to the promotion of the common weal.*"[72] Equal education would produce citizens who could think more of the collectivity, rather than of their selfish interests: "a nation to be strong, must be united; to be united, must be equal in condition; to be equal in condition, must be similar in habits and in feeling; to be similar in habits and in feeling, *must be raised in national institutions, as the children of a common family, and citizens of a common country.*"[73] Education could reinforce the fundamental principles of the Declaration of Independence—that "all men are free and equal."[74]

The "national" education advocated by Wright would be enacted by every

state legislature—not through national legislation. It was from this perspective that Wright argued in 1829 that the solution to society's ills: "IS NATIONAL, RATIONAL, REPUBLICAN EDUCATION; FREE FOR ALL, AT THE EXPENSE OF ALL; CONDUCTED UNDER THE GUARDIANSHIP OF THE STATE, AT THE EXPENSE OF THE STATE, AND FOR THE HONOR, THE HAPPINESS, THE VIRTUE, THE SALVATION OF THE STATE."[75]

Although language such as the "salvation of the state" suggests a focus on a strong central government, Wright did not seem to accept this equation, contending, when it suited her, that "the state" merely meant "the people." As she clarified in her own definition of a national education: "I understand a [national] education conducted at the expense, and under the protection of the people, acting through their fairly chosen and properly instructed representatives, [to be] the only safeguard of youth, and the only bulwark of a free constitution."[76]

Wright proposed that the states set up boarding schools to replace all other schools or reformatories for youths: "I would suggest that the state legislatures be directed (after laying off the whole in townships or hundreds) to organize, at suitable distances, and in convenient and healthy situations, establishments for the general reception of all the children resident within the said school district."[77] From the age of two on, all children, boys and girls, rich and poor, would be educated together away from their parents, without reminders of their class- and sex-based disadvantages or advantages.[78] Citizen-taxpayers in each state would fund education reform through new state taxes. One would be a progressive tax on all incomes, with the wealthiest paying more, and one would be an extra tax to be paid by all parents. "When two years old," she proposed, "the parental tax should be payable, and the juvenile institution open for the child's reception; from which time forward it [the child] would be under the protective care and guardianship of the state, while it need never be removed from the daily, weekly, or frequent inspection of the parents."[79] For Wright, the state had intellectual properties, a consistency, and an ability to enforce equality that average people, including parents, did not have.

Intolerant of anything less than her perfect society, Wright imagined parents as obstacles to progress whose rights to determine or influence their children's futures would have to be limited. She imagined that "the parents who would necessarily be resident in their close neighborhood, could visit the children at suitable hours, but, in no case, interfere with or interrupt the rules of the institution."[80] Wright's plan was, as historian Sean Wilentz argues, "authoritarian and moralistic." Author Lewis Corey suggests that

Wright "attacked contemporary education and religion as authoritarian, yet she wanted to give the task of rearing and educating children exclusive to ONE authority, the state!"[81] For Wright, authoritarianism was not an issue; although states, not parents, would be responsible for producing good citizens, the good citizens themselves made up the states and would collectively produce a better nation.[82]

Although Wright endorsed the notion that state-run boarding schools could raise children better than their parents could, her comfort with this kind of authoritarian control was tempered by her concurrent dreams of a society with fewer rules and regulations: "The people who shall once organize and carry into universal effect, a system of enlightened, industrial and protective education may lay aside their penal and their civil codes, their statutes and enactments, and confine their legislative operations to the simple regulation of such matters as shall be found positively and immediately to regard the comforts and convenience of the whole mass of society."[83] Universal education, she believed, would lead to the gradual obsolescence of oppressive laws. Penal codes would no longer be necessary, for a better trained and classless populace would not turn to crime. Still, the absolute abolishment of government represented an untenable ideal. While punitive laws were undesirable, some functions would have to remain. First among them would be the law she championed most—that mandating free and universal education. Without it, a new society could not be created or perpetuated. Once the people passed universal education laws, "Let government do this, and, for aught we care, it may then wind up business."[84] Government was still an entity that would preferably be dismantled.[85]

In a more pragmatic sense, Wright's vehement opposition to the Second Bank of the United States in the mid-1830s illustrates her opposition to strong centralized control as well as her sympathy with a major Democratic Party platform. Suspicious of the credit and national banking system, President Andrew Jackson decided against reissuing to the Bank the charter that gave it monopoly control of banking in exchange for handling federal deposits. Like many working-class Jacksonians, Wright condemned the arbitrary power of such a "consolidated national monopoly" which was "an enemy to the country."[86] Engaging in partisan politics, she linked the new Whig party to Alexander Hamilton and the Federalists, charging that "those leaders first tried their scheme of despotism under the form of one central strong government with obliterancy of state divisions," had failed, and then turned to a national bank as their "Federal design."[87]

Wright's last book, *England, the Civilizer* (1848), ambitiously outlined the

history of state formation from the ancient world to her contemporary era. Wright pointed to America and England as the countries with the most potential for immediate and radical change.[88] Her suspicion of limitless centralized power remained, for she optimistically asserted that existing governments, once reformed, would disappear completely: "[G]overnment will cease to be; and the human family, in its state of panocracy, will exhibit the world in federation, and all human affairs under administration." In her final vision of a utopian society, Wright thus asserted that there would be no government. Yet her proposal of an all-encompassing centralized bureaucratic structure of communes was perhaps as oppressive. Ostensibly reduced to small administrative bodies, central control had in fact become omnipresent. No one was free from public scrutiny and evaluation.[89] In these communes, she suggested:

> Lists, showing the standing of all the employed, [should] be made daily or weekly, and held open for inspection in the administrational office, of each occupation in every branch of the public service. The same to be passed to the administrational offices, under each head of occupation in the circle, and so on in the commune. By which means, the precise standing of each individual, with her or his positive value to society, may be at all times evident. And the question, *what is a man or a woman worth?* Be susceptible both of a definite and a righteous answer.[90]

Work would be rewarded and honored, but also closely monitored and judged by committees set up to determine the value of an individual's contribution to the community. No action would escape notice within the commune.[91]

Wright's increasing reliance on concepts of collective good and the collective will of the people obstructed and belied her ideal of individual freedom. She held contradictory notions regarding the primacy of personal action on the one hand and the necessity for the collective good on the other.[92] In addition to the disconcertingly coercive nature of universal guarantees of freedom, Wright fell into the quandary of how to establish a more just distribution of goods and power without violating guarantees of individual freedom.[93]

The dilemmas and contradictions inherent in Wright's conceptualizations of the means for reform highlight some of the difficulties of creating plans for change in an atmosphere of political and legal uncertainty.[94] Wright's various attempts at radical reform illustrate the kinds of paradoxical choices Americans faced as the federal government and its correlative concept of citizenship gradually solidified. Wright's insistence on the power of moral example to

transform society went hand-in-hand with an insistence that only the voters in southern states could legislate slavery out of existence. Wright shifted her ideas about the use of moral suasion and legislation in accordance with the causes she advocated and the likelihood that changes could be made through the ballot box and legislatures. In the case of slavery, she relied on moral suasion and rejected immediate legal emancipation, especially at the national level. In the case of education reform, she advocated the immediate passage of new state laws implementing equal education since that would prove that the people were ready for them. Thus, with Nashoba, Wright envisioned the eventual civilization of former slaves and a gradual reform of state laws through moral suasion. Education reform could be effected immediately but would be achieved through similar means—state legislation. Like other Jacksonians, Wright fought for decentralized institutions and for legislators who would truly represent the will of the people in each state.[95] The Second Bank of the United States or the domination of Congress by privileged, monied elites also represented the potentially dangerous strength of the central government. Wright was ambivalent: Even as she pushed for state-run boarding schools for all children, she expressed concerns about governments with too much power over citizens. At the same time that she imagined a new type of utopian commune with extensive supervisory capacities over its members, she also hoped that government as an oppressive entity would somehow be abolished or disappear.

Throughout her career as a reformer, Wright maintained a positive sense of the power invested in the government of the people by the Constitution. She saw "national" education reform as "the only bulwark of a free constitution."[96] For Wright and for most average citizens of the Jacksonian era, as John Murrin explains, "the Constitution became a substitute for any deeper kind of national identity. American nationalism is distinct because, for nearly its first century, it was narrowly and peculiarly constitutional. People knew that without the Constitution there would be no America."[97] Like Wright, most Americans idealized the founding documents and the corresponding concept of "the nation" even as they suspected increased powers for the central government.

Other antebellum activists eventually changed their reform strategy; they began to hope that a strong federal government might enforce their reform agendas and approached this prospect with a combination of excitement and fear. Antislavery perfectionists, for instance, turned from a purely moral stance of avoiding interaction with a tainted government that condoned slavery toward urging the federal government to repeal the Fugitive Slave Acts,

keep slavery out of the territories, or abolish slavery altogether. Abandoning their earlier strategy of boycotting the system by not voting or holding political office, perfectionists later sought to make these changes by participating in party politics.[98] Similarly, women reformers of the late 1840s and 1850s found that previous attempts to use moral suasion for social reform had not been successful. Temperance pledges had not eliminated alcoholism, and strong moral arguments against the sins of slavery had not emancipated the slaves. They turned, therefore, to partisan party politics, national legislation, and demands for woman suffrage.[99] Although these reformers moved tentatively toward a greater acceptance of federal solutions to societal ills, antebellum Americans were generally uncomfortable with a visibly strong central government. Wright participated in a shift toward legislative solutions; her advocacy of *state* legislation captured the interests of moral reformers as well as of those skeptical of strong central authority.

Like other Jacksonian reformers, Frances Wright believed that she could profoundly shape the direction and the character of the nation. Wright presented serious and often radical alternatives to the values or practices of mainstream antebellum America, yet her ideas were also entirely within the tradition of revolutionary America and its founding documents. Wright's faith in communitarian experimentation as a means to effect change epitomizes the hopes of numerous Americans who entered utopian communes or were sympathetic to their ideals during the antebellum era. Proclaiming her patriotism and the mainstream nature of her demands, Wright championed the Constitution's recognition of states' rights. Ultimately, the enactment of state legislation would demonstrate that people's values had changed. Wright's advocacy of state laws such as equal education reflected her confidence that "the people" could transform their nation.

Notes

I would like to thank Stephanie Cole, Lori Ginzberg, Sarah Barringer Gordon, Geoffrey Hale, and Kathleen Underwood for their perceptive and patient critiques of this essay.

1. For discussions of utopian communitarianism, see Priscilla J. Brewer, *Shaker Communities, Shaker Lives* (Hanover, Conn.: University Press of New England, 1986), p. 203; and Donald Pitzer, ed., *America's Communal Utopias* (Chapel Hill: University of North Carolina Press, 1997).

2. For discussions of Wright, see Celia Morris, *Fanny Wright: Rebel in America* (1982; rpt., Urbana: University of Illinois Press, 1992), pp. 3–4, 174, 180, 282–83; William Randall Waterman, *Frances Wright* (New York: AMS Press, 1967), pp. 222, 255–56; Helen Heine-

man, *Restless Angels: The Friendship of Six Victorian Women, Frances Wright, Camilla Wright, Harriet Garnett, Frances Garnett, Julia Garnett Perz, Frances Trollope* (Athens: Ohio University Press, 1994), pp. 26, 59; Lori D. Ginzberg, "'The Hearts of Your Readers Will Shudder': Fanny Wright, Infidelity, and American Freethought," *American Quarterly* 46, no. 2 (June, 1994): 196, 200; and Susan Kissel, *In Common Cause: The "Conservative" Frances Trollope and the "Radical" Frances Wright* (Bowling Green, Ohio: Bowling Green State University Popular Press, 1993), pp. 94, 145.

3. Wright's status as a woman who insisted on radical equality was indeed threatening. See Robert Abzug, *Cosmos Crumbling: American Reform and Religious Imagination* (New York: Oxford University Press, 1994), pp. 189, 204–205, 228; John Higham, *From Boundlessness to Consolidation: The Transformation of American Culture, 1848–1860* (Ann Arbor: William Clements Library, 1969), p. 14; and Ginzberg, "'Hearts of Your Readers,'" pp. 196, 202.

4. Frances Wright, "Biography and Notes of Frances Wright D'Arusmont," (1844), reprinted in *Life, Letters and Lectures: Frances Wright D'Arusmont* (New York: Arno Press, 1972), pp. 28–30.

5. See Heineman, *Restless Angels,* p. 23.

6. For a discussion of state activism, see Charles Bright, "The State in the United States During the Nineteenth Century," in *Statemaking and Social Movements: Essays in History and Theory,* ed. Charles Bright and Susan Harding (Ann Arbor: University of Michigan Press, 1984), pp. 123, 138; and Richard Franklin Bensel, *Yankee Leviathan: The Origins of Central State Authority in America, 1859–1877* (New York: Cambridge University Press, 1990), p. 2. Also see John M. Murrin, "A Roof Without Walls: The Dilemma of American National Identity," in *Beyond Confederation: Origins of the Constitution and American National Identity* (Chapel Hill: University of North Carolina Press, 1987), pp. 333–48.

7. On the instability of the New Republic, see Richard B. Morris, *The Forging of the Union, 1781–1789* (New York: Harper and Row, 1987); and David Szatmary, *Shay's Rebellion: The Making of an Agrarian Insurrection* (Amherst: University of Massachusetts Press, 1980).

8. Ira Katznelson and Kenneth Prewitt, "Limits of Choice," in *Capitalism and the State,* ed. Richard Fagen (Stanford, Calif.: Stanford University Press, 1979), pp. 31–33, quoted in Theda Skocpol, "Bringing the State Back In: Strategies of Analysis in Current Research," in *Bringing the State Back In,* ed. Peter Evans, Dietrich Rueschemeyer, and Theda Skocpol (New York: Cambridge University Press, 1985), p. 22.

9. For debates about the strength of the nineteenth-century state, see Stephen Skowronek, *Building a New American State: The Expansion of National Administrative Capacities, 1877–1920* (New York: Cambridge University Press, 1982), p. 19; Bensel, *Yankee Leviathan,* 17; Bright, "State in the United States," pp. 125–26; and William J. Novak, *The People's Welfare: Law and Regulation in Nineteenth-Century America* (Chapel Hill: University of North Carolina Press, 1996), p. 24.

10. Some scholars see more significant changes occurring during and after the Civil War. George Fredrickson, *The Inner Civil War: Northern Intellectuals and the Crisis of the Union* (New York: Harper and Row, 1965).

11. See Higham, *From Boundlessness to Consolidation,* pp. 15–16, 21–23, 26–27.

12. See Bensel, *Yankee Leviathan,* p. 192.

13. Frances Wright, "Delivered in the Walnut Street Theater, Philadelphia, on the Fourth of July, 1829," in *Life, Letters, and Lectures,* p. 133.

14. Frances Wright, "Letter XX," *Views of Society and Manners in America: In a Series of Letters from that Country to a Friend in England, During the Years 1818, 1819, and 1820, By An Englishwoman* (London, 1821), p. 358.

15. Frances Wright, "Geographical, Political, and Historical Sketch of the American United States," in *Course of Popular Lectures,* vol. 2 (Philadelphia: Published by the author, 1836), from the Celia Morris Eckhardt papers at the New Harmony Workingmen's Institute and Library, Folder 44, pp. 35–39.

16. Wright, "Letter XX," pp. 361, 372; and Wright, "Delivered in the New Harmony Hall, on the Fourth of July, 1828," in *Life, Letters, and Lectures,* pp. 119–20.

17. Frances Wright, "On Existing Evils and their Remedy, as delivered in Philadelphia, on June 2, 1829," in *Life, Letters and Lectures,* p. 104.

18. Lewis Perry argues that more women reformers made this connection in the 1850s. See Lewis Perry, *Radical Abolitionism: Anarchy and the Government of God in Antislavery Thought* (Ithaca, N.Y.: Cornell University Press, 1973), pp. 214, 228.

19. Wright's concerns with marriage in the 1820s reflects Ginzberg's argument in this volume about the ways in which marriage conveyed sexual respectability—a link and a priority that Wright denied. Wright, *New Harmony Gazette,* (later *Free Enquirer,* hereafter *NHG*), series 2, vol. 4, no. 207, p. 407.

20. Elizabeth Ann Bartlett, *Liberty, Equality, Sorority: The Origins and Interpretations of American Feminist Thought: Frances Wright, Sarah Grimke, and Margaret Fuller* (Brooklyn, N.Y.: Carlson, 1994), p. 41.

21. See also Kissel, *In Common Cause,* p. 145.

22. Gilbert Hobbs Barnes, *The Anti-Slavery Impulse, 1830–1844* (1933; rpt., New York: Harcourt, Brace and World, 1964), chs. 2 and 3.

23. Laurence Veysey, *The Perfectionists: Radical Social Thought in the North, 1815–1860* (1973; rpt., New York: Wiley Press, 1980), pp. 5, 10.

24. For the position and role of antebellum white women, see, Ginzberg, "'Hearts of Your Readers,'" 195–226; Barbara Welter, "The Cult of True Womanhood: 1800–1860," *American Quarterly* 18 (summer, 1966): 151–74; Nancy A. Hewitt, *Women's Activism and Social Change: Rochester, New York, 1822–1872* (Ithaca, N.Y.: Cornell University Press, 1984), chaps. 1 and 2; and Mary P. Ryan, *Cradle of the Middle Class: The Family in Oneida County, New York, 1790–1865* (New York: Cambridge University Press, 1981), chaps. 2, 3. Also see Morris, *Fanny Wright,* pp. 184, 195; and Alice Perkins and Theresa Wolfson, *Frances Wright, Free Enquirer: The Study of a Temperament,* (New York: Harper Brothers, 1939), p. 227.

25. Frances Wright, "Nashoba: Explanatory Notes, respecting the Nature and Objects of the Institution of Nashoba, and of the Principles upon which it is founded. Addressed to the Friends of Human Improvement, in all Countries and of all Nations," *NHG,* Jan. 30, 1828, p. 124.

26. Ibid.

27. Ibid., p. 125.

28. See Janet Sharp Hermann, *Joseph E. Davis: Pioneer Patriarch* (Jackson: University Press

of Mississippi, 1990), pp. 38–45; and Janet Sharp Hermann, *Pursuit of a Dream* (New York: Oxford University Press, 1981), pp. 8–12.

29. Morris, *Fanny Wright,* pp. 100–104.

30. Wright, "Biography and Notes," pp. 24–25.

31. Ibid., pp. 28–30.

32. Ibid., p. 133.

33. Frances Wright, "Origin and History of the Federal Party; With a General View of the Hamilton Financial Scheme," (Lecture 2, 1836), in *Course of Popular Lectures Historical and Political,* vol. 2, p. 53.

34. Frances Wright, "On the Sectional Question—Southern Slavery," (Lecture 3, 1836), in *Course of Popular Lectures,* vol. 2, pp. 74–75.

35. Wright, "Origin and History of the Federal Party," p. 53.

36. Wright, "On the Sectional Question," pp. 77–78.

37. Wright, "Nashoba," p. 133.

38. Wright, "Biography and Notes," pp. 24–25.

39. See Wright, "On the Sectional Question," pp. 74–76, 90.

40. Murrin, "Roof Without Walls," p. 346.

41. Wright, "Biography and Notes," pp. 24–25.

42. Wright, "Nashoba," p. 133.

43. Ibid.

44. See Martha Hodes, *White Women, Black Men: Illicit Sex in the Nineteenth Century South* (New Haven, Conn.: Yale University Press, 1997), introduction.

45. Most frequently, Wright was charged by newspaper editors with being a free lover, a loose woman, and a "priestess of Beelzebub." Sean Wilentz, *Chants Democratic: New York City and the Rise of the American Working Class, 1788–1850* (New York: Oxford University Press, 1984), p. 176.

46. Wright, "Nashoba," p. 133.

47. Robert Dale Owen, "Address to the Inhabitants of New Orleans," *NHG,* Apr. 9, 1828, pp. 186–87.

48. Wright, "Nashoba," p. 132.

49. Bartlett, *Liberty, Equality, Sorority,* pp. 15–16. Frances Wright, *A Few Days in Athens,* excerpted in *NHG,* Apr. 11, 1827, p. 220.

50. Morris, *Fanny Wright,* ch. 8.

51. Wright, "Nashoba," p. 124.

52. See Lawrence Foster, *Religion and Sexuality: The Shakers, the Mormons, and the Oneida Community* (Urbana: University of Illinois Press, 1981).

53. Communitarianism could lead to, Perry claims, "systems of totalitarianism" (*Radical Abolitionism,* pp. 150, 212).

54. Morris, *Fanny Wright,* pp. 141–45.

55. Wright, "Address, Delivered at the New York Hall of Science on Sunday the 18th October 1829," *NHG,* Oct. 31, 1829, p. 1.

56. Morris, *Fanny Wright,* ch. 6.

57. Ibid., pp. 207–208.

58. Wright, "On the Sectional Question," pp. 77–78.

59. Wright reiterated her support for colonization: "The African race, trained and civilized by its American guardian . . . would necessarily supply to tropical climates, colonists fitted by organization no less than experience, to vanquish their dangers and sanify [*sic*] the richest, though now the most deleterious regions of the globe." Colonization would effect "simultaneously the civilization and removal of its slave population, and the introduction of free, enlightened, and, as it ever should be, honorable and honored labor, by immigration from the northern states." See Frances Wright, "Biography and Notes," pp. 28–30; and "On the Sectional Question," pp. 80, 88.

60. As Wright directed her attention away from Nashoba, she began contributing to a journal edited by Robert Dale Owen, the son of Robert Owen. Read by urban workers and middle-class intellectuals, the *New Harmony Gazette,* later renamed the *Free Enquirer,* was a free-thought periodical of which Wright soon became the co-owner and coeditor. Robert Dale Owen and Frances Wright, "Prospectus of the New-Harmony and Nashoba Gazette, in Continuation of the New-Harmony Gazette," *NHG,* July 30, 1828, p. 318.

61. See Arthur Schlesinger, Jr., *The Age of Jackson* (Boston: Little, Brown and Co., 1945), pp. 132–43; and Wilentz, *Chants Democratic,* pp. 182, 200.

62. Schlesinger, *Age of Jackson,* pp. 30–35, 67–71. Also see Charles Sellers, *The Market Revolution: Jacksonian America, 1815–1846* (New York: Oxford University Press, 1991); and Harry Watson *Liberty and Power: The Politics of Jacksonian America* (New York: Noonday Press, 1990).

63. Frances Wright, "Editorial: Jefferson Institute," *NHG,* Apr. 8, 1829, p. 190. For a discussion of labor's suspicion of lawyers, see Skowronek, *Building a New American State,* p. 33. For her appeal to (and among) the working classes, see Wright, "To the Intelligent among the Working Classes; and Generally to All Honest Reformers," *NHG,* Dec. 5, 1829, pp. 46–47.

64. For a discussion of democratization, see Skocpol, "Bringing the State Back In," p. 26.

65. Morris, *Fanny Wright,* p. 197.

66. John Murrin, "Roof Without Walls," p. 346.

67. Morris, *Fanny Wright,* p. 171.

68. Higham, *From Boundlessness to Consolidation,* p. 17.

69. Frances Wright, "State of the Public Mind [1829]," in *Supplement Course of Lectures, Containing the Last Four Lectures Delivered in the United States* (London, 1834), p. 178.

70. Frances Wright, "Address, Containing a Review of the Times" (1830), reprinted in *Life, Letters and Lectures,* p. 196.

71. Frances Wright, "Wealth and Money, No. 5," *NHG,* Oct. 16, 1830, p. 405.

72. Frances Wright, "Parting Address" (1830), in *Life, Letters and Lectures,* p. 216.

73. Wright, "On Existing Evils," pp. 109–10.

74. Frances Wright, "Plan of National Education," reprinted in Robert Dale Owen and Frances Wright, *Tracts on Republican Government and National Education: Addressed to the Inhabitants of the United States of America* (London: James Watson/Holyoake and Company, 1857), p. 15.

75. Frances Wright, "To the Intelligent among the Working Classes," *NHG,* Dec. 5, 1829, pp. 46–47.

76. Wright, "State of the Public Mind," p. 179.

77. Wright, "On Existing Evils," p. 114.

78. Wright, "Address, Containing a Review of the Times," p. 196.

79. Wright, "On Existing Evils," pp. 114–15.

80. Ibid., p. 114.

81. See Wilentz, *Chants Democratic,* p. 180; and Lewis Corey papers—Columbia University Rare Books and Manuscripts Library, Box 5, "Outline of Last 12 Chapters," ch. 11. "Education for the People," (unpublished manuscript on Frances Wright, ca. 1950), p. 7, Corey papers.

82. Wright, "State of the Public Mind," pp. 178–81.

83. Wright, "The Nature of True Civilization: The Third and Best Age of Man," *NHG,* Oct. 30, 1830, p. 7.

84. Wright, "Wealth and Money, No. 5," *NHG,* Oct. 16, 1830, p. 405.

85. Wright, "Address: Containing a Review of the Times," *NHG,* Aug. 14, 1830, pp. 329–30. Also see, Wright, "Parting Address," p. 218; and Wright, "Nashoba: Explanatory Notes," p. 124.

86. Wright, "Origin and History of the Federal Party," pp. 62, 70.

87. Wright, "Origin and History of the Federal Party," pp. 65, 68.

88. Wright ignored her own earlier assault on English common law as holding back the United States.

89. Wright, *England, the Civilizer: Her History Developed in Its Principles* (London: Simpkin, Marshall, and Co., 1848), p. 415.

90. Ibid., p. 460.

91. Ibid., p. 463.

92. Bartlett, *Liberty, Equality, Sorority,* pp. 36–37.

93. For a discussion of utopian socialism, see ibid., p. 21.

94. See Higham, *From Boundlessness to Consolidation,* pp. 15–16, 21–23, 27.

95. Wright, "Geographical, Political, and Historical Sketch," pp. 39–40.

96. Wright, "State of the Public Mind," p. 179.

97. Murrin, "Roof Without Walls," pp. 346–47.

98. See Lewis Perry and Michael Fellman, eds., *Antislavery Reconsidered: New Perspectives on the Abolitionists* (Baton Rouge: Louisiana State University Press, 1979); and Perry, *Radical Abolitionism,* ch. 8.

99. See Lori Ginzberg, *Women and the Work of Benevolence: Morality, Politics and Class in the Nineteenth-Century United States* (New Haven, Conn.: Yale University Press, 1990), ch. 4; Ruth Bordin, *Woman and Temperance: The Quest for Power and Liberty, 1873–1900* (Philadelphia: Temple University Press, 1981); and Molly Ladd-Taylor, *Mother-Work: Women, Child Welfare, and the State, 1890–1930* (Urbana: University of Illinois Press, 1994).

Chapter 4

Superseding Gender
The Role of the Woman Politico in Antebellum Partisan Politics

JANET L. CORYELL

On May 28, 1852, Anna Ella Carroll, writer and political lobbyist, wrote to President Millard Fillmore. She advised him that her reading of the current political situation held his chances for renomination by the Whig Party to be excellent, except for what she called "traitors" within the party. Of the 100,000 men who held patronage positions in his administration, she told him, 15,000 were "genuine friends" and the other 85,000 stood "ready to deliver you over to the stronghold of the enemy." It might be odd, she wrote, "for an 'American lady' to be so heartily embarked in the interest of the political condition of the country, but I am sure it will be considered a pardonable offense when I tell you that by blood and name and spirit I am identified with those who largely contributed to achieve and perpetuate our free institutions" (a reference to her alleged kinship with the Revolutionary War figure Charles Carroll of Carrollton). Her advice to Fillmore was to throw every Democrat he could out of office in order to strengthen his position and ensure his renomination. He was sure to triumph.[1] He did not, and lost the nomination to General Winfield Scott at the June convention.

On September 15, Carroll took up her pen again. Exhibiting the flexibility necessary to partisan politicians, she wrote this time to William Henry Seward, rising star in the Whig Party and head of the anti-Fillmore faction in New York state. "Unable to contain" her admiration for her correspondent, Carroll discussed party matters with ease. Those Southern Whigs who had split from the party over Scott's failure to state his support for the Compromise of 1850 were ungrateful "imbeciles," she asserted. Furthermore, she warned him, the Democrats and Locofocos had merged into what she deemed an "unhallowed brotherhood" and would exclude from office any-

one who did not adopt their views. Once again, she justified her interest as a "lady," claiming she was "by *blood & name & spirit identified* with those who contributed greatly to establish and perpetuate our free institutions." To boost her image as a political insider, Carroll asked his opinion of Whig party sentiment in New York, informing him that he could reply to her at Whig Party headquarters in Washington.[2]

From the 1850s through the 1880s, Anne Carroll involved herself in partisan politics, corresponding with governors, representatives, senators, and presidents. She wrote election pamphlets and books on the political matters of the day, articles and letters to newspapers, all vociferously promoting her chosen party. This political pamphleteer, lobbyist, sycophant, and opportunist was not merely an unusual woman for her time nor was she an anomaly. By asserting that her gender was less important than her political background and interests, she assumed the role, to coin a phrase, of a woman politico: a person actively engaged in politics and the affairs of national leadership but concerned more with the intricacies of partisan politics than the actual business of government.[3]

The lives and careers of women such as Carroll provide a more complex view than traditional interpretations of nineteenth-century women and their relationship to formal politics have provided by making clear that there were a number of women involved in politics in significant ways that were not particularly shaped by their gender. Despite middle-class cultural demands that women adhere to the cult of domesticity, mid-nineteenth-century women juggled innumerable interests and responsibilities that precluded any slavish adherence to roles dictated solely by gender. Woman politicos, convinced of the importance of partisan politics, embraced a role that allowed them to think and act first and foremost as part of the body politic rather than as part of a community of women.[4] Defining themselves as politicians enabled woman politicos to pursue their individual interests in partisan politics as part of their identity as humans. Those interests seldom reflected their gender, fought against the restrictions society placed on women, or dealt with matters that better-known politically active women deemed important. Instead, their partisan interests superseded their gender, allowing them to voice opinions on matters that had nothing to do with what was culturally defined as women's concerns.

Analysis of woman politicos does not fit neatly into traditional political history, which emphasizes methods of party politics, nor into women's history, which tends to focus on how gendered conventions shaped women's political activities. The closest paradigms in the current literature come from

studies of mid-nineteenth-century political women such as those on woman's rights advocates and domestic feminists. Woman's rights advocates, such as Susan B. Anthony and Elizabeth Cady Stanton, were more likely to eschew partisanship in the antebellum period in favor of arguing for women's political participation by citing the ideas of John Locke, Immanuel Kant, and Thomas Jefferson and interpreting those ideals to argue that women possessed the same inalienable rights as men. Domestic feminists, such as Catherine Beecher, Sarah Josepha Hale, and Dorothea Dix, found their rationale for political action in the cult of domesticity's designation of women as the moral force of the nation and regarded partisan politics as too corrupt to be appropriate for any woman's involvement.[5]

As useful as these paradigms are in understanding and classifying much of the formal political actions of mid-nineteenth-century women, the lives of woman politicos such as Anna Ella Carroll require another definition that encompasses their partisan political behavior. Their experiences exemplify the limitations of historical paradigms, which often diminish the complexity of women's lives. Better terminology than paradigms or models for women's actions might be "roles," which reflect the way that changing circumstances in women's lives lead to changes in activities. The role played by woman politicos illustrates the complex relationship between disenfranchised women and formal partisan politics in this era of mass party politics and large-scale involvement by American citizens in partisan concerns. A more complete picture of nineteenth-century women and politics must take account of women who exercised their right to participate in politics without demanding equal rights or aligning with traditional women's issues.[6]

Writing about partisan politics and national matters was a common means for woman politicos to assert their right to become involved politically. Anna Ella Carroll made a living for years as a political writer, and her work demonstrates the way women could adopt various roles in order to accomplish their personal goals to be politically active. In her early work for the American Party, Carroll took on the role of the domestic feminists, embracing their rationale and methodology and carefully separating herself from the woman's rights advocates. In fact, the primary limitation to Carroll's written political rhetoric was the societal expectation of proper feminine behavior as laid out in the Cult of True Womanhood and promoted in prescriptive literature of the day. Even those who advocated an increased public role for women denied the usefulness of partisanship. To become involved in partisan politics meant that a woman would enter the corrupt and corrupting sphere of men: political deals, conspiracies, and smoke-filled back rooms abounded.[7] Fur-

thermore, as a southern woman, Carroll's task as infiltrator into the political realm was made doubly difficult by the indomitable image of the proper "Southern Lady," another cultlike figure. The two most powerful cultural images of the antebellum period, the Republican Mother and the True Woman, both of which helped determine limits on women's political actions, had been joined in the South by this third image, the Southern Lady. Republican Mothers raised children, not their voices; True Women were domestically oriented; and a proper Southern Lady was passive, pious, and home-centered. She was voiceless in public. And she was not to involve herself in action outside her God-given sphere.[8]

Despite this great Trinity of images, Carroll still managed to present to the reading public her version of the political ideology of the American, or Know-Nothing, Party. She first succeeded in her attempt at public political action in part because she recognized, accepted, and conformed to the rhetorical limitations domestic feminism exercised upon her work. Carroll might well have found role models for both her interests and her rhetoric from the groups of politically interested women invited to participate in mass political meetings in the 1840s and 1850s. These women were vociferously partisan in their public discussion of issues, although they still tended to approach politics using the rhetoric of domestic feminism, even when their concerns seemed to lie more with the party than reform issues. Limited by male expectations of proper feminine behavior, even in such instances where they were invited by men to attend a clearly unwomanly activity, these partisan women nevertheless pushed the boundaries of the possible for politically interested women.[9]

Carroll's family background no doubt also played a large role in the formulation of her political outlook and ambition. Born on the Eastern Shore of Maryland in 1815, Carroll was the eldest of nine children. She received an unusually thorough education from her father, Governor Thomas King Carroll, including the subjects of history and geography, the philosophy of Immanuel Kant, and the legal writings of Blackstone.[10] Although little evidence remains of her life prior to midcentury, Carroll exhibited a precocious fascination with politics. Writing at age fourteen to her father, then governor, she explained, "'It is my principle, as well as that of Lycurgus, to avoid 'mediums'—that is to say people who are not decidedly one thing or the other. In politics they are the inveterate enemies of the state.'"[11]

When, in the 1840s, financial problems plagued her father, Carroll used her pen, as a sort of private lobbyist for those who would hire her, to make her own living. By the early 1850s, she also became a political pamphleteer for

the nativist Know-Nothings. Her most important work for them was *The Great American Battle; or, The Contest Between Christianity and Political Romanism* (1856), a book delineating the foundations, beliefs, and platform of the American Party, and calling for a return to traditional values personified by Revolutionary ancestors to prevent the corruption of America in the form of a Jesuit takeover of the government. It was a success, running to three editions and selling well over ten thousand copies.[12] The American Party's positions in favor of temperance and traditional moral values and against corruption of all kinds appealed to many white, middle-class, Protestant women. Numbers of them wrote for the American Party throughout the 1850s, printing their letters and articles of support in newspapers such as Boston's *American Patriot* and *Know-Nothing* and Philadelphia's nativist weekly, *American Woman.*[13] Carroll's work was part of this activity and was deemed the "textbook of the cause," she claimed, by none other than E. B. Bartlett, national president of the Know-Nothings.[14]

In her early work for the Know-Nothings, Carroll assumed the role of a domestic feminist and constructed her political rhetoric accordingly. Because Carroll was trying to reach a large voting audience with a primer text of the party's beliefs, she did not want her work to be dismissed because of her gender. Consequently, at this early stage, she chose her rhetoric to defuse the impact of her gender upon people's perception and acceptance of her work. Because her work incorporated these norms, rather than battled against them, Carroll achieved her goal that her work would be read and taken seriously by politicians.

The literary devices that enabled her to express her political ideas appear in several pieces of her antebellum writing for the Know-Nothings and can be classified into four distinct categories: the mitigating power of the penitent, an apology; her motivating force for taking actions others might deem inappropriate, which was duty; her tendency to practice individual over collective action, writing alone although recommending collective action against the threat to American liberties; and the pervasive use of images of motherhood and womanliness. As she did in her letters to Fillmore and Seward, Carroll employed these devices openly, first acknowledging her sex and the apparent impropriety of her actions, stating that she was very aware that she was a female operating in a male sphere and apologizing for her intrusion into the masculine world of politics. She was not a woman's rights advocate demanding the franchise; rather, she argued in a campaign pamphlet supporting Fillmore's presidential run in 1856, "the interests and destiny of mothers and daughters are common with those of their fathers and brothers."

Duty was her sole motivation, she reassured her readers.[15] Perceptive of her unusual role, and doubtless aware of the attacks against those arguing in favor of women voting, Carroll knew claiming a right to participate fully in politics could raise a backlash that would shut her out completely. Duty as a motivating force, on the other hand, was clearly a feminine motivation with enough religious overtones to place that motivation precisely within the sphere of acceptable feminine action. Carroll's right as a woman to speak out in political matters could not be abridged, first, because she made it clear she was occupying the moral high ground and, second, because she did not have nor did she want the vote: "no selfish aspiration, no sordid interest, no *political distinction* has actuated me," she once told Millard Fillmore.[16] Carroll communicated her ideas through print and personal contact, through petitioning rather than confrontation or mass action. She wrote letters to leading men, pamphlets for public consumption, and arranged meetings at her rooms in New York City and Washington with politicians in what amounted to a salon, all with the intent of influencing politicians, while avoiding accusations of unwomanly public activity.

Carroll's style of politicking is typical of what one historian has called "prepolitical" behavior: the acknowledgment of inferiority (hence the apology), the rhetoric of humility (hence the assurance that only duty had drawn Carroll into political matters and away from her more appropriate sphere), and the individual nature of the act of petitioning (hence Carroll wrote alone, even when the ideas she presented were shared by many). But for Carroll, a more appropriate designation might be "pre-enfranchisement" political behavior. Her rhetoric of petition and apology is familiar to any reader of petitions to monarchs or governments and her actions as a writer were unquestionably political behavior, with political goals in mind, such as publication of her work, patronage positions for family and friends, or the public acknowledgment of the value of her opinions and intelligence.[17] A letter to Thurlow Weed on the 1859–60 fight for the U.S. House of Representatives' speakership, for instance, made apparent Carroll's understanding of partisan struggles and her rightful place in them: she would serve the country by telling Republican John Sherman, center of the struggle, "the whole truth as I know it and as no man, no not you, would ever tell him." She was able to be more forthcoming, she wrote, "for the reason that I feel my position . . . my knowledge . . . my principles and my sincerity in the maintainance [*sic*] of Rep[ublican] sentiments, which I will cherish while I live (for better reasons than influence you politicians) enable *me.*" Furthermore, such sincere and allegedly nonpartisan wishes for the country's good, she continued, "will

make me indifferent even should Mr. Sherman not adopt my wise and patriotic counsel. I shall have the approval of my conscience & my country hereafter."[18] Such a moral high road was feminine influence at its most acceptable.

What Carroll wanted with her early writings on political matters was to save America from what she perceived as a conspiracy by Catholic Jesuits to overthrow the republican government of America through the unscrupulous or unwitting connivance of priest and parishioner. While historians formerly dismissed these fears as irrational political paranoia, they were common fears in the mid–nineteenth century. Carroll, as a serious Know-Nothing writer, articulated them with appropriate concern.[19] But her examination almost always tended to express itself within those parameters delineated above: duty and apology, and an individual, rather than a collective action. In addition, as she constructed her description of the American Party's stance on political matters, she added another literary device: the comfortable imagery of a mother whose task was to educate the citizens of the new (Know-Nothing) republic—another version of the Republican Mother.

Though primarily a statement of the more moderate wing of the anti-Catholic and anti-immigrant Know-Nothings (Carroll did distinguish between foreign and native-born Catholics), *The Great American Battle* is also valuable as an example of the support the male leadership of the party gave her. The introduction to the work, written by Horace Galpen, another leading Know-Nothing, soothed those readers disconcerted by female political activity by stating that Carroll had been "induced" by friends to write the work in order to "revive the memories of their noble Revolutionary sires, to rekindle an emulation, to imitate their virtues, to remind them of their heroic deeds."[20] Furthermore, wrote Galpen, the work was "the production of a young lady [Carroll was forty-one] of refined education, and of a high order of intellect," who had inherited "the love of country, the social and noble virtues, the heroic chivalry of her ancestry." "Would that there were a thousand such talented female pens," he pontificated, "glowing with emotions of love and devotion to their country."[21] He finished with a call for women's political action by explicitly summoning the visionary ideal of the Republican Mother: "Let the women of America, and especially the daughters, who would emulate all that is lovely and matronly in the noble virtues of the Mothers of the Revolution," he wrote, read Carroll's work and absorb its "salutary lessons."[22]

Even with such an introduction by a leading male politician, or perhaps because of it, Carroll continued rhetorically to emphasize her place within

the boundaries of domestic feminism. This was her first public venture, she noted, adding, "I shrink with timidity and distrust."[23] But the dangers of the times to the survival of America meant women could not shrink from their duty. "The Fate of America is the work of America's daughters," she wrote. "On their stern virtue, their cultivated intelligence, their faithfulness to duty, to God, and their country, depend America's salvation now."[24] Because patriotism was intuitive in women, she argued, it was essential that they should act to save America.[25] But while women might be afraid such a call to action might be construed as a political mission, Carroll reassured her readers, "it is only as a moral agent" that any woman should act: "her aim is to develop the child for God and his country," a comforting reference to Republican Motherhood.[26] Furthermore, political action for women was not to include the franchise. In one of the few comments Carroll made regarding votes for women, she continued in no uncertain terms, "Let no cry of *woman's rights'* deter you [from reading this work]. That charge has no significance here."[27]

Carroll's use of language and imagery, as well as her recommendations that the proper kind of political activity for women focused around education of the young, clearly placed *The Great American Battle* within the confines of the paradigm of domestic feminism. She did not, however, remain within those limits. In her later work, she increasingly omitted the rhetoric that conformed her writing to the social limitations on women's participation in the political process. She stopped apologizing, she stopped justifying, she stopped using feminine imagery. She also changed what she wrote about. She moved from rescuing the United States from moral corruption, a task justifiable under the aegis of a Republican Mother or a True Woman, to discuss other matters of partisan political importance.

The Star of the West, or National Men and National Measures, a collection of ten essays published in 1857, is the best case in point.[28] While her earlier work had been written to benefit the American Party, she considered her exposé of the threat to American liberties an issue that would appeal to all true patriots, whatever their party. In *The Star of the West,* however, Carroll wrote on issues which were overtly partisan in nature. In consequence, Carroll also more clearly identified herself as an individual with partisan political interests, rather than as a domestic feminist.[29] Rather than apologizing for her unwomanly appearance before the public, Carroll no longer mentioned her gender. The only apology appears in the introduction and is directed toward readers of *The Great American Battle* who might have accepted her misinterpretation therein regarding Commodore James T. Gerry, whom she had implied had dismissed a young officer for wanting to establish a religious library

on board his ship.[30] Other issues Carroll deals with might seem at first to keep her acting as a domestic feminist. She does write about corruption and reform, for instance, but her target is the ballot box and, as before, she does not suggest women's enfranchisement as a solution. She deals with reform, but in this case, she advocates the reform of the United States Navy. That subject alone separates this work from the domestic sphere, and she discusses the issue on partisan grounds rather than with any eye toward deflecting possible critics of her participation in politics. "The material of our navy," she wrote critically,

> bears no comparison with that of other nations' and this is the reform we need to exalt the nation, instead of ruining its *personelle*. We want a navy to progress with our country's growth, in the quality of our ships and efficiency of our men. For a whole year there was but one single ship bearing our national flag in the Baltic Sea, while so much of our commerce needed to be protected. And, while our resources, properly managed, could make a navy to meet the world, we have but little improvement in naval construction in the last forty years. Why? Because the navy commissioners and navy bureaus have ruined the navy. These men, put in places which properly belong to civilians, have squandered millions of the nation's money, without benefiting [*sic*] the country or service in any sense whatever. Where is there any evidence of originality, any evidence of benefit, by the enormous outlays of these bureaus? We challenge these men to point to any improvement in naval architecture originating with them. All the improvements of any importance have been obtained from other nations; and were the United States to go to war to-morrow, we should find our men-of-war thirty years behind the advancement of all other maritime nations.[31]

This discussion of naval matters by Carroll bears little resemblance to her earlier work in terms of her use of domestic imagery and rhetoric. In her analysis, she argues that naval reforms should not be allowed to exclude civilians from naval bureaus, an important issue for any partisan politician eager for more patronage positions for party loyalists (reflecting Carroll's own attempts to have her father appointed to the Naval Office in Baltimore). The only "True Woman" who appears in the work was the wife of a dismissed Naval officer who wrote a complaint to the Naval Board of Fifteen, responsible for his dismissal.[32] The Republican Mother appears not at all.

None of the other essays in *The Star of the West* are concerned with issues related to the woman's sphere. Carroll wrote a long piece on the First American Exploring Expedition, a congressionally funded round-the-world exploration to gather scientific data. Rather than focusing on its educational value

to the nation as might be expected of a domestic feminist, Carroll decried the allegedly partisan replacement of Jeremiah N. Reynolds, a longtime proponent of the journey who had fought for congressional funding. The command went instead to naval Lieutenant Charles Wilkes, and the mission supposedly shifted from scientific exploration to more military concerns.[33] In another partisan essay, she discussed the necessity of a railroad to the Pacific, focusing primarily on its economic benefit to the country and the necessity for it to be a United States rather than Mexican project. She also wrote of the loss of the sloop-of-war *Albany,* which went down in December, 1854, which Carroll claimed happened as a result of a partisan political appointee's incompetence.[34]

Carroll's goals in this book were to place the ideals and men of the American Party before the public. Some of what she wrote was done at the behest of an individual, such as with the defense of naval officers dismissed from the ranks, requested and presumably paid for by one aggrieved wife. The rest simply gave to the public Carroll's opinion of what had occurred, an opinion obviously valued, she reasoned, by those who had purchased her other writings. Like most Know-Nothings, she saw conspiracies abounding and maintained her argument that "Jesuitical" influence was responsible for the sinking of the *Albany,* the choice of Reynolds, and the selection of those men relieved of their naval careers. But that is all that is here. Carroll moved beyond rhetorical limitations on her actions, and beyond the boundaries of domestic feminism. She did not, however, move toward any demand for political rights in the male sphere based upon the inalienable rights argument. Rather, she proceeded in a different direction, toward the assumption of the right as an individual to be involved in politics as she wished, a direction that served, in one sense, to supersede her gender.[35] Her interests were the partisan politics of the "masculine" American political system, not the informal or the formal domestic feminism of reform in the antebellum woman's world.[36]

Carroll's shift away from domestic feminism might be related to the broader shift among women activists in the 1850s as they abandoned moral suasion as a method of political activism. Acknowledging its failure, proponents of moral suasion opted instead for the activism of the woman's rights movement or the reform efforts of benevolent institutions, such as reform schools, industrial schools, orphan asylums, and the like. But for Carroll, the shift meant embracing political rather than moral reform—the ballot box, the armed forces, the president's cabinet. Wherever she saw partisan political corruption taking place, she directed her vituperative pen.[37]

Once freed from the constraints of the role of domestic feminist, Carroll never returned to it, although she continued to take advantage of some of domestic feminism's methods. Writing petitions remained in her repertoire, for example, as did the use of a salon as a way to meet and attempt to influence leading politicians. As the Civil War began in 1861, she turned her attention to the legal aspects of the war, writing a number of pamphlets in support of Abraham Lincoln's legal rationale of the rebellion. *Reply to Breckinridge,* a short pamphlet published in August of 1861, laid out the legal basis for Lincoln's actions taken in the spring and early summer of that year.[38] Neither here nor in her later pamphlets protesting Lincoln's approval of the Confiscation Acts and outlining what war powers the general government enjoyed did she employ any rhetoric of domestic feminism.[39] While Carroll still actively promoted her beliefs in conspiracies against true Americans, she no longer felt compelled to apologize for her alleged unwomanliness in her attempts to shed light upon them.

Carroll's actions exemplify the role of woman politico, and she was not alone. A brief survey of the three volumes of an early encyclopedia of publicly active women nets such examples of fellow woman politicos as Mary E. Clemmer Ames, journalist and author of "Woman's Letter from Washington;" Anne Charlotte Lynch Botta, who ran a salon for both literary and political figures in New York City beginning about 1855; Emily Pomona Edson Briggs, a journalist who wrote about political trends in the border states; Eliza Farnham, who wrote about customs and institutions of frontier democracy; Mary Holley, a writer who supported Texas annexation; Mary S. C. Logan, who wrote on behalf of her candidate husband in the 1850s and later became a magazine editor; Anna S. U. Ottendorfer, by 1849 a publisher of *New Yorker Staats-Zeitung,* a daily newspaper which served as the voice of the liberal German community, and others.[40] Some of these women occupied roles other than that of woman politico at different points in their careers. A woman active in partisan politics in 1840, for instance, might move into the role of domestic feminist in 1850, back to woman politico for the election of 1856, and to a role as a woman's rights advocate by 1860. The search for woman politicos, then, is best understood as a search for a role women play at certain times and under certain conditions for certain reasons, rather than an exclusive category that is used to define a woman's actions in the public world.

Carroll was relatively unique in abandoning domestic rhetoric while acting in the role of woman politico, but not in her fascination with and in-

volvement in partisan politics. The career of Elizabeth Blair Lee illustrates the vital interest other woman politicos shared, even as they consistently recognized the rhetorical boundaries of their proper sphere. Lee, born into the famous Blair family from Missouri, was raised in an actively partisan political household.[41] Daughter of presidential advisor Francis Preston Blair, sister of Montgomery and Frank Blair, postmaster general and congressman, respectively, Lee was accustomed to discussions of partisan politics at the dinner table as a child, and maintained her interest as she moved to Washington and subsequently married a naval officer. Like Carroll, Lee tried occasionally to sway politicians' opinions and used her salon to influence matters that concerned her, such as patronage appointments, at one point enlisting her father's help to speak to senators on behalf of her husband's promotion.[42] Her father objected strenuously to Lee's plans to lobby senators personally and prevailed upon her to give up such public activity. She explained to her husband that she "gave it up upon faith & not conviction. [T]hat is, it is right for a woman to obey—at the same time I was egotistic enough to think I could get things done he could not."[43] Her attempt to push the boundaries of the woman's sphere ultimately had the desired effect, however; her father began to meet with politicians to promote his son-in-law's chances.[44]

Lee exhibited considerable knowledge of the inner workings of the Republican Party in her letters. Her analysis of Lincoln's process of selection of cabinet members ("Bates has certainly got a place & L[incoln] feels obliged to ask Seward & yet he dont want him to accept—but *he will*") was sound.[45] So were her comments regarding the struggles between the Radicals and the administration.[46] Unlike Carroll, however, Lee was limited in her political actions by her marital status.[47] While Carroll, unmarried, could travel about the country and set up her salon in New York, Washington, or Chicago, as the occasion demanded, Lee was limited by her home, which she shared with her in-laws; by her son, for whom she was primarily responsible; by her father-in-law's horror at her desire to participate in partisan politics publicly; and by her husband's desire that she remain in either Washington or the country house they had in Silver Spring, Maryland. She maintained her use of domestic rhetoric, not surprisingly; what makes her a woman politico is the focus of her interest—partisan political concerns. For Lee, the woman politico role was an occasional one; much of her desire to participate actively in public matters could be met in her work for the Washington City Orphan Asylum, whose board she joined in 1849 and for whom she became director in 1862.[48] Playing the role of the domestic feminist was a way for Lee to

participate in the reform of society. However, she continued her comments on partisan politics, even when they had nothing to do with her work at the Asylum or reform issues.

Lee's ability and choice to move from one politically active role to another, dependent upon other facets of her life, exemplifies the difficulties historians can have in finding woman politicos. One area where historians' examinations have begun yielding evidence of their activity is among the authors of the vast number of political papers and literary magazines published in the nineteenth century. Woman politicos took advantage of the conventions of nineteenth-century publishing, such as anonymity, to argue their positions and participate in politics. These conventions provided protection to citizens with unpopular ideas, a technique long used by male politicians. For example, in 1828, John Caldwell Calhoun of South Carolina responded to a request from South Carolina state legislators to defend the state from what they perceived as federal encroachment and economic tyranny in the form of the Tariff of 1828. The result was the *South Carolina Exposition and Protest,* in which a sitting vice president of the United States promoted the doctrine of state nullification of federal laws. Calhoun agreed to write the *Exposition* only if his anonymity were assured. Such a condition made sense, given the radical nature of the ideas within the *Exposition.*[49] The publication of such an important and thoughtful political document with an anonymous author was not unusual in the nineteenth century. The protection of print, provided here by the mechanism of anonymity, enabled such people as Calhoun to publish their thoughts in comparative safety and increased the ability of the body politic to participate in the nation's political life.

As was true of male politicos with unpopular ideas, woman politicos also used such conventions as anonymity, along with pseudonymity, apologetic rhetoric, and satire in their published works to comment on public affairs, to influence public policies, to protect themselves from public criticism, and to continue to participate in the public political sphere.[50] Anonymity in particular assured any woman the right to comment on partisan politics. One example of this may be found in the *American Woman,* a weekly newspaper supporting the Native American Republican Party in Philadelphia, Pennsylvania. Published by Harriet Probasco, a Philadelphia printer, between September, 1844, and July, 1845, the *American Woman* was a four-page weekly paper containing party news as well as reporting national events and providing reviews of cultural activities. Probasco edited the paper with three other women, all from different parts of the city, who shared her goal of supplying articles detailing the activities of the Native American Republicans, the

women's auxiliaries associated with the party's voters, and the mass meetings held by women throughout Pennsylvania to support the party.[51]

While Probasco was careful to invite men to read the paper, particularly when discussing candidates for the fall elections, this political weekly was for women. The "Prospectus," a statement serving as a raison d'etre and published in every edition, declared that "female writers of acknowledged ability" had been hired to contribute columns.[52] Articles ran a gamut from current affairs and history, suffrage for women and proper voting choices for men, temperance and dress reform, the inclusion of the Protestant Bible in public schools, and other nativist concerns. But most of the early issues reflected the desire of these women to elect Native American Republican Party members into office.[53] Probasco and her editors insisted that their interests were nonpartisan because they promoted good morals for all Americans, but that argument was simply paying lip service to the doctrines of domestic feminism: the goal of the editors was to put party members in office.[54] Mass meetings of women were held to support the party and were reported on by the paper; editorials directed at men to influence their choices in political matters were printed; lectures and speeches by leading candidates were reprinted for the edification of readers.[55] This was, without question, partisan political activity by woman politicos.

Most of the articles in the *American Woman* were unsigned. This anonymity meant that the criticism the paper was sure to engender, that of women meddling in the public sphere of politics, was lessened, since no one could name the woman (other than Probasco herself) and what she might have written. Indeed, Probasco never named her three coeditors since anonymity ensured that the other woman politicos could continue their partisan political activity.[56] In addition, the writers continually employed domestic rhetoric. Women, as mothers, had a duty to influence the men who voted. "Ancient History," the *Prospectus* read, "teems with instances of the blessed and the direful results of maternal instruction. . . . Female influence is the novel, conservative principle of all countries." Furthermore, in times of such trouble as the United States was suffering in the 1840s, and as men worked to rid the land of "foreign influences," it was the duty of women, Probasco wrote, "of mothers, wives and sisters [to] show their cordial approbation." What better way, she argued, than in a newspaper, where "may appear female sentiment appropriately expressed and permanently recorded."[57] Such apologetic, self-effacing, and propitiatory statements are, in the end, largely meaningless if taken at face value. They are, properly understood, signals, and subversive signals at that. They are a way for historians to measure

woman politicos' awareness of the potential for criticism, or they were lip service, or they were a way for women to justify the acts they were determined to do anyway.

Anonymity, while common, poses the most difficult obstacle faced by historians interested in retracing woman politicos. Pseudonymity may have been more common still, chosen for a variety of reasons and not always to disguise the writer's gender. It was not necessarily adequate protection against a curious public, as author and sometime woman politico Mary Abigail Dodge found out. Dodge wrote as "Gail Hamilton," illustrating that she wished to protect her own name from an association with politics but not the fact that a woman could write intelligently on the topic. In *Country Living and Country Thinking* (1862), for example, she scolded her readers for their attempts to gain more information about the person behind the pseudonym. Privacy was presumed essential by the author who used a pseudonym, she argued. If she chose to serve up her ideas to the public in that manner, they had no business at all trying to find out who was behind the false name.[58]

Another woman politico who chose a pseudonym was Jane McManus Storms Cazneau. A journalist of some renown, Cazneau wrote pro-annexation articles during the question of Texas annexation, was the only American correspondent writing from behind Mexican lines during the Mexican-American war, and lobbied three successive administrations of the benefits of Cuban annexation.[59] Cazneau often wrote under a pseudonym, but despite her subject matter, she chose a woman's name, Cora Montgomery, rather than a man's.[60] She wrote primarily on matters such as diplomacy and the economic and physical expansion of the country, particularly into the Caribbean. As a woman politico, Cazneau began her career using a pseudonym, but she also wrote under Storms, her first husband's name and then briefly under her second husband's name, Cazneau. The pseudonyms were effective, at least to some readers; one historian even referred to expansionist works by Cazneau's three pen names as though they were written by three different people.[61]

Cazneau's pseudonyms served her by allowing her to shift from one persona to another as well as from one role to another. Her decision to use a pseudonym at first may have been literally a search for protection: Jane McManus (her birth name) wished to escape the notoriety of being named as the adulterous corespondent in Aaron Burr's divorce from his wife (when he was seventy-eight). J. M. Storms, a woman politico, wrote pro-expansion editorials for the *New York Sun*, and threatened the U.S. secretary of the Navy, George Bancroft, with her ability to create public sentiment in favor of her

positions on foreign policy.[62] Cora Montgomery focused her writings on Cuban annexation and was well known and well published. Jane Cazneau was married to a man with political ambitions who might occasionally need her pseudonyms to protect him from criticism regarding a too-public wife.[63]

The use of initials, also common in public writing in the antebellum period, might be seen as either anonymity or pseudonymity; either way, the practice lessened the possibility of public identification and enabled other woman politicos to keep writing. Louisa S. C. McCord, the brilliant southern theorist who wrote on political economy, signed nearly all her work, when she signed it, with her initials alone. She pursued her political interests throughout her life and, as far as can be discerned, rarely referred to her gender unless writing specifically on the subject of women's roles. Signing her submissions "L. S. M." maintained her ability to subsume her gender to her more individualistic interest in politics. Her initials thus protected her from the harsh criticism and social ostracism that faced public women, particularly in the South. For McCord, the protection of the pseudonym and its near-anonymity enabled her to ignore her own rules of womanly actions. When discussing intelligent women, she argued that they should subsume their intelligence to their gender. "[L]aws cannot be made for exceptional cases," she wrote, "and if Mrs. Betty has good sense, as well as talent, she will let the former curb the latter; she will teach her woman-intellect to curb her man-intellect, and will make herself the stronger woman thereby." The protection provided by pseudonymity enabled McCord, a leading writer, political thinker, and public woman politico to continue her work but provided other ambitious women with an example of "do as I say, not as I do."[64]

Some women also wrote for their husbands in their husbands' names. Jessie Benton Frémont, for example, daughter of Senator Thomas Hart Benton of Missouri and married to 1856 Republican presidential nominee John Charles Frémont, maintained a lifelong interest in politics. Her private letters show her keen grasp of partisan politics, but her public writings were attributed to her husband, until she wrote under her own name to save his reputation and then to save their family from destitution after his financial failures. Frémont knew the value as well as the price of disguising her identity. Early in the Civil War, after her husband was relieved of his command for declaring martial law and trying to force emancipation on Missouri, Jessie took on the task of writing a defense of his actions for publication. But when an opportunity arose for John to receive a new command, Jessie deferred momentarily her battle to paint him as a national hero and a possible presidential candidate. She withheld publication of her newspaper

article that defended John to the detriment of President Lincoln, attended the Lincolns' ball, and, she wrote Frederick Billings, "in my secession cousin's finery, emancipation shook hands with modification & Kentucky." She knew she had to bide her time and mind her public writing in order to help her husband defeat his political enemies; in an allusion to the legendary Pope Sixtus V's assumed frailty that supposedly convinced the College of Cardinals it was safe to elect a pope who would no doubt shortly expire, she continued, "Sixtus wore his crutches until he was well in the seat you understand. It will be about ten days before I throw mine away but they will hit hard when they are thrown." Subsequently, she clarified the allusion in a letter to her nephew: "But now I am Sixtus the 5th. Feminine courtesy, and deference, are the crutches the public expects a woman to use. I must be firmly on my seat of authority before I drop them." [65]

Herein lay the woman politicos' dilemma. These women all wanted to participate in the political life of the nation. For some, it was a family tradition—Carroll, Lee, McCord, and Frémont all came from politically active families; for some a sense of duty—Cazneau and Probasco both had political goals to achieve to save the nation. All of them, however, possessed a consuming personal interest in the partisan politics that made up the nation's political life. They all sought to circumvent the constraints of middle-class Victorian virtues embodied in the Cult of True Womanhood. Disguising their identities offered one possibility to get past the boundaries.

The experience of woman politicos who refused to employ any of these strategies reveals just what the boundaries were. Jane Swisshelm, editor of the St. Cloud, Minnesota, *Visiter,* who occasionally assumed the role of woman politico along with her more frequent roles of abolitionist and reformer, parodied what might have occurred when a male editor discovered the existence of a woman-run political paper:

A woman had started a political paper! A woman! Could he believe his eyes? A woman! Instantly he sprang to his feet and clutched his pantaloons, shouted to the assistant editor, when he, too, read and grasped frantically at his cassimeres, called to all the reporters and pressmen and typos and devils, who all rushed in, heard the news, seized their nether garments and joined the general chorus, "My breeches! oh, my breeches!" Here was a woman resolved to steal their pantaloons, their trousers, and when these were gone they might cry "Ye have taken away my gods, and what have I more?" The imminence of the peril called for prompt action, and with one accord they shouted, "On to the breach, in defense of our breeches! Repel the invader or fill the trenches with our noble dead." [66]

Such an unapologetic and dismissive approach to men's fears of women's encroachment on their sphere of politics garnered Swisshelm few supporters and numerous attackers, but she continued her writings under her own name without apology for years.

Like Swisshelm, Ada Clare, an actress and writer who never employed apology or a pseudonym or anonymity, took refuge in the mechanism of satire that granted her some protection from public disapproval. By using sarcasm and wit, Clare was able to make the point that women (also known as people) ought to be educated, ought to dress as they please, ought to do as they wished, without having to rely on men, or on women, or on the limits imposed by separate spheres and the cult of domesticity. She made fun of men and women and reformers of all types in her columns in the *Saturday Press,* a New York literary newspaper. She produced a hilarious takeoff on the excesses of temperance testimonies, for instance, by declaring herself to be an "anti-pietist," and passed on the sad tale of the man who forced his wife and children, one cold and snowy night, despite their tears and protestations, to consume pie, till he left them in horror at his actions, and never returned (nor had he touched a morsel of pie since).[67] In another column, she attacked the criticism of women authors by writing about a rise in the numbers of male authors. Writing men were all right in their place, she argued facetiously, but their place really was the home.

> There is something effeminate in the literary or artist man. . . . We do not want man to be too highly educated; we want him sweet, gentle, thick-skulled. . . . He should learn the multiplication tables. . . . He should learn to read . . . but above all things in his education, let not the sacred dumpling be neglected. Do not suppose I would keep the man in ignorance; but why puzzle his brain, built for the cultivation of the moral sense, with such abstruse sciences as geography, history, grammar, spelling, gauging, etc. [And as for the suggestion that men have more capacity than domestic pastimes would provide]. . . . Vain will it be to enumerate to me the great things men have done. In the first place I will intemperately deny the existence of those things. If you corner me so that I am forced to acknowledge them, I will retreat to my great stronghold, that we don't want intelligent men, that our choice is only the angelic dunce.[68]

Clare believed that men and women should be able to do as they wished, that they should embrace the differences between the sexes and not try to force individuals to behave in certain ways based solely on their gender. She did not hold with those who would try to make women—or men—into the humorless bluestockings and overly earnest reformers she relentlessly ridiculed.

Not surprisingly, Clare suffered from public criticism because she wrote over her own name about political and cultural matters and made no apology for her actions. Scandalous gossip was repeated widely that her relationship with her publisher, Henry Clapp, was inappropriate. Private lives should remain private, she wrote, finally deigning to respond to her critics. "Nothing could be more false and foolish than the idea that any man or woman's private life can ever be honorably dragged before the public. What the individual does or says in a public capacity is all that belongs to the public."[69] Clare's work took on all comers, and all topics, from reform movements to the arts, to the unrest in the political world just before the Civil War. She embraced numerous roles, including that of woman politico, and used humor to distance herself from public censure, but she could not avoid the prospect that people would criticize her for her actions. The criticism against her she occasionally found daunting: "I do not blame most women," she wrote, "for sinking down into deceit and hardness of heart, they have so much against them; but the struggles and the pains that those women like me who have said, 'I belong to myself and God' must pass through, are richly rewarded."[70]

Few women in American partisan politics possessed Clare's sense of autonomy. Despite the public appearances of Frances Wright, the Grimké sisters, Anna Dickinson, Maria Stewart, and other women speakers, women's presence in the antebellum American political and literary world was limited by societal horror at their appearance in public.[71] But the times were so unsettled and these women were so adamant about the necessity to share their views that it was imperative for them to find some way to transmit their ideas. The sphere of the press let them maintain a public presence that did not necessarily impinge upon their private lives.

While some of the conventions of nineteenth-century political writing can make woman politicos more difficult to find and document, it is important to include them in the portrait of the partisan political landscape of the nineteenth century and to ignore their protestations that they did not really belong in the male sphere of politics in order to understand why these women wrote and acted as they did. Their inclusion in the political landscape gives historians a more realistic portrait of women's roles in this most partisan of eras. With male voter turnouts at 70 to 90 percent, no one can assume women would be uninterested or inactive in partisan politics just because they could not vote. The women prevented from voting were clearly not prevented from participating in politics.[72] But woman politicos did not necessarily support suffrage for women. Carroll and McCord were both adamantly

opposed; many other woman politicos seemed content to influence politicians rather than vote.[73]

Unlike the vast majority of Americans and certainly most politically aware American women, woman politicos did not seem to see citizenship as a gendered concept and individualism as a male-only possibility.[74] When assuming the role of woman politico, these women at that moment clearly identified themselves less with their gender, if at all, than with some other aspect of their lives—their region, the political party of their family, their ethnic group, their economic class.[75] The political historians who have examined the impact of these latter factors on voting practices in the antebellum period have ignored the former.[76] Gender was, like these other factors, only one determinant of one's political choices rather than an essentialist factor in one's choices of action, or an all-encompassing determinant that would eventually lead women through a "proper" evolution of political activity to the ends of woman's suffrage and woman's rights.[77]

The woman politico role illuminates numbers of women active in the political landscape who have heretofore been marginalized or dismissed as anomalies. Their actions as woman politicos, while unusual, were not anomalous. These women's activities are better interpreted by using this awareness that women can and do occupy different roles, one of which assumes a right to participate in public life without reference to gender. This more inclusive interpretation will serve in the continued dismantling of the exclusionary images engendered by the "separate spheres" ideology of the period and provide a more realistic understanding of the flexibility of women's roles in the partisan political landscape of the mid–nineteenth century.[78]

Notes

The ideas in this paper have been developed over several years and have benefited from comments at several conferences: "The Protection of Print: Women Politicos in Action," Society for Historians of the Early American Republic Annual Conference, 1997, comment from Elaine F. Crane; "The Woman Politico: Women and Mid–Nineteenth Century Partisan Politics," Southern Historical Association Annual Meeting, 1995, comment from Ron Formisano; "The Woman Politico: Women and Partisan Politics in the Nineteenth Century," Duquesne History Forum, 1993, comment from Jean Hunter; and "Social Boundaries and the Formation of Know-Nothing Rhetoric," Organization of American Historians Annual Meeting, 1991, comment from Jean Gould Bryant. Financial support has come from the following: a Travel to Collections Grant from the National Endowment for the Humanities; Auburn University Humanities Grant; and a Western Michigan University Faculty Research and Creative Activities Support Fund Grant. Innumerable comments, careful readings, and suggestions have come from the

following individuals: James R. Smither, Sandra Gioia Treadway, Gail S. Terry, Holly Mayer, Robert May, Daniel Szechi, Kathleen Berkeley, Elizabeth Varon, Jean Baker, Catherine Clinton, Stephanie Cole, Alison Parker, Paula Lange, and JoAnne Thomas. My thanks to these individuals and institutions.

1. Anna Ella Carroll to Millard Fillmore, May 28, 1852, Millard Fillmore Papers, Buffalo and Erie County Historical Society and State University College at Oswego, Oswego, N.Y.

2. Anna Ella Carroll to William Henry Seward, Sept. 15, 1852, William Henry Seward Papers, University of Rochester, Rochester, N.Y.

3. The etymology of *politico* derives from the Latin *politicus,* meaning politician, and is found in Italian and Spanish by 1630 to mean a person engaged in party politics as a profession rather than simply one who ran for office for short-term gain.

4. Thus woman politicos differ from women who chose independence rather than marriage but who then relied upon the larger community of women for self-definition and support as described in Virginia Chambers-Schiller, *Liberty, A Better Husband* (New Haven, Conn.: Yale University Press, 1984). The question of the degree to which women's lives actually reflected the culture's demands that they live in "separate spheres" has been answered by pointing out that most women often had activities in public/male spheres, with an implication that there were no meaningful separate spheres, and that the mode of analysis associated with those spheres is outdated. But nineteenth-century women were quite cognizant of the spheres and responded to them very specifically in how they lived their lives. Eliminating the category seems to be a bit like throwing the baby out with the bathwater. See Linda Kerber, "Separate Spheres, Female Worlds, Woman's Place: The Rhetoric of Women's History," *Journal of American History* 75 (June, 1988): 9–39.

5. The most relevant works for this study are Mary G. Dietz, "Context Is All: Feminism and Theories of Citizenship," *Daedalus* 118 (fall, 1987): 1–5; Ruth Bloch, "The Gendered Meanings of Virtue in Revolutionary America," *Signs* 13 (autumn, 1987): 40–41; Eleanor Flexner, *Century of Struggle: The Woman's Rights Movement in the United States,* rev. ed. (Cambridge: Harvard University Press, 1975); Carole Pateman, *The Sexual Contract* (Stanford, Calif.: Stanford University Press, 1988), pp. 5–6, 9; Paula Blanchard, *Margaret Fuller: From Transcendentalism to Revolution* (New York: Delta/S. Lawrence, 1978); Karlyn Kohrs Campbell, *Man Cannot Speak for Her: A Critical Study of Early Feminist Rhetoric,* vol. 1 (New York: Praeger, 1989). Barbara Welter, "The Cult of True Womanhood, 1820–1860," *American Quarterly* 18 (1966): 151–74; Nancy F. Cott, *The Bonds of Womanhood: Woman's Sphere in New England, 1790–1835* (New Haven, Conn.: Yale University Press, 1975); Paula Baker, "The Domestication of Politics," *American Historical Review* 89 (June, 1984): 620–47; Barbara Leslie Epstein, *The Politics of Domesticity: Women, Evangelism, and Temperance in Nineteenth-Century America* (Middletown, Conn.: Wesleyan University Press, 1981); Nancy Hewitt, *Women's Activism and Social Change: Rochester, New York, 1822–1872* (Ithaca, N.Y.: Cornell University Press, 1984); Lori D. Ginzberg, "'Moral Suasion Is Moral Balderdash': Women, Politics and Social Activism in the 1850s," *Journal of American History* 73 (Dec., 1986): 617; Anne Firor Scott, *Natural*

Allies: Women's Associations in American History (Urbana: University of Illinois Press), pp. 37–57.

6. I have defined "woman politico" most thoroughly in a paper before the Southern Historical Association's Annual Conference, "The Woman Politico: Women and Mid–Nineteenth Century Partisan Politics," at the Southern Historical Association Annual Conference, New Orleans, Nov., 1995. Paula Lange, a history graduate student at Western Michigan University, has suggested that political historians cannot "see" woman politicos because many seem to maintain the separate spheres interpretive framework for viewing politically active women, and women's historians cannot "see" woman politicos because of their tendency to argue that there was a community of women in the nineteenth century and that gender overrode all other factors in determining life choices.

 Much additional work is being done on these politically active women. The most notable recent work is that of Ronald J. Zboray and Mary Saracino Zboray, "Whig Women, Politics, and Culture in the Campaign of 1840: Three Perspectives from Massachusetts," *Journal of the Early Republic* 17 (summer, 1997): pp. 277–315; Ronald J. Zboray and Mary Saracino Zboray, "Political News and Female Readership in Antebellum Boston and Its Region," *Journalism History* 22 (spring, 1996): 2–14; Elizabeth Varon, *We Mean to Be Counted: White Women and Politics in Antebellum Virginia* (Chapel Hill: University of North Carolina Press, 1998); Ronald P. Formisano, "The Role of Women in the Dorr Rebellion," *Rhode Island History* 51 (Aug., 1993): 89–104; Jayne Crumple DeFiore, "Come, and Bring the Ladies: Tennessee Women and the Politics of Opportunity during the Presidential Campaigns of 1840 and 1844," *Tennessee Historical Quarterly* 51 (winter, 1992); Robert E. May, "Southern Elite Women, Sectional Extremism, and the Male Political Sphere: The Case of John A. Quitman's Wife and Female Descendants, 1847–1931," *Journal of Mississippi History* 50 (Nov., 1988): 251–85. Woman politicos are apparent neither within the divisions between men and women outlined in Paula Baker's important work, "The Domestication of Politics: Women and American Political Society," *American Historical Review* 89 (June, 1984), nor in Michael McGerr, "Political Style and Women's Power, 1830–1930," *Journal of American History* 76 (Dec., 1990): 864–85.

7. This study has been most informed by the work of Michael Holt, *The Political Crisis of the 1850s* (New York: Norton, 1978); Daniel Howe, *Political Culture of the American Whigs* (Chicago: University of Chicago Press, 1979); Ron Formisano, *The Birth of Mass Political Parties: Michigan, 1827–61* (Princeton, N.J.: Princeton University Press, 1971); Jean Baker, *Affairs of Party: The Political Culture of the Northern Democrats* (Ithaca, N.Y.: Cornell University Press, 1983), Lawrence Frederick Kohl, *The Politics of Individualism: Parties and the American Character in the Jacksonian Era* (New York: Oxford University Press, 1989); William Gienapp, *Origins of the Republican Party, 1852–1856* (New York: Oxford University Press, 1987); and Joel Silbey, *The Partisan Imperative: The Dynamics of American Politics Before the Civil War* (New York: Oxford University Press, 1985).

8. Anne Firor Scott, *The Southern Lady: From Pedestal to Politics, 1830–1930* (Chicago: University of Chicago Press, 1970), was the first to delineate the Southern Lady, the restrictions placed upon her by society, and the ways in which women were politically active while within that restrictive framework. See also Anne Goodwyn Jones, "Southern Literary Women as Chroniclers of Southern Life," in *Sex, Race, and the Role of Women in the*

South, ed. Joanne V. Hawks and Sheila L. Skemp (Jackson: University Press of Mississippi, 1983), pp. 75–94. The Republican Mother was first defined in both Linda Kerber, *Women of the Republic: Intellect and Ideology in Revolutionary America* (Chapel Hill: Institute for Early American History and Culture by the University of North Carolina Press, 1980) and in Mary Beth Norton, *Liberty's Daughters: The Revolutionary Experience of American Women, 1750–1800* (Boston: Little, Brown, 1980). Kerber's work defining the Republican Mother has been further refined with an additional category of Republican Woman by Margaret Nash, "Rethinking Republican Motherhood: Benjamin Rush and the Young Ladies' Academy of Philadelphia," *Journal of the Early Republic* 17 (summer, 1997): 171–92.

9. Varon, *We Mean to Be Counted;* Elizabeth R. Varon, "'The Ladies Are Whigs': Lucy Barbour, Henry Clay, and Nineteenth-Century Virginia Politics," *Virginia Cavalcade* 42 (autumn, 1992): 73–76; Mary Ryan, *Women in Public: Between Banners and Ballots, 1825–1880* (Baltimore: Johns Hopkins University Press, 1990), pp. 135–41. Varon declares quite rightly that partisan women's activities have long been ignored in the discussion of the rise of partisanship in the Jacksonian era. She has presented a superb analysis of women in Virginia political circles who did not hesitate to participate in partisan politics, albeit with politically domestic rhetoric always employed. I thank her for her invaluable suggestions for this paper. The session on women in the public arena held at the annual conference of the Society for Historians of the Early Republic, with papers by Kirsten Wood, "Partisan Men and Powerful Women: Gender Politics in the Eaton Affair," and Christopher J. Olsen, "Women and Party Politics in the Old South: Mississippi in the 1840s and 1850s," upon which I commented, was also useful.

10. The limited biographical information on Carroll regarding her childhood and education is drawn from Sarah Ellen Blackwell, *Life of a Military Genius: Anna Ella Carroll of Maryland* (Washington, D.C.: Judd and Detweiler, 1891). This work was completed prior to Carroll's death and included information drawn from interviews with Carroll. Given Carroll's proclivity for exaggeration and prevarication, such sources must be used with extreme care. Still, with respect to the intellectual nature and philosophical underpinnings of her writings on constitutional theory, this particular assertion may be presumed accurate.

11. Anna Ella Carroll to Thomas King Carroll, Feb. 17, 1830, cited in Blackwell, *Life of a Military Genius,* p. 18.

12. Anna Ella Carroll, *The Great American Battle; or, the Contest Between Christianity and Political Romanism* (New York: Miller, Orton and Mulligan, 1856). This was a subscription book, with publication costs covered by monies gathered from party members and leading Know-Nothings whose biographies and portraits were included. The third edition was published in 1857; the ten thousand copies sales figure came from a letter from Anna Ella Carroll to Thomas King Carroll, May 23, 1856, Anna Ella Carroll Papers, Maryland Historical Society, Baltimore. While the Know-Nothings' nativism and anti-Catholicism appears particularly unappetizing to modern-day Americans, the fact is that the American Party quite well could have occupied the place enjoyed by the Republican Party, both parties fighting it out in the 1850s to become the next national party to replace the moribund Whigs. In a nation that voted for the Know-Nothings' presidential nominee Mil-

lard Fillmore at the rate of 21.53 percent, a third-party percentage unmatched until 1912's Bull Moose party, there was no reason for Carroll to assume her work would go unread. Congressional Quarterly, *Guide to U.S. Elections* (Washington, D.C.: Congressional Quarterly, 1975), pp. 231, 306, 411.

13. Jean Gould Hales [Bryant], "'Co-Laborers in the Cause': Women in the Ante-bellum Nativist Movement," *Civil War History* 25, no. 2 (1979): 130. My thanks to Professor Bryant for her comments on the 1991 OAH conference presentation from which parts of this study were developed.

14. Anna Ella Carroll to Millard Fillmore, Feb. 28, 1856, Millard Fillmore Papers, Buffalo and Erie County Historical Society, Oswego, N.Y. Carroll's proclivity for exaggeration has been well documented. Janet Coryell, *Neither Heroine Nor Fool: Anna Ella Carroll of Maryland* (Kent, Ohio: Kent State University Press, 1990), particularly chaps. 2 and 6; see also Charles McCool Snyder, "Anna Ella Carroll, Political Strategist and Gadfly to President Fillmore," *Maryland Historical Magazine* 68 (spring, 1973): 36–63.

15. Anna Ella Carroll, *Review of Pierce's Administration; Showing Its Only Popular Measures to Have Originated with the Executive of Millard Fillmore* (Boston: James French, 1856), pp. iii–iv.

16. Anna Ella Carroll to Millard Fillmore, May 26, 1852, Fillmore Papers; Baker, "Domesticity," 631. This concept of being above the fray and thus perhaps more, rather than less, qualified to speak on political issues can also be found in the patronage arbiters Catherine Allgor discusses in this volume.

17. Kerber, *Women of the Republic,* 85; see also Coryell, *Neither Heroine Nor Fool,* 122–23, for an earlier discussion of this interpretation of Carroll's methodology. In particular, Carroll's manipulation of domestic rhetoric was common in this period for women who wished to participate in public matters. See, for instance, a discussion of the same attribute in the writings of Lydia Maria Child in Jean Fagan Yellin, *Women and Sisters: The Antislavery Feminists in American Culture* (New Haven, Conn.: Yale University Press, 1989), pp. 54–55. For a closer analysis of the language of petitions to monarchs, see James Smither, "The Prince and the Pamphleteer: Political Propaganda and the Evolution of the French Monarchy during the Wars of Religion" (Ph.D. diss., Brown University, 1989).

18. Anna Ella Carroll to Thurlow Weed, Jan. 27, 1860, Thurlow Weed Papers, Rus Rhees Library, University of Rochester, Rochester, N.Y.

19. The influence and importance of the nativist movement in American antebellum politics has recently been reevaluated. See William E. Gienapp, "Nativism and the Creation of a Republican Majority in the North Before the Civil War," *Journal of American History* 72 (Dec., 1985): 529–59, and Stephen E. Maizlish, "The Meaning of Nativism and the Crisis of the Union: The Know-Nothing Movement in the Antebellum North," in *Essays on American Antebellum Politics, 1840–1860,* ed. Stephen E. Maizlish and John J. Kushma (College Station: University of Texas at Arlington by Texas A&M University Press, 1982), pp. 166–98. See also Holt, *The Political Crisis of the 1850s,* who has provided a more sophisticated interpretation of the rise of the Know-Nothings than Richard Hofstadter's dismissal of their ideas as political paranoia in *The Paranoid Style in American Politics and Other Essays* (New York: Knopf, 1966). A recent interpretation of the

American Party has made clear their appeal to many Americans as part of the reform efforts of the 1850s: see Tyler Anbinder, *Nativism and Slavery: The Northern Know Nothings and the Politics of the 1850s* (New York: Oxford University Press, 1987).

20. Carroll, *Great American Battler,* p. ix. From surviving evidence, Carroll appears not to have been related to Charles Carroll of Carrollton, though she claimed the relation at every conceivable opportunity, along with a familial link to Alexander Hamilton. Sally D. Mason, associate editor, Charles Carroll of Carrollton Papers, to author, Dec. 6, 1985; Daniel Ullmann to Millard Fillmore, Nov. 25, 1856, Fillmore Papers.

21. Ibid., p. x.

22. Ibid., p. xii.

23. Ibid., p. v.

24. Ibid., p. 14.

25. Ibid., p. 18.

26. Ibid., pp. v., 13–14, 18.

27. Ibid., pp. 98, 238, 223.

28. Anna Ella Carroll, *The Star of the West; or, National Men and National Measures,* 3rd ed. (Boston: James French, 1857). All of these essays could have stood alone, and at least one was published separately: Anna Ella Carroll, "The First American Exploring Expedition," *Harper's New Monthly Magazine* 44 (Dec., 1871): 60–64. Carroll's name as author is misspelled in the table of contents as S. E. Carrell.

29. While Carroll's actions might here be interpreted as Republican Womanhood, I would argue that she does not act as a woman with interests that reflected part of the greater community of women whose existence was assumed by most Americans but pursued an atomistic existence rather than a communitarian one in order to do what she wanted. Nash, "Rethinking Republican Motherhood"; for an examination of atomism versus communitarianism in women's lives, see Carl Degler, *At Odds: Women and the Family in America from the Revolution to the Present* (New York: Oxford University Press, 1980).

30. Carroll, *GAB,* pp. 294–95; Carroll, *Star,* pp. 187–89. The only one of Carroll's many works that does not carry her name on the title page is a scurrilous anti-Catholic text called *Pope or President? Startling Disclosures of Romanism as Revealed By Its Own Writers. Facts for Americans* (New York: R. L. Delisser, 1859). It was published anonymously, most likely because of its rather blatant sexual content.

31. Carroll, *Star,* pp. 275–76.

32. Carroll to Weed, Mar. 17, 1861, Weed Papers, continued the pleas for her father's appointment; Carroll, *Star,* p. 282.

33. Carroll, *Star,* pp. 103; 112–16. The American Exploring Expedition took place from 1838 to 1842; Carroll exaggerated the degree to which science was replaced by military concerns. See Donald Dale Jackson, "Around the World with Wilkes and His 'Scientifics,'" *Smithsonian* 16 (Nov., 1985): 48–63.

34. Carroll, *Star,* p. 236.

35. Resonances between the Revolution and Carroll's own era abound, particularly in her use of republican rhetoric and imagery in her partisan writings. Joan Gunderson, "Independence, Citizenship, and the American Revolution," *Signs* 13 (autumn, 1987): 76–77.

36. Baker, "Domesticity," pp. 625–28, 646–47; Carroll, *GAB,* p. 272–97. See also Anna Ella Carroll, *The Union of the States* (Boston: James French, 1856).

37. Ginzberg, "'Moral Suasion," pp. 603, 611–14.

38. Carroll's pamphlet, paid for and distributed by the administration to Congress, was more accessible than Attorney General Edward Bates's opinion on the same subject, published a month previously. Historians have disregarded Carroll's pamphlet, which has never been as well known as that of noted lawyer Horace Binney, who covered much the same ground when he published a year later. Anna Ella Carroll, *Reply to the Speech of Hon. J. C. Breckinridge, Delivered in the United States Senate, July 16, 1861, and, In Defence of the President's War Measures* (Washington, D.C.: Henry Polkinhorn, 1861); Edward Bates, 10 *Opinions of the Attorney General* 74 (1861); Frank Freidel, ed., *Union Pamphlets of the Civil War, 1861–1865*, 2 vols. (Cambridge,: Belknap Press of the Harvard University Press, 1967), vol. 1, pp. 202–205.

39. Anna Ella Carroll, *The War Powers of the General Government* (Washington, D.C.: Henry Polkinhorn, 1861); Anna Ella Carroll, *The Relation of the National Government to the Revolted Citizens Defined* (Washington, D.C.: Henry Polkinhorn, [1862]).

40. The following are all from Edward T. James, ed., *Notable American Women*, 3 vols. (Cambridge: Harvard University Press, 1971): Elizabeth Anne Chase Akers Allen, 1:36–38; Mary E. Clemmer Ames, 1:40–42; Anne Charlotte Lynch Botta, 1:212–14; Emily Pomona Edson Briggs, 1:242–43; Jane Cazneau, 1:315–17; Mary Boykin Chesnut, 1:327–30; Ada Clare, 1:339–40; Mary Abigail Dodge, 1:493–95; Eliza Farnham, 1:598–600; Jessie Benton Frémont, 1:668–71; Jeanette Leonard Gilder, 2:32–34; Laura de Force Gordon, 2:68–69; Margherita Arlina Hamm, 2:125–26; Florence Kling Harding, 2:132–33; Ida Harper, 2:139–40; Mary Holley, 2:204–205; Mary S. C. Logan, 2:421–22; Louisa S. C. McCord, 2:450–52; Clarina I. H. Nichols, 2:625–27; Anna S. U. Ottendorfer, 2:656–57; Harriet H. J. Robinson, 3:181–82; Anne Newport Royall, 3:204–205; Elizabeth E. Sanders, 3:229–30; Ellen B. Scripps, 3:250–52; Katharine M. B. Sherwood, 3:281–83; Margaret B. Smith, 3:317–18; Marion M. Todd, 3:469–70; Julia G. Tyler, 3:494–96; Cornelia W. Walter, 3:536–37.

41. Virginia Jean Laas, ed., *Wartime Washington: The Civil War Letters of Elizabeth Blair Lee* (Urbana: University of Illinois Press, 1991).

42. Elizabeth Blair Lee to Stephen P. Lee, Feb. 17 and 24, 1863, in Laas, *Wartime Washington*, pp. 240–41.

43. Ibid., Feb. 26, 1863, p. 243.

44. Ibid.

45. Ibid., Dec. 25, 1860, p. 19.

46. Ibid., Dec. 20, 1862, pp. 217–19.

47. This would be true of most woman politicos; in the thirty-person sample from James, *Notable American Women*, twenty-six were married.

48. Laas, *Wartime Washington*, pp. 3–4.

49. William W. Freehling, *The Road to Disunion: Secessionists at Bay, 1776–1854* (New York: Oxford University Press, 1990), pp. 257, 275–76.

50. For discussions of nineteenth-century publishing conventions, see Patricia Okker, *Our Sister Editors: Sarah J. Hale and the Tradition of Nineteenth-Century American Women Editors* (Athens: University of Georgia Press, 1995), particularly ch. 4. Okker's interpretation of Hale and how she defined and disseminated her understanding of the ideology of separate spheres is particularly useful. See also Glenda Riley on Hale in *Inventing the*

American Woman: An Inclusive History, 2nd ed. (Wheeling, Ill.: Harlan Davidson, 1995), pp. 100–101, 145.

51. For another interpretation of Probasco's career, see Jean Gould Hales, "'Co-Laborers in the Cause': Women in the Ante-bellum Nativist Movement," *Civil War History* 25, no. 2 (1979): 119–38.

52. See for example, *American Woman,* Nov. 22, 1844.

53. For more on the Know-Nothing controversies, see Anbinder, *Nativism and Slavery,* and Gienapp, *Origins of the Republican Party.*

54. See the Native American Republican ticket, for city, county, and state offices, for example, in *American Woman,* Sept. 21, 1844.

55. *American Woman,* Oct. 12, 1844.

56. *American Woman,* July 19, 1845. Probasco continually asked for support from men to fund the paper and complained that "liberal promises of support were made to her [by party leaders, but] scarcely one of them has been kept." The paper's demise owed much to a lack of funds.

57. *American Woman,* Sept. 21, 1844.

58. Gail Hamilton [Mary Abigail Dodge], *Country Living and Country Thinking* (New York: James T. Fields, 1862), introduction. Most of Hamilton's partisan political work came after the Civil War, particularly in her association with Republican James G. Blaine. Her coauthorship of his *Twenty Years in Congress* might be placed in the same category as Jessie Benton Frémont's work, below. See entry in James, *Notable American Women,* vol. 1, pp. 494–96.

59. Robert May, "'Plenipotentiary in Petticoats': Jane M. Cazneau and American Foreign Policy in the Mid–Nineteenth Century," in *Women and American Foreign Policy: Lobbyists, Critics, and Insiders,* ed. Edward P. Crapol (New York: Greenwood Press, 1987), pp. 19–23; Anna Kasten Nelson, "Jane Storms Cazneau: Disciple of Manifest Destiny," *Prologue* 18 (spring, 1986): 25–40.

60. May, "Plenipotentiary," p. 25.

61. Nelson, "Jane Storms Cazneau," p. 36.

62. Cazneau also threatened Thurlow Weed of New York, telling him that while she knew that "one of my sex should not meddle in these matters," she would nonetheless petition him for a patronage position for one of her relatives. She then pointed out that she could always "command from 6 to 10 votes actively and can neutralize double the number." Jane M. Storms [Cazneau] to Thurlow Weed, Mar. 23, 1841, Seward Papers.

63. Nelson, "Jane Storms Cazneau," pp. 25–36. General Cazneau's ambitions centered on a political appointment to Santo Domingo; Jane Cazneau's pseudonym only went so far in aiding him, since her critics referred to him as the husband of Cora Montgomery.

64. Richard C. Lounsbury, ed., *Louisa S. McCord: Political and Social Essays* (Charlottesville: University Press of Virginia, 1995), p. 121; "Louisa S. C. McCord," in James, *Notable American Women,* vol. 2, pp. 450–52; see also Elizabeth Fox-Genovese, *Within the Plantation Household: Black and White Women of the Old South* (Chapel Hill: University of North Carolina Press, 1988), pp. 242–89. Fox-Genovese maintains that McCord viewed gender as less important than class in maintaining the culture of the Old South. Susan Conrad, *Perish the Thought: Intellectual Women in Romantic America, 1830–1860* (New York: Oxford University Press, 1976), pp. 190–91, called McCord a "Southern Elizabeth

Cady Stanton." She was not, except perhaps in literary style. Instead, McCord incorporated both woman politico and domestic feminist models: woman politico in her political writings, domestic feminism in her poetry and prose pieces. In her works on political economy, McCord argued against using individualism as a basis for reforming society, but given her elitism, it can be argued that she too assumed an individual right to act, based on a belief in what amounted to noblesse oblige. See, for example, "Enfranchisement of Women," in her *Essays,* pp. 109–10, 121, for women's roles and an anti-individualism stance, but then see Louisa McCord to Hiram Powers, Dec. 24, 1860, "Even a woman has the right to wake up when revolution is afoot," *Essays,* p. 27. McCord's views, in toto, may have been set by her Southernism. See Stephanie McCurry, "The Two Faces of Republicanism: Gender and Proslavery Politics in Antebellum South Carolina," *Journal of American History* 78 (Mar., 1992): 1257–58 on women, 1264 on independence/dependence and its relationship to republicanism.

65. Jessie B. Frémont to Frederick Billings, Feb. 7, 1862; Jessie B. Frémont to William Carey Jones, Jr., Oct. 28, 1890, in *The Letters of Jessie Benton Frémont,* ed. Pamela Herr and Mary Lee Spence (Urbana: University of Illinois Press, 1993), pp. 312–13, 535–38. See the editors' introduction for an evaluation of her political acumen.

66. Jane Grey Swisshelm, *Half A Century* (1880; rpt., New York: Source Book Press, 1970), pp. 113–14.

67. Ada Clare, "Thoughts and Things," *Saturday Press,* Dec. 3, 1859.

68. Ibid., Nov. 26, 1859.

69. Ibid., Apr. 20, 1860.

70. Ibid., June 2, 1860.

71. African American women such as Maria Stewart who participated in public politics were far more concerned with the fate of other members of their race than with white, racist, partisan politics. Marilyn Richardson, ed., *Maria W. Stewart: America's First Black Woman Political Writer: Essays and Speeches* (Bloomington: Indiana University Press, 1987).

72. Baker, *Affairs of Party,* p. 212.

73. The question of how best to measure or understand women's influence on men in power is an old one. See, for instance, Mary Beard, "The Legislative Influence of Unenfranchised Women," in *Mary Ritter Beard: A Sourcebook,* ed. Ann J. Lane (New York: Schocken Books, 1977), pp. 89–94.

74. Bloch, "Gendered Meanings," pp. 41–44; Linda Kerber, "Can a Woman Be an Individual: The Discourse of Self Reliance," *Toward an Intellectual History of Women: Essays* (Chapel Hill: University of North Carolina Press, 1997), pp. 200–23.

75. A psychologist or sociologist would term this the "mutability of identity," that is, the emphasis of distinct parts of one's identity according to the situation. Robert VanNoord, Ph.D., to author, Oct. 10, 1995.

76. Lee Benson, *The Concept of Jacksonian Democracy: New York as a Test Case* (Princeton, N.J.: Princeton University Press, 1961); Gienapp, "Nativism and the Creation of a Republican Majority"; Maizlish, "Meaning of Nativism"; Silbey, *Partisan Imperative;* and Holt, *Political Crisis of the 1850s;* Formisano, *Birth of Mass Political Parties;* and Howe, *Political Culture of the American Whigs.*

77. Women's activities in partisan politics remain understudied. See Ronald Formisano,

"The New Political History and the Election of 1840," *Journal of Interdisciplinary History* 23 (spring, 1993): 681–82; Elizabeth Varon, "Tippecanoe and the Ladies, Too: White Women and Party Politics in Antebellum Virginia," *Journal of American History* 82 (Sept., 1995): 494–521. Varon's work on Virginia women in *We Mean to Be Counted* provides a model for a state study of this phenomenon.

78. Kerber, "Separate Spheres, Female Worlds, Woman's Place."

Chapter 5

Patriotism, Partisanship, and Prejudice
Elizabeth Van Lew of Richmond and Debates over Female Civic Duty in Post–Civil War America

ELIZABETH R. VARON

Elizabeth Van Lew was one of the most colorful, enigmatic, and controversial women of the Civil War era. She is well known to historians of the war as the leader of the Richmond underground, a pro-Union spy ring in the heart of the Confederate capital. Countless short biographies, essays, children's books, and even a made-for-TV movie have attempted to tell her story, extolling her exploits of helping Union inmates escape from Confederate prisons, infiltrating the Confederate White House, and passing vital information about Confederate forces on to General Ulysses S. Grant as he moved against Petersburg and Richmond.[1]

While Van Lew's spy career is without doubt both fascinating and significant, this essay will argue that the postwar chapters of her life are equally or even more so. Her espionage activities were concealed from the public gaze and remain shrouded in mystery and therefore largely inaccessible to history. Her postwar political activities, by contrast, were a matter both of public record and public scrutiny and offer us a rich example of the intersection of political and gender issues in the post–Civil War South. In 1869, in recognition of her wartime services to the state, President U.S. Grant appointed Van Lew postmaster of Richmond—a lucrative and coveted civil service post with significant and explicit patronage dimensions, and the highest federal office a woman could hold in the nineteenth century. During her eight years in the postmastership, Van Lew fought a bitter battle to retain control of her office, only to be replaced when Rutherford B. Hayes succeeded Grant as president in 1877. The story of Van Lew's brief political career is not only

dramatic and poignant in its own right, but full of implications for the study of women's political identities and their relationship to the state.

Van Lew's every move received extensive coverage in the national press, and she became a focal point for a heated and protracted debate over women's civic role. Her political defenders—a group that included white Republicans, female suffragists, former Union soldiers, and Afro-Richmonders—argued that Van Lew was the very embodiment of female patriotism, that her pure and selfless devotion to country, writ Union, were ideal qualifications for the civil service. Her detractors—who numbered among them not only members of Virginia's Conservative party but also some prominent Republicans—held that as a woman she suffered from disabilities that disqualified her from holding public office. She lacked, so they charged, the temperament, civic experience, and political tools it took to fulfill the duties of so important a position as that of postmaster.

Van Lew herself, her journal and correspondence reveal, was painfully aware that she was snared in a web of contradictory ideas, and she resorted to a wide array of rhetorical strategies in her political battles. She positioned herself sometimes as a genderless partisan, an earnest and loyal Republican; sometimes as an exemplary patriot whose actions transcended partisanship; sometimes as a helpless woman, a victim of intractable prejudice.[2] Through all her struggles Van Lew held fast to her identity as a southerner while at the same time championing a doctrine of racial equality and harmony that was anathema to most whites in her native state.

This essay considers Van Lew's life in terms of the connections it establishes between two important processes in American women's history— women's integration into partisan politics and their entrance into the federal civil service. Van Lew was in some ways an iconoclast, a category unto herself; but she was also a pioneer, whose political career prefigured the movement of thousands of women into appointive office. Van Lew and her fellow female officeholders, I argue, are symbols of the paradoxical nature of women's relationship to the state in the late nineteenth century.

Elizabeth Louisa Van Lew was born in Richmond in 1818 to John and Elizabeth (Baker) Van Lew. Her father, a successful merchant and leading Whig politico, made his Church Hill mansion a center of the city's social life. Apparently influenced both by her father and her Philadelphia-born mother, who sent Elizabeth to that city for her education, Van Lew developed, as she grew into womanhood, strong and distinctly unpopular political views. We can glean from Van Lew's fragmentary journal that in the 1850s, as the Whig party disintegrated, she came to embrace Republicanism.[3]

Van Lew's wartime reflections on the secession crisis read like a primer in Republican party ideology. The root cause of sectional conflict, Van Lew was quite sure, was the irresponsible actions of the "slave power conspiracy." Like commentators in the North, she blamed a fanatical cadre of southern politicians for whipping up a popular frenzy; secession, she claimed, took place under a system of intimidation, in which loyal Unionists like herself were under constant threat.[4]

Van Lew expressed not only contempt for those who spearheaded secession but also sympathy for the plight of those most victimized by the "slave power"—the slaves themselves. She had successfully prevailed upon her mother to free nine of the family's slaves after her father's death in 1843; she saw to it that others were purchased so that they could rejoin family members who belonged to the Van Lews. The outbreak of the Civil War Elizabeth saw both as divine retribution for the South's sin and as the culmination of the inexorable historical process by which the "slave power" was giving way to "honest and enlightened free labor."[5]

Not content merely to mouth Republican rhetoric, Van Lew put her principles on the line when the war began. She frequently visited federal prisoners in Richmond to bring them supplies; she is credited with providing a safehouse for fugitive prisoners and for helping to orchestrate the February 9, 1864, escape of 103 inmates from Richmond's Libby Prison. In April, 1864, she and other members of the Unionist Richmond underground arranged for the clandestine reburial of Union hero Colonel Ulric Dahlgren. Dahlgren had been killed on March 2 leading a surprise raid on Richmond; on his body were papers instructing him and his troops to burn down Richmond and assassinate Jefferson Davis and his cabinet. Enraged by this discovery, Confederate forces mutilated Dahlgren's body and buried it at a secret location. Stirred by the "outrages" committed upon Dahlgren, Van Lew and a handful of Unionist coconspirators ascertained the body's whereabouts and saw to it that Dahlgren's "honored dust" was reinterred on the farm of a Virginia Unionist.[6]

The most storied aspect of Van Lew's espionage work is her collaboration with Mary Elizabeth Bowser. According to traditional accounts, Bowser, a slave in the Van Lew family, was freed sometime before the war and sent to Philadelphia to be educated. At Van Lew's behest, she returned to Richmond and gained employment during the war as a domestic in the Confederate White House. There Bowser gathered military information and conveyed it, through Unionist operatives such as Thomas McNiven, to Van Lew. During the last months of the war, Van Lew's intelligence operations included a

network of five relay stations from Richmond to federal headquarters down-river. The standard explanation—one that is part of Van Lew lore but dif-ficult to document—for how Van Lew avoided capture and incarceration by Confederate authorities is that she acted and dressed bizarrely to foster an im-age of herself as a harmless eccentric. Richmonders knew her during the war, and have known her ever since, as "Crazy Bet."[7]

After the war Van Lew asked that the War Department hand over all records pertaining to her, presumably in order to protect from reprisals those Richmonders, black and white, who had aided in Van Lew's espionage work. Because Van Lew apparently destroyed those records, vital details of her spy tradecraft are unrecoverable. But postwar testimonials from enlisted men and officers alike pay homage to her crucial role in the Union war effort. "For a long, long time," wrote General George Henry Sharpe, who headed the Union's Bureau of Military Information during the war, Van Lew "repre-sented all that was left of the power of the U.S. government in the city of Richmond."[8]

In the wake of the war, Van Lew would come to represent the government in the literal as well as figurative sense. On March 17, 1869, Republican Pres-ident U. S. Grant, in open acknowledgment of her services to the Union army, appointed Elizabeth Van Lew deputy postmaster of Richmond. Van Lew had, after a fashion, lobbied for the position: she made it known to Grant and to other prominent Republicans that she had spent her family's savings aiding the Union cause during the war and expected compensation for her sacrifices.[9]

Grant's was a singularly controversial move. In order to understand why Van Lew's appointment would stir up so much controversy, it is necessary to know something about the nature of postmasterships and about the political climate in 1869. The post office department had been, ever since Andrew Jackson's day, both the largest and the most politicized of federal agencies. Whichever political party was in power had the opportunity, in filling post office positions, to exercise patronage on a grand scale. The president ap-pointed the postmaster general, a cabinet member who headed up the de-partment in Washington, D.C.; the postmaster general in turn appointed deputy postmasters to fill thousands of local offices around the country. The president also handpicked the deputy postmasters of such major cities as Richmond.[10]

Deputy postmasters could expect not only to draw an excellent salary but also to exercise considerable political clout. Responsible for the hiring of

clerks and mail carriers, postmasters could dispense patronage and thereby build a "sizable partisan army"; once their staffs were in place, they could use their time to "attend political conventions, organize political rallies, and collect money . . . for the party's treasury." Postmasters also controlled the dissemination of political information and had a monopoly on the flow of information in general. Proslavery postmasters in the antebellum South, for example, destroyed rather than processed abolitionist tracts that came through their offices. Like congressmen, postmasters possessed the franking privilege—the right to send out documents without paying for postage—and could therefore freely distribute speeches, newspapers, and government documents of their choosing. Finally, because of their prominence in community affairs, postmasters had the opportunity to advance their own political fortunes. Postmasterships were often stepping-stones to elective office; the most famous example of a postmaster turned politician is none other than Abraham Lincoln.[11]

A bastion of partisanship, the postal service was also a bastion of male privilege. Post offices themselves were, historian Richard John has written, male spaces—men gathered there to discuss politics, catch up on the latest news, and conduct business. So "aggressively masculine" were post offices that "respectable ladies" were advised to avoid them and to send their servants to pick up the mail; post offices in major cities often featured "ladies's windows," where women could pick up their mail without coming into contact with unruly crowds of men.[12]

While female postmasters were not unheard of, they constituted, on the eve of the Civil War, less than 1 percent of the total number in office, and they tended to serve in small communities rather than major cities. During the war, with men off fighting, women assumed civil service positions, postmasterships included, in unprecedented numbers. The vast majority of these jobs reverted to men when the war ended—particularly in the South, as the Confederate government was dismantled. But women had nonetheless gained a foothold in the terrain of white-collar employment. It was unclear, at the time of Van Lew's appointment in 1869, whether or not women's wartime gains would lead to the large-scale integration of women into government service.[13]

Not only did Van Lew's appointment represent female encroachment on what had traditionally been a male domain, it also represented federal intervention writ large in the defeated South. Grant's nomination of Van Lew was one of his first official acts as president, and therefore a sign of how he might

wield his powers of patronage and of whether his policies would reflect his conciliatory campaign motto—"Let Us Have Peace." Given the great practical and symbolic significance of the postmastership of Richmond, it is not surprising that formerly Confederate newspapers, in Virginia and elsewhere, expressed outrage at Grant's choice of Van Lew. The *Richmond Enquirer and Examiner* declared: "We regard the selection of a Federal spy to manage our post-office as a deliberate insult to our people." The *Southern Opinion,* a Richmond paper "devoted to white supremacy, state equality and Confederate memories," fumed, in a derogatory allusion to Van Lew's age (fifty, at the time of her appointment) and the fact that she was unmarried, that Grant had chosen a "dried up maid for Postmistress" who would soon gather around her a "gossiping, tea-drinking, quilting party of her own sex." Ironically, only a single or widowed woman possessed the legal standing to assume the role of postmaster, with its assumption of financial culpability, in Virginia; since the Old Dominion had not yet granted married women property rights, they were not able to keep their own wages, to sue or be sued, make contracts, and conduct business in their own names.[14]

Formerly Unionist papers that favored a lenient course of Reconstruction also condemned Grant's choice. The Washington, D.C. *National Intelligencer,* for example, doubted "whether any one could have been appointed who is more offensive to the people of Richmond" and hoped that the "utterly mean and malignant spirit" that Grant demonstrated in Van Lew's case would not control other government appointments.[15]

Republican newspapers farther north cast Van Lew's appointment in a positive light. An article in the *Troy Times* told the story of Van Lew's efforts on behalf of Union prisoners, concluding with the observation that "such devotion of loyalty was rare during the war, and deserves to be rewarded and recognized"; the *New York Times,* for its part, averred that Grant's appointment had "given the highest satisfaction to the country." Moreover, Union soldiers around the country came forward on behalf of Van Lew. The Seventy-Ninth Regiment of Highlanders, Fourth Brigade, First Division, New York, for example, sent Grant a resolution commending him for bestowing the post office on one so worthy.[16]

To complicate matters, Van Lew's appointment also pitted woman suffragists against antisuffragists. The organized struggle for woman's rights was some two decades old in 1869, and on the eve of a resurgence. That year would witness the founding of two new suffrage organizations: the American Woman Suffrage Association, under the leadership of Lucy Stone, and the

National Woman Suffrage Association (NWSA), under Elizabeth Cady Stanton and Susan B. Anthony. Together, the two groups faced a protracted battle, one that would not culminate in victory until 1920. Opposition to woman's suffrage was particularly strong in the conservative South.[17]

Much of the commentary on Van Lew played itself out in the context of the woman's rights debate. An editorial in the *Philadelphia Evening Standard* praised Van Lew but mused nervously that in appointing her Grant had given a "semi-endorsement" to women's rights. The *New York Herald* saw Van Lew's appointment as evidence of how well women could do without the vote: "a fat office is better than a lean ballot," its editors opined. Though the NWSA was extremely critical of Grant and the Republican Party for ignoring women in the voting provisions of the Fourteenth Amendment, it saw in Van Lew a potential standard-bearer: the organization's official organ, the *Revolution,* edited by Elizabeth Cady Stanton, praised Van Lew's appointment in March of 1869 and followed her career closely in subsequent years. To the *Herald*'s quip that a "fat office is better than a lean ballot" the *Revolution* replied pointedly, "the 'ballot' is not 'lean' in a man's hand, but the talisman that brings many fat things." When Susan B. Anthony visited Richmond in December of 1870 to help the fledgling Virginia State Woman Suffrage Association, she paid a visit to the home of Van Lew; Van Lew's nephew later wrote that Anthony was a "great admirer" of his aunt's.[18]

Van Lew, then, entered upon her post office career under an intense public gaze and unusual pressure. How did she fare at her duties? In some ways she was an unqualified success, presiding over the expansion and modernization of the Richmond Post Office. She instituted citywide delivery of letters; enlarged the money order and registered letter facilities; had boxes placed on the principal streets of the city for the dropping off of outgoing letters; and expanded the number of clerks from twenty-one to thirty-two. In 1871 she even published a post-office manual that the *Revolution* described as "the best in use."[19]

These accomplishments notwithstanding, Van Lew soon found herself caught in the vortex of shifting political winds. Her first years in office were turbulent times in state politics, as they witnessed the formation and then rapid demise of a ruling coalition of Conservatives (former Whigs and Democrats) and moderate, or "True," Republicans. With President Grant's aid and blessing the coalition won control of the state government in July of 1869, and engineered the ratification of a new state constitution that, in the name of compromise, both enfranchised blacks and preserved the voting

rights of ex-Confederates. To the dismay of Radical Republicans, who felt that Grant's conciliation of the moderates was a betrayal, Virginia was read-mitted to the Union in January of 1870. The compromise coalition soon broke down, however, and party lines hardened, with Conservative ranks filled primarily by ex-Confederates committed to white supremacy and Re-publican ranks filled by white southern Unionists, Afro-Virginians, and white northerners who had settled in Virginia. In Virginia, as elsewhere in the Reconstruction South, the Republican Party was rent by factionalism and besieged by enemies willing to use the tools of fraud, intimidation, and vio-lence to achieve their political ends. During the 1870s, Conservatives consol-idated their dominance over state politics, while Republicans retained the White House. As Republican influence in state politics waned, Elizabeth Van Lew represented, for Conservatives, an ever more galling and anomalous symbol of the federal government's unwanted presence in the South.[20]

In this volatile atmosphere, Van Lew was compelled time and again to defend herself against charges—emanating both from within the Republi-can party and without—of incompetence, corruption, and radicalism. Very early on in her tenure, she established a reputation for "insubordination" to the postmaster general and the post office department. According to the memoirs of David B. Parker, who served as a United States marshal in Vir-ginia, Van Lew defied postal regulations by reducing the pay of certain of her clerks in order to increase the pay of others—her "old friends and acquain-tances"—whom she had hired herself. This action brought a reprimand from Postmaster General John Creswell and from Grant himself, and represents the first of many battles Van Lew would wage with her employees. In March of 1872, for example, a dozen of her mail carriers angrily resigned after she had dismissed a Mr. Doughty, the chief of the carriers' department. Van Lew felt perfectly justified in her decision; she had asked Doughty to perform overtime duties to cover for a sick clerk, and he had refused. According to the striking employees and to the *Richmond Daily Dispatch,* however, Van Lew had acted unjustly, and "on a whim."[21]

Incidents like this should be seen in light of what we know about the nine-teenth-century workplace and of Van Lew's personality. As historian Cindy Aron has demonstrated in her study of government clerks in Washington, D.C., sexually integrated offices were a new phenomenon in the 1860s. Typ-ically, female clerks worked for male bosses; it was exceedingly rare for male clerks to work for a woman. Not only were the work arrangements in the Richmond Post Office novel, but the female boss in this case was a woman who also had a reputation for being eccentric and "troublesome." An anec-

dote in the memoirs of the aforementioned David Parker conveys aptly how most white Richmonders looked upon "Crazy Bet." A prominent citizen of Richmond once asked Parker whether he believed that Van Lew's wartime Unionism had been motivated by her patriotic principles; Parker replied that he did. The Richmonder shot back that Van Lew had supported the Union not out of principle but "out of sheer contrariness," and that if she were to fall off of Richmond's Mayo bridge into the James River, "her body would float up the rapids to Lynchburg instead of down the river to Norfolk." [22] Such characterizations of Van Lew were of course utterly ideological; a less passionate reading of the record of her life suggests that she was not so much contrary as extremely proud.

Van Lew's pride was much in evidence in her relations with the Republican Party. From the start, she was determined not only to preside over the mail service but also to assume a prominent position within the Republican Party hierarchy—to exercise her powers of patronage; to orchestrate campaign events; and to serve as a public mouthpiece for the party. Such aspirations were at odds with the prescribed role for women in electoral politics. A consensus prevailed among Van Lew's contemporaries that men and women had distinct functions within the political arena and wielded distinct forms of "influence." While men had a direct impact on public affairs by voting and holding office, women's influence on electoral politics was indirect, that is, channeled through the men who represented them in the ballot box and halls of power. Political parties valued women's ability to motivate voters and to sanction their choices, and encouraged women to attend campaign speeches, rallies, and processions; indeed Conservatives and Republicans alike routinely paid stirring homage to the "powerful influence," as legislator John Goode put it, that women exerted over election results. But women were not invited to participate in the decision-making process of the parties; they were shut out of the conventions and caucuses at which men formulated party platforms and chose candidates. Women were, in other words, cast as strictly supporting players on the political stage. [23]

Undaunted by the restrictive culture in which she operated, Van Lew tried her hand at the role of leader. She wrote to and called on Republican luminaries, the president included, with advice and requests; her tone in these interactions was not deferential but assertive. Shortly after taking office, for example, she dashed off a letter to President Grant, addressing him "not as the president but as a dear friend." She asked Grant to find a civil service position for her brother John, whom she assured Grant was a "faithful Republican." "I do not think you would want to humiliate my only sensible &

beloved brother by overlooking him," Van Lew exhorted the president. (When Grant did indeed overlook John, Van Lew hired her brother as a clerk in the Richmond Post Office.) More controversial was her decision to hire two female clerks; Van Lew's rivals within the Republican Party responded, Van Lew would later recall, by demanding "what are these women doing here—we want voters" and complaining to Grant that she had overstepped the bounds of her authority.[24]

That Van Lew had political aspirations beyond the dispensing of patronage is evidenced in a series of missives she wrote to James Garfield. In June of 1876, at the outset of that year's presidential campaign, she invited Garfield, then a member of the House of Representatives, to an upcoming Republican meeting. "We desire to make this meeting a success and take it beyond our local politics and give it a national standing," she informed him, adding "many disaffected democrats will gladly hear you." Her request, along with two follow-up missives that July, fell on deaf ears.[25]

Van Lew cast herself not only as a spokesperson for but also as the conscience of the Virginia Republicans. In January of 1871, the *Revolution* reported, Van Lew publicly objected to the fact that "certain Congressmen while at Washington franked alot of envelopes and sent them to their friends at Richmond to be used by them, thereby defrauding the United States of their revenue." When she refused to allow such franked letters to pass through her office, Van Lew implicated herself in bitter factional battles within the Republican ranks. For much of the winter and spring of 1871, she found herself under attack from Richmond Congressman Charles Howell Porter and his allies, who were determined to unseat her. Porter harbored animosity not only toward Van Lew but toward the federal officeholders of Richmond "as a class," most of whom, he charged, belonged to the rival faction of state's radical Republicans and were intent on destroying his own political reputation and career. In making a case against Van Lew, Porter's clique utilized a readily available ideological weapon—gender aspersions. They charged that Van Lew should be replaced by a man because no woman possessed the requisite "dignity" for the office of postmaster.[26]

Although Van Lew survived Porter's challenge, she never shook the stigma of being inherently unfit for office. Ambitious men among the moderate and radical Republicans alike set their sights on the postmastership and pointed up the disabilities of Van Lew's gender. Among those who jockeyed to unseat Van Lew were radical ex-mayor George Chahoon and moderate ex-legislator George K. Gilmer. As they saw it, not only the "dignity" of the office but the success of the party were at stake. Van Lew must be replaced by a man,

Alexander Rives wrote Gilmer early in 1876, for Virginia Republicans could not do well in the upcoming presidential election with "one so disqualified by her sex if not other infirmities from exerting influence."[27]

In charging that Van Lew lacked "dignity" and "influence," her detractors were drawing attention to her anomalous position. Van Lew did not speak through men, as the doctrine of women's "indirect influence" would have her do; as postmaster she had her own political platform and voice. But neither, so her critics believed, could she speak *for* men; lacking both the political experience and the legal standing of rank-and-file voters, she could never be accepted as a leader among them. Van Lew prided herself on putting principle above partisanship. She refused to ally herself fully with any faction within the Republican Party, "being friendly," as she put it, to the "good men" across the political spectrum. Such independence did not serve her well politically; she would later concede that she failed to build a following among white Republican voters.[28]

That very failure was interpreted by suffragists as a badge of honor. Throughout Van Lew's battles, the National Woman Suffrage Association took up her banner, principally through articles in the *Revolution*. The journal described Van Lew as a "thoroughly incorruptible" model of efficiency, who rightly refused to let her post office be "used for political purposes." Such a characterization tapped into a powerful current in nineteenth-century discourse on female civic duty—the notion that women were morally superior to men. Female moral superiority was a malleable doctrine. Antisuffragists argued that enfranchisement would put women's virtue at risk by bringing them into competition with men. Suffragists, by contrast, argued that the vote was a tool that women could use to purify the public sphere. The NWSA believed that Van Lew served as a shining example of how women might operate within the male sphere of partisan politics without being tainted by it.[29]

Neither the depiction of Van Lew as someone who lacked political influence nor the image of her as someone who repudiated its use accurately reflects her political identity. For her proudest accomplishments in office were her courageous efforts—efforts that defied racial proscriptions as well as gender conventions—to exert influence on behalf of Richmond's African Americans. Van Lew had always perceived herself, and was perceived by Richmonders, as a "friend of the negro." For example, shortly after the war a black militia unit in Richmond paid tribute to Van Lew by stopping in front of her house and borrowing her American flag, to carry in that day's parade. Van Lew recalls that the militiamen hailed her as the "Goddess of Liberty"; the

unit's leader, William Evins, later wrote a thank you note to Van Lew that she proudly kept among her personal papers.[30]

Van Lew's activities on behalf of the African American community of Richmond fell into four categories: relieving the plight of the indigent; supporting the cause of education; using her patronage powers to promote black officeholding; and publicizing, through contacts with the northern press, the deplorable state of race relations in Richmond. Van Lew was determined to be "serviceable," as she put it, to the "poor creatures" who struggled to eke out an existence in postwar Richmond; to that end she reached out to Virginia's Freedmen's Bureau. In November of 1867, she wrote its assistant commissioner, telling the story of a "mulatto woman, aged about sixty, of excellent character," who had badly injured her arm and was without a home, and asking for assistance in transporting the woman to the house of her brother-in-law, Dr. Joseph Klapp of Philadelphia, where she would be "sheltered and cared for." Once she was appointed postmaster, Van Lew spent her salary, an early biographer has written, "chiefly in charities to the negro race."[31]

The cause of African American education was dear to Van Lew's heart, and she used the press as a vehicle for its advancement. In April of 1871, she published a stirring tribute to a northern white woman, Mrs. Howe, who had devoted the last years of her life to educating freedpeople in Richmond. Van Lew clearly identified with her subject, who had "walked our streets under the loathing scorn of ignorance . . . to do what she thought duty." Van Lew ended her short eulogy with a poignant plea to her fellow citizens: "[we] should cultivate a spirit of toleration and charity towards all from whom we differ—then would our community prosper." This sentiment underlay Van Lew's sponsorship of a library for Richmond's African Americans in 1876. A notice she sent to the *Richmond Daily Dispatch* announced her intention to use the post office as a repository for donations of books, and reminded the "charitable" of "the thirst for knowledge among our colored citizens."[32]

Among the African Americans who worked together with Van Lew to establish the library were two of her postal clerks, James Bowser and N. V. Bacchus. By hiring these and other African American men to work at the post office, Van Lew struck a powerful blow at the South's racial caste system. Before the Civil War, the postal service had made a policy of excluding African Americans from employment, in the North as well as in the South. After the war, blacks were slowly integrated into the civil service; Van Lew and the Richmond Post Office were on the leading edge of this significant transformation. She hired African Americans not only to the important and hitherto unattainable position of mail carrier but to lucrative clerkships that could be

stepping-stones to elective office. One of her clerks, Josiah Crump, went on to serve on Richmond's city council and to earn a reputation as one of the black community's most influential leaders. Van Lew's efforts to promote African American officeholders extended beyond Richmond: in 1869, she secured the appointment of a "mulatto" man, George E. Stephens, to the post of sheriff of Essex County.[33]

While the presence of African Americans in desirable civil service positions bespeaks progress, the political gains made by African Americans were fragile, as conservative whites used a host of nefarious measures, legal and extralegal, to restrict black voting and officeholding. One of these measures, historian Michael Chesson explains, was the passage of a law making petty larceny grounds for disfranchisement; trumped-up charges were the pretext for depriving thousands of African Americans of the vote in the period from 1870 to 1892. Van Lew was outraged at the treatment of black Republicans by white Conservatives and took it upon herself to educate northerners about conditions in Virginia. In an 1872 interview with a correspondent of the *New York Tribune,* Van Lew reported that "there were at least 200 negroes now in the penitentiary for no crime except being Republicans." In October of 1876, at the height of that year's presidential campaign, she published a newspaper appeal to northern Democrats, urging them to repudiate the Democrats/ Conservatives of the South. She told of the violence and fraud whites perpetrated against black Republicans, and noted with palpable horror that the "lash was used even upon the women."[34]

In using the medium of the newspapers to reach out to the public, Van Lew was, in effect, attempting to compensate for one of her most severe political disabilities—the fact that as a woman she was barred, by southern gender conventions, from speaking in public.[35] She seems not to have defied this proscription; there is no documentary evidence of her having delivered public addresses. Instead, the press was her chosen vehicle for publicity, and she used it not only to describe conditions in Virginia but to bring her views and record before the people. Van Lew's 1876 letter to the northern press provides a window into her self-image as well as into race relations. She portrayed herself by turns as a political insider and outsider, as powerful and disempowered. The letter began confidently, with Van Lew stating that as a "representative of loyalty to the Government," she had the duty to disabuse northern men of their misconceptions about the South and give them "facts as they really are." By the middle of the letter she had turned, reluctantly, to the subject of her own persecution. A martyr to the principles of Republicanism, she had been the victim of "constant and repeated gross personal insults" but had

stood firm; there is "no political act for which I blush," she declared. At the end of the letter, she confronted the political reality of women's disfranchisement. "As a woman, I have no power but through your vote," she implored, in deference to the doctrine of indirect influence. "Remember the ballot is the moral lever by which you put in place and power your officials."[36]

Van Lew's sense of her own powerlessness would deepen profoundly in the wake of the 1876 election, as she battled to retain her office. When Republican Rutherford B. Hayes emerged the victor in that contest, Van Lew had some reason to be hopeful about her prospects. After all, Grant had thought well enough of her performance in office to reappoint her, in 1873, to a second term, and even many of her political enemies were willing to concede that she had significantly improved the operations of the post office during her eight-year tenure.[37]

Her hopes for a speedy reappointment and confirmation were soon dashed. With Hayes promising to end Reconstruction and to reform the civil service, moderate Republicans and Conservatives alike saw the opportunity to rid the Richmond Post Office of Elizabeth Van Lew. To that end, they mounted a calculated and at times vicious campaign to slander Van Lew and undermine the administration's confidence in her. The *Richmond Enquirer* inaugurated the campaign shortly after Hayes took office, noting that although Van Lew had proved quite competent, there might yet be a chance to unseat her if only a "sufficient complaint" might be brought.[38] Van Lew, it turns out, was in for the fight of her life.

Van Lew campaigned for her reappointment on two fronts. In Richmond, she followed the standard practice among office seekers of submitting petitions to the public for its support; among those citizens who endorsed her were Reverend W. B. Derrick of Richmond's Third Street Church, one of the city's principal African American congregations. She could boast supporters among the ranks of influential whites as well: Judge Robert W. Hughes, a moderate Republican who had been the party's candidate in the 1873 Virginia gubernatorial race, declared that the post office had been "more efficiently administered" during Van Lew's tenure than ever before; this positive appraisal was seconded by General William C. Wickham, a former member of the Confederate Congress. Van Lew also campaigned in Washington, D.C., calling on Hayes in March; she was supported in that mission by a delegation of African American men from Richmond, who secured a "private interview" with the president to plead Van Lew's case. The Republican Party's organ in Washington, D.C., the *National Republican,* editorialized on Van Lew's be-

half, casting her a "good Union woman" who was being victimized by "intriguing politicians."[39]

Despite entreaties from Van Lew and her allies, President Hayes delayed making a decision on the Richmond Post Office and thereby gave her opponents the time they needed to make a persuasive case against her. Conservatives argued that Van Lew represented the discredited regime of Radical Reconstruction and "pernicious social-equality doctrines" on which it was founded. Holding Hayes accountable for his promise to restore "self-rule" to the South, Conservative papers argued that Van Lew was "objected to by the great mass" of Richmonders; they considered it a great strike against her that "Northern Radical politicians," "military men," and local African Americans constituted her base of support. Van Lew's political enemies were especially enraged by her negative comments about Richmond in the northern press; they repeatedly took her to task for "reviling and abusing the people among whom she lives." "Can the most ardent friend of Hayes claim that the Southern question is disposed of while Elizabeth L. Van Lew sits immured in the Richmond Postoffice?," the *Richmond Enquirer* pointedly demanded as the president pondered his options.[40]

As she had throughout her tenure in office, Van Lew also faced opposition from within the Republican Party. The United States marshall in Richmond, C. P. Ramsdell, headed up a faction that put forward the collector of customs, Dr. C. S. Mills, for Van Lew's post; the group called on Hayes early in April to make the case for that candidate. (In 1870, Van Lew had recommended Mills to Grant as a "worthy citizen"; she now characterized him to Hayes as a man of "small mental calibre".) A second and more formidable Republican challenger was Van Lew's own assistant postmaster, J. A. Jefferds.[41]

Showing a keen awareness of the political climate, Van Lew adopted, in April of 1877, a rather opportunistic tack. She portrayed herself, to the Hayes administration and the public, as the defenseless victim of a "carpetbagger" conspiracy. In an April 10 letter to Hayes's secretary, Van Lew reported that her chief clerks had joined forces against her and were conducting a smear campaign, trying to undermine her reputation. "[T]hey say I am a sick & crass peculiar irritable old maid," she complained, adding, "I am a woman and not able to protect myself for that reason." Van Lew was willing to fight fire with fire. She told the *National Republican* that her principal opponent, Jefferds, was "not identified with the people of Richmond" but was a "Boston carpet-bagger." At the end of April she struck a still more potent blow at her enemies by discharging Jefferds and a clerk, Major Carruthers, who had

supported him. She defended these measures in a pair of interviews with the *Richmond Enquirer.* "I am a Richmond woman," she tearfully told the *Enquirer* reporter, proudly showing him the respectful and admiring obituary of her father, which had run in the paper some thirty three years earlier. Though she had tried to "conciliate" the people of her beloved native city, she had been, Van Lew lamented, misunderstood and mistreated by them.[42]

Unfortunately for Van Lew, the *Enquirer* was openly hostile to her, and juxtaposed her words with scathing and mean-spirited attacks from Carruthers. Hoping to tap into public skepticism about women's competence to hold office, the ex-clerk suggested that Jefferds was the "actual postmaster"; he did the real work of running the office while Van Lew simply "paid exorbitant salaries" to her favorite clerks. He also lambasted Van Lew for her "erratic" personality and "obnoxious manner." The citizens of Richmond, he claimed, "entertain an absolute hatred for her."[43]

Van Lew's southern opponents were not the only ones to cast her as a female interloper on the male terrain of political office. On May 2, 1877, the *New York World* ran a tendentious article entitled "Arrival of the Woman of the Future." "It seems that the coming woman has already got to Richmond, and she is making it pretty hot for the effete man," the article intoned. The "ability which [Van Lew] has displayed in the intrigue for her reappointment," was guaranteed to "strike terror into the heart of the average man." In a tone both humorous and ominous, the essay asked "Is it possible that the sphere of public office is to be taken from him?"[44]

A few weeks later, President Hayes answered that question in the negative when he appointed Colonel William W. Forbes, a native Virginian "of the moderate stripe," to replace Van Lew. (Van Lew described Forbes as a "Confederate colonel of loose character.") The *National Republican* criticized Hayes for putting political expediency above principle; its offices were flooded by letters from former Union soldiers defending Van Lew and her record. But that very record of wartime loyalty had become a political liability. Van Lew was one of hundreds of southern Republicans turned out of office by Hayes and replaced with Conservatives/Democrats, many of them former Confederates. Post offices in Louisville, Memphis, and other prominent locales went to Democrats; one observer estimated that in his first five months in office, Hayes bestowed one third of all his appointments in the South on Democrats.[45]

Even after her bitter defeat, Van Lew held to her belief that she had done a good job and therefore deserved to be reinstated. When James Garfield replaced Hayes in 1881, Van Lew could again be found in Washington, lobby-

ing for her old job. She also worked behind the scenes, sending pointed missives to influential Republicans, among them Thurlow Weed. To Weed she wrote that the front-runner for the post in 1881, a Mr. Pelouze, was neither a "true Republican" nor a "gentleman." "If I get to office I propose to take care of your friends," she promised. In keeping with her earlier efforts to appeal, through the press, directly to the public, Van Lew published a "card" in the *Washington Evening Star* in 1881, expressing her dismay at the fact that she had been declined an interview with Garfield and boldly averring that if the issue of who should be made postmaster were "left to the nation it would be decided in my favor."[46]

Van Lew's efforts were in vain. She did obtain a clerk position in the post office department in Washington, D.C., in 1883, but ran into trouble there too. In 1887, she was handed a pay cut and a demotion, which she attributed to the fact that her boss, a former Confederate, had conspired against her. She soon thereafter tendered her resignation and returned to Richmond.[47]

Van Lew's last years brought with them both a deepening gender consciousness and increasing social isolation. Looking back on her embattled career, she concluded that her downfall as a politician lay not in her political views but in her gender. She had always been an "active and earnest Republican so far as a woman can be." In her day women could "subscribe freely to party purposes—get up torch light processions—tell men what to say at meetings." But such exercises of indirect influence, Van Lew concluded, were ineffectual. If women were truly to have an impact on the policies and conduct of political parties and of the government, they needed to ratchet up their voices and ask for their due—the right to vote. The ballot, she wrote in a handwritten essay among her personal papers, was the "moral lever," the "creative force" of the government. When her critics had charged that no one who lacked this fundamental right could wield meaningful political influence, they, alas, had been correct. Van Lew summed up her political career with a seven-word epitaph: "I had not the power—the ballot."[48]

Though committed to the principle of woman's suffrage, Van Lew seems to have remained aloof from the suffrage movement. She was, perhaps, uncomfortable with the rhetorical strategies favored by suffragists in the late nineteenth century—their argument that white women should be enfranchised so that they could counteract the votes, and thereby undermine the power, of African American men; and the notion that voting would be a means for women to advance feminine reforms and feminine sensibilities. A loner by inclination, Van Lew did not make common cause with women or speak out on their behalf, preferring instead to act as an individual citizen. In

1880, she sent a one-line letter to Elizabeth Cady Stanton, president of the National Woman Suffrage Association, laying out her views. "I am a property holder and taxpayer [who] ought of right to vote and wish[es] to do so," Van Lew wrote. She sent the same simple and blunt message to the municipal authorities in Richmond: in 1892, when Van Lew paid her annual tax to the city treasurer, she attached a note of "solemn protest," explaining that it was unjust to tax one who was "without representation" in the government.[49]

Van Lew was a controversial figure in Richmond right up until her dying day. Over the course of her political battles, her reputation for eccentricity, and for treachery, had grown. According to Richmond lore, Van Lew spent her last years embittered, unbalanced, and lonely, ostracized by white adults and feared by their children. When Van Lew died, in 1900, mainstream Richmond newspapers characterized her spy exploits and suffragism as just so much evidence of her "contrariness." Only the *Richmond Planet,* the city's primary African American paper, eulogized Van Lew in a way she would have found fitting: as a "zealous and true . . . representative of the Union."[50]

A female officeholder in the era before women's suffrage, Elizabeth Van Lew embodied a series of paradoxes. She became a powerful representative of the state but never had representation in it. She acted on the belief that a solid job performance was the best job security, only to find that that was not enough, particularly for a woman in a political appointment. And she pushed the boundaries of women's partisanship only to be undermined by the very party to which she had pledged her allegiance.

Van Lew was unable, or unwilling, to recognize how many other women around the country were faced with similar challenges. In the decades during which Van Lew struggled to retain and then to regain her postmastership, thousands of women were appointed to postmasterships around the country: in 1852 women had held an estimated 81 postmasterships; by 1893, they held 6,335, nearly 10 percent of the national total.[51] Women's integration into the post office department was part of their broader integration into the civil service, a process which has yet to receive its due from historians of women. Cindy Aron's study of office clerks in late-nineteenth-century Washington, D.C., stands alone as the only rigorous scholarly treatment of female federal employees. Though she does not discuss the post office department, her conclusions about the experiences of women who worked in such government branches as the Treasury Department are rich in resonances with Van Lew's case. Female clerks typically sought government employment as a solution to financial problems, problems that had in many cases been precipitated by the Civil War (such as the loss of male providers or of property). The

formidable task of getting and keeping their jobs compelled clerks to over-step the boundaries of "woman's sphere": they evoked partisan allegiances in their quest for positions and "contended with competition and political intrigue" when in office. They were vulnerable not only to the charges of political disloyalty that male officeholders and office seekers routinely leveled at each other but also to gender-based attacks on their competency to hold "male" jobs.[52]

Female postmasters were the most politicized of all women in the civil service, not only because of the very public nature of their responsibilities and the patronage aspects of their positions but also because the post office department proved the most resistant of all government agencies to civil service reform. The Pendleton Civil Service Act of 1883, the culmination of nearly two decades of agitation by civil service reformers, classified certain civil service posts as "merit-based"—to be allotted on the basis of standardized, competitive exams rather than political influence peddling. Well after the majority of government clerkships had been brought under the merit system, postmasterships remained unclassified and therefore politically contested; postmasterships were not converted from patronage plums into classified bureaucratic positions until the administration of Theodore Roosevelt.[53]

Female postmasters are absent from both the burgeoning literature on the late-nineteenth-century state and from recent scholarship that charts women's deepening involvement in politics after the Civil War. This absence is regrettable, for the ranks of female postmasters furnish evidence of the depth of women's political credentials and the surprising extent of their influence during the final stage in the evolution of the "party state": the period during which, to borrow historian Steven Skowronek's terminology, the old party-controlled national government was giving way to the rational, bureaucratic administrative institutions that are the hallmarks of the modern state.[54]

In 1869, at the same time he chose Van Lew, Ulysses Grant appointed two other women, Eliza F. Evans of Ohio and Emily J. C. Bushnell of Illinois, to coveted "presidential" postmasterships. As his critics feared, these high-profile appointments had national repercussions: they inspired a veritable "rush of female office seekers," to quote the *New York Times,* to descend upon Washington. While a collective biography of the thousands of women who assumed postmasterships in Van Lew's wake awaits future researchers, anecdotal evidence illustrates that "postmistresses" were as much politicians as bureaucrats: in order to attain and then to perform their jobs they needed to win the support of party leaders and of their communities.[55]

Some postmasters, such as Cassie Hull of Bath, Maine, who was the favor-

ite candidate of "all the leading Republicans of her district," and Virginia Thompson of Louisville, Kentucky, who endeared herself to her townsmen by being an "intense Democrat"—and was appointed by Hayes in the very same year that Van Lew lost her postmastership—seem to have had little trouble in gaining the public trust. Mary E. P. Bogert of Wilkes-Barre, Pennsylvania, and Emma J. Zeluff of Grant City, Missouri, to give two more examples, were appointed to postmasterships in the 1880s after hundreds of citizens in their respective towns petitioned the post office department and local congressmen on their behalf. Local communities could make their patronage preferences known not only by forwarding petitions to officials in Washington but also by holding elections; in at least one case, a female candidate emerged victorious in such a contest. Angie King of Janesville, Wisconsin, reported to the *Revolution* in 1869 that the "best republican citizens" (male and female) of her town had taken a vote on the subject of who should be postmaster and had given her a "handsome majority." [56]

Many female postmasters proved more successful than Van Lew at weathering changes in the political climate. The aforementioned Virginia Thompson headed up the Louisville, Kentucky, office from 1877 to 1890, while Mary H. Sumner Long was postmaster of Charlottesville, Virginia, from 1877 until 1901. Most impressive of all is the tenure of Mary L. Ballom, who served as postmaster of Dixon Spring, Tennessee, from 1869 until 1914. The sheer number of female postmasters in the South is itself noteworthy. While Pennsylvania boasted the largest number (463) of postmistresses in 1893, Virginia was a close second (460). Indeed, there were more female postmasters in the South than in any other region of the country. [57]

Taken together, the stories of and statistics on female postmasters suggest that Elizabeth Van Lew's assessment of her political demise—her conviction that her gender was the cause of her downfall—does not do justice to the complexity of her situation. Van Lew was driven from office not simply because she was a woman but because she was a former Unionist and Grant Republican, associated in the public mind both with the era of Radical Reconstruction and with the heretical doctrine of racial equality. A male postmaster of a similar political ilk as she would surely have found himself the subject of vitriolic attacks and might have lost his job as well when Hayes replaced Grant. Van Lew's gender was, however, determinative of the *kind* of attacks to which she was subjected; it provided men with a language in which to express their opposition to her. When Republicans claimed Van Lew lacked "influence" and when Conservatives accused her of emotional instability

they were tapping into time-tested and resonant images of female impotence and incompetence. Unfortunately for Van Lew, there was no readily available language with which to counter these images, no script for a pioneering female politician to follow. Labeled as a patriot and traitor, idealist and partisan, heroine and villain, Van Lew sought the one title that her time and place could not abide in a woman—the title of citizen.

Notes

I would like to thank Kelley Brandes of the Library of Virginia for expert research assistance; Alison Parker, Stephanie Cole, and Barbara Varon for invaluable editorial input; and Professor Richard Lowe of the University of North Texas for helpful commentary.

1. The most thoroughgoing published account of Van Lew's life is David D. Ryan's annotated collection of her papers, David D. Ryan, ed., *A Yankee Spy in Richmond: The Civil War Diary of "Crazy Bet" Van Lew* (Mechanicsburg, Pa.: Stackpole, 1996); see also Ernest B. Furgurson, *Ashes of Glory: Richmond at War* (New York: Knopf, 1996). For examples of fictionalized accounts of her life, see Janet Stevenson, *Weep No More* (New York: Viking, 1957); John Brick, *The Richmond Raid* (New York: Doubleday, 1963); and James Gindlesperger, *Escape from Libby Prison* (Shippensburg, Pa.: Burd Street, 1996). Children's books include Karen Zeinert, *Elizabeth Van Lew: Southern Belle, Union Spy* (Parsippany, N.J.: Dillon, 1995). On the TV movie "A Special Friendship," based loosely on Van Lew's life, see *Richmond News Leader,* Mar. 28, 1987, and *Richmond Times-Dispatch,* Mar. 29, 1987.

2. In this volume, Janet Coryell discusses other women who positioned themselves as genderless partisans.

3. Ryan, introduction to *Yankee Spy,* pp. 4–6.

4. The papers of Elizabeth Van Lew, which are at the New York Public Library, include both dated correspondence and a haphazardly organized "occasional journal" Van Lew kept during the war (some of the journal entries are missing dates and page numbers, while others have a series of conflicting page numbers scrawled on them). Although I consulted a microfilmed version, at the Library of Virginia, of the original manuscripts, for the sake of clarity, I will cite Ryan's published transcription of Van Lew's journal. Elizabeth Van Lew, Occasional Journal, Apr., 1861, and Feb., 1864, in Ryan, *Yankee Spy,* pp. 30–31, 63–64.

5. For Van Lew's attitudes towards slavery, see William Gilmore Beymer, "Miss Van Lew," *Harper's Monthly* 123 (June, 1911): 86–87; Ryan, *Yankee Spy,* pp. 6, 63–64.

6. Meriwether Stuart, "Colonel Ulric Dahlgren and Richmond's Union Underground, April 1864," *Virginia Magazine of History and Biography* 72 (Apr., 1964): 152–204; Ryan, *Yankee Spy,* pp. 13, 68–82.

7. Kathleen Thompson, "Bowser, Mary Elizabeth," in *Black Women in America: An Historical Encyclopedia,* ed. Darlene Clark Hine (Brooklyn, N.Y.: Carlson, 1993), pp. 157–58; Brent Tartar, "Bowser, Mary Elizabeth," in *Dictionary of Virginia Biography* (Richmond:

Library of Virginia, forthcoming); "Recollections of Thomas McNiven and His Activities in Richmond During the American Civil War," unpublished typescript, Library of Virginia (hereafter LV), Richmond.

8. Beymer, "Miss Van Lew," p. 94; General George Henry Sharpe to General C. B. Comstock, Jan., 1867, Elizabeth Van Lew Papers (microfilm), LV. Modern-day scholarship on military intelligence has seconded Sharpe's praise for Van Lew: Edwin C. Fishel, the preeminent scholar of the Union secret service, has written that Van Lew's Unionist underground was the "most productive espionage operation of the Civil War." Edwin C. Fishel, *The Secret War for the Union: The Untold Story of Military Intelligence in the Civil War* (Boston: Houghton Mifflin Company, 1996), p. 551.

9. General George Henry Sharpe to General C. B. Comstock, Jan., 1867, Van Lew Papers, LV; Benjamin Butler to Elizabeth Van Lew, May 14, 1867, Virginia Historical Society, Richmond.

10. Wayne E. Fuller, *The American Mail: Enlarger of the Community Life* (Chicago: University of Chicago Press, 1972), pp. 288–89, 294–95. While most postmasters were appointed by the postmaster general, those with salaries over one thousand dollars were appointed by the president with the advice and consent of the Senate. Dorothy Ganfield Fowler, *Unmailable: Congress and the Post Office* (Athens: University of Georgia Press, 1977), pp. 13, 24.

11. William E. Nelson, *The Roots of American Bureaucracy, 1830–1900* (Cambridge: Harvard University Press, 1982), pp. 24–25; Fuller, *American Mail,* pp. 294–95; Richard John, *Spreading the News: The American Postal System from Franklin to Morse* (Cambridge: Harvard University Press, 1995), p. 124.

12. John, *Spreading the News,* pp. 112, 138–39, 164–66.

13. Ibid., 139; George Rable, *Civil Wars: Women and the Crisis of Southern Nationalism* (Urbana: University of Illinois Press, 1989), pp. 265–88.

14. *Richmond Daily Enquirer and Examiner,* Mar. 23, 1869; *Richmond Southern Opinion,* Mar. 27, 1869. The Virginia General Assembly did not guarantee married women property rights until 1877. Suzanne D. Lebsock, "Radical Reconstruction and the Property Rights of Southern Women," in *Half Sisters of History: Southern Women and the American Past,* ed. Catherine Clinton (Durham, N.C.: Duke University Press, 1994). For examples of Virginia women who were "disqualified by marriage" to hold postmasterships, see *Richmond Daily State Journal,* July 9, Nov. 4, 1870.

15. *Washington, D.C., Daily National Intelligencer,* Mar. 18, 1869. Grant has not left a record of the reasoning behind his appointment of Van Lew; indeed the appointment seems inconsistent with the conciliatory course of action he would soon adopt in Virginia. His nomination of Van Lew is consistent however with his habit of letting personal loyalty dictate his patronage choices. William Gillette, *Retreat from Reconstruction, 1869–1879* (Baton Rouge: Louisiana State University Press, 1979), p. 21.

16. *Troy Times,* Mar. 17, 1869; *New York Times* as quoted in *Richmond Daily Enquirer and Examiner,* Mar. 23, 1869; James D. Horan, *Desperate Women* (New York: G. P. Putnam's Sons, 1952), p. 162.

17. Sara Evans, *Born for Liberty: A History of Women in America* (New York: Free Press, 1989), p. 124; Elna C. Green, *Southern Strategies: Southern Women and the Woman Suffrage Question* (Chapel Hill: University of North Carolina Press, 1997).

18. *Philadelphia Evening Standard,* Mar. 20, 1869; *New York Herald,* Mar. 19, 1869; *Revolution,* Mar. 25, 1869; Sandra Gioia Treadway, "A Most Brilliant Woman: Anna Whitehead Bodeker and the First Woman Suffrage Association in Virginia," *Virginia Cavalcade* 43 (spring, 1994): 166–77; *Richmond Times-Dispatch,* Sept. 23, 1937.

19. *Richmond Daily Dispatch,* Apr. 2, 1869; *Richmond Daily Enquirer and Examiner,* Apr. 2, 1869; *Register of Officers and Agents, Civil, Military, and Naval, in the Service of the United States* (Washington, D.C.: Government Printing Office, 1870), p. 768; *Register of Officers and Agents, Civil, Military, and Naval, in the Service of the United States* (Washington, D.C.: Government Printing Office, 1874), pp. 402–403; *Revolution,* Apr. 22, 1869, Feb. 23, 1871.

20. Richard Lowe, *Republicans and Reconstruction in Virginia, 1856–70* (Charlottesville: University of Virginia Press, 1991); Jack P. Maddex, *The Virginia Conservatives, 1867–1879: A Study in Reconstruction Politics* (Chapel Hill: University of North Carolina Press, 1970); Gillette, *Retreat from Reconstruction,* pp. 80–85. According to one Virginia newspaper, as of 1877, there were some 1,458 post offices in the state; 18 of Virginia's postmasterships were designated as presidential appointments; the rest fell under the appointment powers of the postmaster general. *Alexandria Gazette,* May 10, 1877.

21. Elizabeth Van Lew to U. S. Grant, Apr. 6, 1869, Van Lew Papers, LV; *Richmond Daily Enquirer and Examiner,* Apr. 2, 1869; David B. Parker, *A Chautauqua Boy in '61 and Afterward: Reminiscences of David B. Parker* (Boston: Small, Maynard and Company, 1909), pp. 59–61.

22. On the tensions in sexually integrated civil service offices, see Cindy Sondik Aron, *Ladies and Gentlemen of the Civil Service: Middle-Class Workers in Victorian America* (New York: Oxford University Press, 1987); Parker, *Chautauqua Boy,* pp. 62–64.

23. Elizabeth Varon, *We Mean to Be Counted: White Women and Politics in Antebellum Virginia* (Chapel Hill: University of North Carolina Press, 1998), ch. 3. On firsthand testimony to women's indirect influence in postwar Virginia electoral politics, see for example John Goode, *Recollections of a Lifetime* (New York: Neale, 1906), p. 107; Charles T. O'Ferrall, *Forty Years of Active Service* (New York: Neale, 1904), pp. 222–23; John Mercer Langston, *From the Virginia Plantation to the National Capitol or The First and Only Negro Representative in Congress from the Old Dominion* (Hartford, Conn.: American Publishing Company, 1894), pp. 271, 473.

24. Van Lew to U. S. Grant, Apr. 6, 1869, Van Lew Papers, LV; Van Lew, handwritten response to newspaper article "Men and Monopolists," c. 1885, Van Lew Papers, LV.

25. Van Lew to Gen. James Garfield, June 20, July 5 and 7, 1876, James Garfield Papers, Library of Congress.

26. *Revolution,* Jan. 26, 1871; *Petersburg Daily Index,* Apr. 5, 6, 7, 1871; *Richmond Daily Dispatch,* Jan. 25, 28, 1871; *Alexandria Gazette,* Apr. 7, 1871; Maddex, *Virginia Conservatives,* pp. 74–75, 82, 87–88. Congressmen and postmasters alike had the franking privilege. John, *Spreading the News,* pp. 58–59, 123–24. Virginia Republicans were divided along a series of fault lines. Moderates, who favored compromise with Conservatives, were antagonistic to radicals, who did not; many native southern "scalawags" were antagonistic to northern "carpetbaggers"; and black Republicans often felt alienated from and misrepresented by white ones. Moreover, white radical Republicans themselves were divided into factions, one led by Congressman Charles H. Porter and represented in the press by

the newspaper the *National Virginian* and the other led by Senator John Lewis and Congressman James Henry Platt, Jr., and represented by the *Richmond State Journal.* On the divisions within Republican ranks, see Lowe, *Republicans and Reconstruction,* pp. 168–69, 172–77, 185–89 and his article "Local Black Leaders during Reconstruction in Virginia," *Virginia Magazine of History and Biography* 103 (Apr., 1995): 181–206; William D. Henderson, *The Unredeemed City: Reconstruction in Petersburg, Virginia, 1865–1874* (Washington, D.C.: University Press of America, 1977), pp. 235–40; Comments of James Henry Platt, Jr., *Congressional Globe,* 41st Congress, 3rd Session, Pt. 2 (Washington, D.C.: F. & J. Rives and George A. Bailey, 1871), p. 881; Speech of Hon. C. H. Porter, *Congressional Globe,* 41st Congress, 3rd Session, Pt. 3 (1871), pp. 291–94; Speech of James Henry Platt, Jr., *Congressional Globe,* 42nd Congress, 2nd Session, Appendix (1872), pp. 196–98.

27. *Richmond Daily Enquirer,* Mar. 18, 19, 1872; Alexander Rives to George K. Gilmer, Jan. 31, 1876, George K. Gilmer Papers, Virginia Historical Society; Ryan, *A Yankee Spy,* p. 155. Gilmer finally succeeded in winning appointment as Richmond postmaster, in 1880. *Richmond Daily Dispatch,* Mar. 8, 1881.

28. Van Lew, handwritten response to newspaper article "Men and Monopolists," c. 1885, Van Lew Papers, LV.

29. *Revolution,* Dec. 22, 1870, Jan. 12, 1871.

30. For Van Lew's reputation as a champion of African American rights, see for example, *Richmond Enquirer,* Apr. 29, May 1, 1877; *Richmond and Manchester Evening Leader,* July 27, 1900; Van Lew, as quoted in Marie Tyler-McGraw, *At the Falls: Richmond, Virginia, and Its People* (Chapel Hill: University of North Carolina Press, 1994), p. 167; Elizabeth Van Lew Papers, folder 4, Manuscript and Rare Books Department, Swem Library, College of William and Mary, Williamsburg, Va.

31. Van Lew to Gen. Brown, Nov. 2, 1867, Register of Letters and Telegrams Received, Jan. 1–Dec. 31, 1867; and Van Lew to General Brown, Feb. 23, 1868, Letters Received by the Assistant Commissioner, from Jan. 1, 1868 to June 30, 1868, in Papers of Bureau of Refugees, Freedmen, and Abandoned Lands: Assistant Commissioner for Virginia, Yale University; Beymer, "Miss Van Lew," p. 98.

32. *Richmond Daily Dispatch,* Apr. 21, 1871, Jan. 8, 1876.

33. John, *Spreading the News,* pp. 140–43; on black mail carriers see *Richmond Daily Dispatch,* Mar. 13, 1872; for the names of the clerks Van Lew hired, see *Official Register,* 1869, p. 768; 1871, pp. 358–59; 1873, pp. 402–403; 1875, pp. 498–99; on Josiah Crump see Eric Foner, "Crump, Josiah," in *Freedom's Lawmakers: A Directory of Black Officeholders during Reconstruction* (New York: Oxford University Press, 1993), pp. 54–55, and Virginius Dabney, *Richmond: The Story of a City* (Charlottesville: University Press of Virginia, 1976), p. 237; on Stephens, *Richmond Times-Dispatch,* Aug. 27, 1911.

34. Michael B. Chesson, *Richmond After the War, 1865–1900* (Richmond: Virginia State Library, 1981), pp. 182–83; *Richmond Daily Dispatch,* Jan. 5, 1872; Elizabeth Van Lew, "To Northern Democrats. An Appeal Which Should Not Go Unheard," Oct. 27, 1876, newspaper clipping, Van Lew Papers, LV.

35. The proscription against female public speaking was stronger in the South than in the North. See Varon, *We Mean to Be Counted,* pp. 37, 96, 101–102.

36. Van Lew, "To Northern Democrats."

37. *Richmond Daily Enquirer,* Mar. 9, 11, and 15, 1873.

38. *Richmond Enquirer,* Mar. 18, 1877.

39. *Alexandria Gazette,* Mar. 14 and 27, 1877; R. W. Hughes to Rutherford B. Hayes, Apr. 6, 1877, Rutherford B. Hayes Papers, Library of Congress, Washington, D.C.; William C. Wickham to Elizabeth Van Lew, Feb. 24, 1877, Van Lew Papers, LV; *National Republican* (Washington, D.C.), Mar. 13, Apr. 11, 14, 1877; *Richmond Enquirer,* Mar. 13, 1877.

40. *Richmond Enquirer,* Apr. 11, May 3 and 6, 1877; *Alexandria Gazette,* Mar. 22, Apr. 6, 1877.

41. *National Republican* (Washington, D.C.), Apr. 6 and 24, 1877; John Y. Simon, ed., *The Papers of Ulysses S. Grant,* vol. 20: *November 1, 1869–October 31, 1870* (Carbondale and Edwardsville: Southern Illinois University Press, 1995), p. 347; Elizabeth Van Lew to Mr. Rogers (Hayes's secretary), Apr. 10, 1877, Van Lew Papers, LV.

42. Van Lew to Mr. Rogers, Apr. 10, 1877, Van Lew Papers, LV; *National Republican* (Washington, D.C.), Apr. 30, 1877; *Richmond Enquirer,* Apr. 29, May 1, 1877.

43. *Richmond Enquirer,* Apr. 29, May 1, 1877.

44. *New York World,* as reprinted in *National Republican* (Washington, D.C.), May 2, 1877.

45. *Richmond Enquirer,* May 20, 1877; Van Lew to George Howland, June 16, 1877, Van Lew Papers, LV; *National Republican* (Washington, D.C.), May 23 and 25, 1877; C. Vann Woodward, *Reunion and Reaction: The Compromise of 1877 and the End of Reconstruction* (New York: Oxford University Press, 1966), pp. 225–26.

46. Van Lew to Thurlow Weed, Mar. 16, 1881, Van Lew Papers, LV; *Washington Evening Star,* Mar. 26, 1881.

47. Van Lew to Mr. Howe, July 13, 1887, Van Lew Papers, LV; Beymer, "Miss Van Lew," p. 99.

48. Van Lew, handwritten response to newspaper article "Men and Monopolists," c. 1885, Van Lew Papers, LV.

49. Van Lew to the National Woman Suffrage Association, May 29, 1880, The Papers of Elizabeth Cady Stanton and Susan B. Anthony, NWSA Collection, Yale University; Van Lew to John Childrey, Nov. 28, 1892, Elizabeth Van Lew Papers, LV.

50. On Van Lew's reputation in postwar Richmond, see for example *Richmond New Leader,* Jan. 7, 1959. On her death, *Richmond Dispatch,* Sept. 25, 1900; *Richmond Planet,* Sept. 29, 1900. In a letter to the editor in 1937, Van Lew's nephew John tried to counter the "unflattering" dominant image of his aunt as crazy and lonely and to present her instead as a "kindly" woman who never lacked for company and who was "always eager to help the oppressed." *Richmond Times-Dispatch,* Sept. 23, 1937.

51. Marshall Cushing, *The Story of Our Post Office: The Greatest Government Department in All Its Phases* (Boston: A. M. Thayer, 1893), pp. 11, 442.

52. Aron, *Ladies and Gentlemen of the Civil Service,* pp. 142–47.

53. Ibid., pp. 106–19; Stephen Skowronek, *Building a New American State: The Expansion of National Administrative Capacities, 1877–1920* (New York: Cambridge University Press, 1982), p. 69.

54. Skowronek, *Building a New American State.* Robert J. Dinkin's synthesis of the historiography on women and partisan politics makes only passing mention of female postmasters. Robert J. Dinkin, *Before Equal Suffrage: Women in Partisan Politics from Colonial Times to 1920* (Westport, Conn.: Greenwood, 1995), p. 65. The same is true of Rebecca Edwards's recent book on women and politics, *Angels in the Machinery: Gender in*

American Party Politics from the Civil War to the Progressive Era (New York: Oxford University Press, 1997).

55. *Revolution,* Mar. 25, 1869; *New York Times,* Mar. 22, 1869.

56. On Virginia Thompson, see *New York Nation,* June 7, 1877, pp. 336–37; on King, *Revolution,* Apr. 8, 1869; on the others, Cushing, *Story of Our Post Office,* pp. 448–51.

57. On Thompson and Long, see "Women Postmasters: Serving America for Over Two Centuries," unpublished manuscript lent to author by postal librarian Meg Ausman at U.S. Postal Service Library, Washington, D.C. On Ballom, see undated clipping in Female Postmasters File, U.S. Postal Service Library, Washington, D.C. For state-by-state estimates, see Cushing, *Story of Our Post Office,* p. 442.

Chapter 6

Pernicious Heresies
Female Citizenship and Sexual Respectability in the Nineteenth Century

LORI D. GINZBERG

"In Virginia, we have comparatively few citizens," explained Alexander Campbell, a delegate to the convention called to amend his state's constitution in 1829. "A citizen is a freeman, who has a voice in the Government under which he lives. . . . No disfranchised man is a citizen. He may be an inhabitant, alien, or what you please, but without a vote he cannot be a citizen." Campbell's associate, Benjamin Leigh, thought differently: "It is not a necessary qualification of a citizen that he should be entitled to vote," he asserted. If it were, "it would be most absurd to exclude from the privilege of citizenship, every female, and every minor in the community."[1]

Indeed. What are we to make of this exchange, which took place a mere two decades before the question of women's voting came before the American public as a serious—and seriously contested—demand? Did Campbell mean by his comment to strip his mother and sisters of their birthright as American citizens or, equally unlikely, did Leigh intend to provide them with the rights and privileges so jealously guarded by his own sex? And what does this disagreement tell us about the nature of women's citizenship in the nineteenth century? Were citizens, in the common sense of the term, merely those who could vote, or did citizenship itself involve broader rights and obligations than those of suffrage? Forty-five years later the Supreme Court decided, in *Minor v Happersett* (1874), that United States citizenship did not, constitutionally speaking, necessitate suffrage; in the meantime, the question of what constituted an American citizen—precisely what full membership in American society entailed—was hotly debated in a variety of settings.

Over the course of that century a seismic shift happened in the thinking of Americans when, arguing that only those who could vote were truly citizens, some Americans—a few at a time, the most legal-minded first—began to picture an electorate that included the female citizen. To make this shift required an enormous accommodation: it required imagining women as both virtuous and independent, wives and people, subjects and citizens. It required finding a way to depict women as both voters and as the embodiment of middle-class Christian sexual virtue. The question of women's citizenship lay at the heart of several struggles, among them how to define the secular republic as a Christian, and virtuous, nation. Thus notions of sexuality, respectability, and deviance would frame ideas about citizenship and its privileges; only when those concerns were accommodated did most women come to see themselves as voters. In the process, the nineteenth century's obsession with religious and sexual morality provides us with categories of exclusion that are still in use today.

In the past decade or so, and as the essays in this volume variously demonstrate, scholars have turned increasingly to the political arena for clues to women's experience in American society. Disenchanted with the limitations of the concept of "separate spheres" adopted by earlier historians for understanding women's lives, they have explored the ways states' legislation obscured the ideological separation between "public" and "private"; how nineteenth-century politicians understood citizenship itself as a male condition; and how a notion of women's subjectivity can aid us in understanding both women's individual agency and their relationship to the state.[2] Most recently historians have focused on the nature of citizenship in light of the decades-old insistence that we apply our insights about gender to categories conventionally assumed to be both universal and male. Linda Kerber argues that the "definition of 'citizen' is single and egalitarian" even as she highlights the ways in which people's experience of citizenship is varied and unequal. Other historians have sought to untangle the complexities of positing a singular notion of civil status alongside the multicultural and gendered challenges of the American experience.[3]

Another track meanders, a feminist endeavor in a conservative landscape, in the field of political theory. Feminist scholars such as Carole Pateman and Anne Phillips have found new ways to talk about women and citizenship or, more accurately, to describe a theory of citizenship in the liberal state that can make sense of women's exclusion. For Pateman, the "sexual contract" that underlies classic social contract theory is always both obscured and justified by the assumption that women's subordination is natural and thus outside of

politics and history. When we lift the veil from the conjugal contract and examine the free, individual citizen who is thus bared, we have a difficult time understanding where women stand in relation to that citizenship. "There is no set of clothes available for a citizen who is a woman," Pateman writes, "no vision available within political theory of the new democratic woman."[4]

Thus, during the nineteenth-century crisis over adapting liberal theory to the notion of the female citizen, the question of women's representation through their husbands was no technicality, no mere rhetorical comment by antifeminist legislators, but a central component to a civil order based on men's protection of the weak. As Pateman asserts, "The reason why women must enter into the marriage contract is that, although they have no part in the social contract, women must be incorporated into civil society." As McCurry's essay on Confederate soldiers' wives confirms, it has been only through marriage—not incidentally through marriage—that women have been understood as citizens, a historical limitation on female independence with important implications for our own contemporary understanding of female citizenship.[5]

Marriage, of course, signals female dependence. As numerous scholars have noted, to the extent that suffrage remained associated with the idea of virtuous independence, it was a concept fraught with difficulty for women. For if virtue had come by the mid–nineteenth century to be associated with personal morality, female independence itself suggested prostitution, a lack of restraint, a loss of male control over female sexuality and of female control over male loyalty. The negative association of women's independence with sexual freedom framed their claims to full citizenship, just as advocates shaped political demands in part through fear of attacks against women's sexual respectability. The struggles over the precise meanings of citizenship and the provisions for its authority provide answers—or at least hints—to numerous questions concerning the relationship of women to the nineteenth-century state.

Throughout the nineteenth century, lawyers, political writers, legislators, and women themselves struggled to establish the limits of citizenship and, by implication, personhood in the context of defining and refining the American state. The movement for woman suffrage is, of course, the best known case of this concern, but discussion and debate about the precise nature of female citizenship took place on other fields as well: juridical writers such as Elisha Hurlbut and Edward D. Mansfield, concerned with questions of political representation, treated the question of women's rights as unavoidable; jurists argued heatedly about women's emerging expectation of custody over

their children; legislators and constitutional convention delegates were confronted with, and sometimes astonished by, such revolutionary questions as whether wives' ownership of property would disrupt the marriage relation. A perhaps surprising range of assumptions about "woman's natural right of self government" (as an Ohio Select Committee on suffrage put it) infused political discussion on all levels. Even if, as Michael Grossberg argues, the courtroom was becoming "ever more rigidly . . . a masculine space,"[6] it seems clear that the language of law and the expectation that important rights were defined legally pervaded public discussion at many levels.[7]

The most recognizable claims, from our perspective, came from woman's right advocates. For them, women's civil inequality constituted a great inconsistency for democracy. To a limited number of nineteenth-century legal writers as well, the law itself granted rights that helped raise or depress people's—including women's—self-esteem. According to Elisha Hurlbut, "Woman is deprived of her natural dignity when the laws depress her below the condition of man." "The honor," he asserted, "belongs to English and American lawgivers, of having discovered the class of human beings which will endure the greatest deprivation of rights, with the least effectual resistance."[8] Similarly, to an Ohio General Assembly Select Committee on Giving the Rights of Suffrage to Women, "It is prejudice, custom, long established usage, and not reason, which have demanded the sacrifice of woman's natural rights of self government; a relic of barbarism still lingering in all political, and nearly all religious organizations." As early as 1837, Professor Timothy Walker wrote in his *Introduction to American Law,* "We hold [women] amenable to the laws when made, but allow them no share in making them. This language applied to males, would be the exact definition of political slavery; applied to females, custom does not teach us so to regard it."[9] That these views existed at all hints at cracks in a universal definition of liberalism and political rights; that they generated so little debate demonstrates how secure most Americans felt in the boundaries they had established between men's and women's political identities and civil responsibilities. Woman suffrage was not a matter to fret over; it was unthinkable.

Antebellum Americans could easily imagine the unimaginable; indeed, they were adept at imagining, describing, and expressing enormous anxiety about it. If respectability, defined always and only by its opposite, was framed in Christian, female terms in the antebellum years, unrespectability was personified by Fanny Wright and, especially, by the epithet that took her name: a string of invectives and slurs that associated anyone with liberal religious views, or who challenged prevailing class divisions, or who questioned tradi-

tional sexual arrangements, with the most *unthinkable* notions possible. This epithet was especially effective in limiting women's radical activities, by inscribing their calls for full citizenship within a religious framework, and in restricting their independence—political, religious, and, especially, sexual.[10] To be associated with Fanny Wright was, in the context of these beliefs, not simply problematic but outside the boundaries of decency itself.

How do ideas considered unthinkable become unquestionable? Nearly all of Fanny Wright's proposals—one notable exception being her support for the blending of the races—have become commonplace, if not universal. One can hardly find, nowadays, an American who will insist that respectable women should refrain from reading or voting. Yet in Wright's time (and long after), the odor of unrespectability so clung to her name as to make the assimilation of her ideas seem impossible. Only concessions to religious and sexual respectability itself made those ideas palatable.[11] Throughout the nineteenth century, and into our own time, those concessions helped define citizenship by establishing particular limitations on women's rights and obligations.

Fanny Wright's and her freethinking followers' pleas for reason, women's rights, and an end to clerical dominance were largely drowned out in the decade of the 1830s, and debates about female citizenship were reworked in the light of that cultural shift. We can look beyond the movement for free thought to an array of sites that describe citizenship claims and rights consciousness to see that a particular analysis of sexuality, respectability, and maternity underscored women's willingness to accept limited rights and frustrated the efforts of those who sought to extricate themselves from the terms of womanhood itself.

By the 1830s, the concept of female sexual purity provided the most salient rhetoric for advancing a view of the republic as Christian, for marginalizing particular groups with the use of sexualized rhetoric and fears of sexual chaos, and for justifying limitations on suffrage generally as natural and essential. The answer to the question of how the unthinkable became thinkable lies not solely in the agitation of early prosuffrage women but also—ironically—in the very fervor with which antebellum Americans clung to that notion of female purity in defining the nation's political character. Most Americans came to consider women's full citizenship possible only when it could be reconciled with these values; women's political independence, that is to say, was respectable only if it was gendered, if it evoked images and involved duties that seemed to uphold rather than undermine sexual differences. Thus the opposite of women's purity—the threat presented by deviance—was ubiquitous

in many of the political and legal settings that helped set the terms for women's citizenship.

In several cases around legitimate witnesses in court (always a contested area of full rights of citizenship and, indeed, personhood), in blasphemy cases, and in constitutional convention debates we find arenas in which questions about citizenship, religion, and sexual respectability were explicitly and forcefully debated. Antebellum judges, for example, considered whether Universalists (who believed that all persons were universally saved after death, that there was no divine punishment) could serve as witnesses in civil cases. With an extreme sense of urgency about the boundaries of full citizenship, they decided that they could not. In *Atwood v Walton* (1830), for instance, it was found that a person who denied heavenly accountability could not be trusted as a witness in a case where "life, liberty, property or reputation are to be affected by his testimony."[12] The separation of church and state, which nearly all Americans by 1830 claimed to have perfected, meant that people could believe as they wished, could, even, deny a belief in eternal punishment; it did not mean that they could testify in court.

What does this have to do with sexuality, or with female citizenship? According to historian David Lawton, "When orthodoxy sees libertinism, it sees both blasphemy and sexual deviance. Sexual deviance as well as sexual excess is therefore a signifier of blasphemy."[13] And, I would add, vice versa, for in the early nineteenth century, conservatives perceived more signs of blasphemy, signaling a sexual danger, than of the reverse. According to Protestants, the belief in eternal damnation was the only thing holding society, and women in particular, in check sexually; without it, sexual anarchy and licentiousness would reign. "[W]hatever strikes at the root of christianity," wrote Justice James Kent in the 1811 case *People v Ruggles*, "tends manifestly to the dissolution of civil government."[14]

In the early 1830s, Samuel Gridley Howe evoked these fears in a couple of rather panicky articles about "Atheism in New-England." For Howe, the link between a disbelief in eternal damnation and sexual chaos was clear and inevitable. Infidels, he asserted, "diminish the inducement to a life of chastity and virtue." Furthermore, they were aggressors: "it is the Christian, the pious, peaceful Christian, whose God they blaspheme, whose religion they insult, whose social ties they would sever, whose wife and daughter they would make common property." Nor did Howe hesitate to draw a firm line between thought and action: "[If] a man has a right to try to shake the belief of his neighbor's wife in the sanctity of the marriage vow, he has a right to seduce her from him." For these writers, doubt about the truth of Christian faith led

directly to questions about the sanctity of marriage and, in turn, to its disso-
lution. Thus, in the 1818 blasphemy case against Robert C. Murray, the court
clearly linked freedom of speech and religion on the one hand to the public
good on the other: "Can it be otherwise than criminal, maliciously to destroy
the happiness of another, by depriving him of his confidence in revealed re-
ligion, and rendering him a prey to doubt and despair?"[15]

This language pervaded nineteenth-century blasphemy cases. For most an-
tebellum listeners, I imagine (and this is, of course, the point), the connec-
tion between religious and sexual infidelity did not have to be spelled out;
happily for us, lawyers and judges did it anyway. For women the dangers of
irreligion were clearly sexual. Take a Pennsylvania case about profane speech
during a session of a debating society: The court agreed that permitting blas-
phemous speech "would provide a nursery of vice, a school of preparation
to qualify young men for the gallows, and young women for the brothel." If
the other side were to win, claimed the prosecutor in a most wonderful im-
age, "every debating club might dedicate the club-room to the worship of the
Goddess of Reason, and adore the deity in the person of a naked prosti-
tute."[16] That reason, which antebellum Protestants understood to mean a
critique of religious orthodoxy, and women's sexual licentiousness were in-
herently connected and uniquely disordering for society could not have been
clearer.

The famous blasphemy case against Abner Kneeland was a veritable orgy
of fearful description. According to the state of Massachusetts (in the person
of its prosecutor), if the former Universalist turned freethinker were allowed
to remain free, the result would be the classic sexual slippery slope: "Starting
from this polluting fountain, I might trace the progress of vice and misery in
a thousand narratives . . . how infidelity towards God leads to infidelity to-
ward man and woman, destroys domestic peace and harmony, breaks up
marriages, blunts the natural feelings and affections between parents and
children, and dissolves families. I might show the origin of fraud and crime
in young men, of lewdness and prostitution in young women."

This was not the worst. "I believe also," the lawyer warned, "it is asserted
quite publicly, that some secrets of physiology, said to be worth knowing to
persons fond of certain pleasures, some checks to a too great increase of pop-
ulation, are now taught to the initiated in the schools of infidelity. I do not
assert these things as matters of fact, but as matters of common report." Only
one juror could withstand the prosecutor's closing instructions to "do [their]
duty": "If marriages are dissolved, prostitution made easy and safe, moral and
religious restraints removed, property invaded . . . and universal mischief and

misery ensue, the fault will not lie on me," he pontificated. "Take care that this day you offend not God, nor injure man, that you violate not the law, and the constitution." [17]

Whether and in what ways the founders of the United States intended their nation to be a Christian one has vexed politicians and jurists ever since the adoption of the First Amendment to the Constitution, and I do not propose to review those debates here. For the most part, it seems fair to say, the nation's founders assumed that a modest—and moderate—Christian ethos would pervade the nation's institutions and communities. Their descendants, faced with the vigor of nineteenth-century dissent, "a wild diversity of churches," and the anxieties these changes elicited, felt compelled to establish that fact more positively and so acted to enforce the Christian sabbath, revitalize individual and communal religious commitment, and more visibly establish Protestantism as the unquestioned—and unquestionable—moral basis of American life.[18] The role of the clergy in this project was essential but was perhaps more of a rhetorical than a political nature; in spite of occasional statements about Christianizing politics, theirs was largely the task of evoking what would befall the nation should religious fervor lapse.

In describing its worst fears, Protestantism set out its appeal (in both senses of the word) to women: it offered women sexual safety in exchange for limiting their claims to full citizenship, protection in exchange for accepting political identities solely as virtuous members of male-headed households. Denying full rights to Universalists and blasphemers was, in other words, a small piece of a package that declared Protestantism best able to defend women against the (sexual) excesses of nonbelief. Throughout much of the nineteenth century, the majority of women appeared willing to accept that package. They participated in respectable society's obsession with the act of drawing its boundaries, boundaries that, in Jean Matthews's phrase, required "strict maintenance and policing." Recently, important work in nineteenth-century women's history (including several of the essays contained in this volume) has explored the myriad ways women participated in political life without claiming the mantle of full citizenship rights; clearly, declaring oneself in favor of woman's suffrage involved, for much of the nineteenth century, a major step. Ironically, the very unquestionableness of the trope of female sexual and religious purity by the mid–nineteenth century opened a space within which to consider female suffrage, and to consider how—under what conditions and with what caveats—women could as a group cross those boundaries in order to act as full citizens.[19]

The conflation of respectable womanhood with restricted religious and sexual practices pervades antebellum claims to the rights of citizens—and to their denial. Thus arguments for women's rights could be delegitimized merely by their implied association with irreligion and its vices—and frantic efforts at dissociating themselves from irreligion did not help. Women's vulnerability to charges of religious and sexual infidelity was, not surprisingly, in proportion to the radicalness of their claims. While religious commitments certainly inspired many women to criticize marriage and engage in transgressive behavior, women remained vulnerable when they asserted their right to full authority in a religious setting. William Craig Brownlee devoted an entire chapter of his 1824 attack against Quakers to their recognition of female ministers. Snidely he acknowledged that some female ministers would be conscientious in their duties, "prepared to overcome the dull propensities which bind *ordinary* females to domestic employment, and to rid themselves of the trammels of that modesty which constrains weaker females to shrink back from the stare of man." Brownlee went on to decry, with an oddly feminine image, a society where the sight of a female minister had ceased to bring about "that burning shame that was on the cheeks of our fathers, when they were first compelled to witness the intrusion on their prerogative, and on delicacy and decency!" [20]

Similarly, as abolitionists painfully discovered, the insistence on their own adherence to religion did not protect women from the suggestion of sexual impropriety when they declared themselves in favor of a radical cause. The much-discussed "Pastoral Letter" of 1837, which responded so vehemently to the Grimkés' antislavery addresses to "promiscuous" audiences, employed a fascinating metaphor to underline the implications of their acts: "If the vine, whose strength and beauty is to lean upon the trellis-work, and half conceal its clusters, thinks to assume the independence and the overshadowing nature of the elm, it will not only cease to bear fruit, but fall in shame and dishonor into the dust." [21] Who in 1837 could have misunderstood what kind of "fall in shame and dishonor" these words imputed to the Grimké sisters and their followers? To propose that women be granted full rights as American citizens was, for most Americans, a sign of both sexual and religious transgression. To overcome that association—to make women's rights palatable—required significant reworking of those assumptions but not, I want to argue, a complete break with them.

We can more closely observe the transition by which women's full citizenship became thinkable (if horrible) in state constitutional convention

debates. Focused insistently on balancing the rights of individuals with those of property, of broad suffrage with elite control, and of slaveholders with non-slaveholding free men, these debates—in Maine in 1819, New York in 1821 and 1846, Virginia in 1829, Pennsylvania in 1873, and Wyoming in 1889—are full of rhetorical flourishes that show how bizarre the notion of women's independent citizenship was, and for how long and with what adaptations that remained the case. According to our traditional notion of things, no one discussed woman suffrage until the late 1840s; even the discovery of at least one petition for full citizenship rights for women prior to the 1848 Seneca Falls Convention does not markedly change our sense that it was the demand for woman suffrage that first provoked mention of it.[22] But this is simply not true.

As they debated securing the franchise of non-property-holding white men, African American men, and others, constitutional convention delegates consistently referred to the notion of women's full citizenship rights and to the appropriate limitations placed on so-called—insistently called—universal suffrage. It was not viewed as either inevitable or inherently just and proper that all white men would vote; on the contrary, universal white male suffrage was debated with great passion—with woman suffrage ever looming as the absurd impossibility at the end of the suffrage-granting tunnel.[23]

Take New York in 1821, where delegates to the constitutional convention argued heatedly about expanding the suffrage to more white men and limiting it to fewer free blacks. That suffrage was not a natural right was "proven" by the fact that not everyone had it. "We exclude aliens," asserted John Z. Ross of Genesee, "we exclude minors, we exclude the better part of creation . . . we exclude the aborigines . . . and no complaints are made." "If there is that natural, inherent right to vote which some gentlemen have urged," agreed James Kent derisively, "it ought to be further extended. In New Jersey, females were formerly allowed to vote: and on that principle, you must admit *negresses* as well as *negroes* to participate in the right of suffrage. Minors, too, and aliens must no longer be excluded, but the 'era of good feelings' commenced in earnest." Elisha Williams concurred that suffrage was an arbitrary, not a natural right; otherwise how to defend "that, at one sweep, . . . you exclude from the right of suffrage one half of the population of the country,—and that half, too, which truth, no less than politeness, requires us to say, is the *better half.* And why this exclusion? Because it is prudent, wise and convenient."[24] Suffrage, therefore, with its implicit control over (other people's) property, was by no means the natural right that those who sought to broaden it claimed; on the contrary, one delegate after another asserted, it

was a right granted by those who owned property to those with whom they felt a natural equality. That women were excluded proved to their satisfaction both the justness of this and of women's natural subordination.[25]

Eight years later, Virginia's delegates became embroiled in a vitriolic debate over whether to permit white men without property (largely settled in the western part of the state) the same electoral representation as their eastern, predominantly slaveholding, counterparts. Several of these gentlemen are worth quoting at length. Judge Abel Upshur was quick to insist on the absurdity of the idea of voting rights inhering in a person, rather than in his [sic] property holdings. "If nature really gives this right to a majority . . . in what does the right consist? Is it in mere numbers? If so, every creature must be counted, men, women and children . . . surely it does not consist with the gallantry of the present day, to say that the ladies are not at least the equals of ourselves. . . . Why are not women, and children, and paupers, admitted to the polls?" Lest he be misunderstood as *advocating* such extremes, the judge went on to assure his colleagues that "I am as ready as any gentleman here, to disclaim every idea of the sort. I use the argument only to shew what consequences this demand, founded on a supposed law of nature, must inevitably conduct us."[26]

John R. Cooke, who supported expanded white male suffrage, disagreed. The argument against allowing women to vote, he maintained, in no way undermined the *natural* right of all white men, including those without property, to do so. The founders of the United States, he insisted, "did not undertake to write down . . . all the rules and all the exceptions which constitute political law. They did not *express* the self-evident truth that the Creator of the Universe, to render woman more fit for the sphere in which He intended her to act, had made her weak and timid, in comparison with man, and had thus placed her under his *control,* as well as under his protection. . . . That nature herself had therefore pronounced, on women and children, a sentence of incapacity to exercise political power."[27] Thus Cooke expressed a common association: those most eager to broaden manhood suffrage were quickest to invoke what Carole Pateman labeled the sexual contract, and thus to justify the naturalness of citizenship based upon men's shared gender.

Virginia delegate Philip P. Barbour drew at some length on the analogy of women's exclusion from the suffrage, unknowingly using language that would several decades later serve an entirely different cause. Insisting that suffrage was a practical, not a natural, right, Barbour "call[ed] upon any gentleman to shew me a principle of natural law, which will sustain [women's] exclusion, to the extent which is thus laid down. . . . Can any gentleman shew

me a reason drawn from *nature,* which subjects females, *as such,* and because of their sex only, to the dominion of men?" Certainly a woman who married accepted her husband's representation, and thus, "impair[ed] her original rights, to the extent of the obligations contracted by this change. But," Barbour continued, "a female who is of mature age, and unmarried, is in possession of all her rights; those rights are by nature the same with those of the other sex; and men, merely as such, have no natural right to exercise any control over her whatsoever." Women, he claimed, have full civil rights; it is only in the *political* realm that they become one of, in his words, "the discarded classes." [28]

Robert Stanard agreed (as, apparently, did all his associates) that "our feelings tell us, that the sex ought not to contaminate its purity, by the pollutions of a political canvass" and, furthermore, that "this is all fair." Another delegate, Samuel Moore of Rockbridge, insisting on the right of those with political power to exclude others (and thus to thwart any arguments on behalf of "natural rights"), went so far as to claim that "our slaves are by nature equally as free and independent as ourselves." He continued: "We have been asked, why it is we exclude the women from all participation in the formation of Government, if it be true that all the human race possess equal natural rights? . . . It will be a sufficient answer to this question, to say, that the women have never claimed the right to participate in the formation of the Government, and that until they do, there can be no necessity for our discussing or deciding upon it: more especially as no one believes that any such claim will ever be insisted upon by them." He then underscored the conflation of women's marital dependency with traditional notions of female citizenship—as well as making explicit what a man's vote was thought by other men to represent: "If I were to attempt to assign the reason why they do not make any such demand," Moore mused, "I would say that it is because their interests are so completely identified with our own, that it is impossible that we can make any regulation injuriously affecting their rights, which will not equally injure ourselves." [29] Only when politicians and woman suffrage activists could articulate a notion of female citizenship that did not openly sever women's interests from those of their husbands—when they could keep in one frame the traditional representation of female religious and sexual purity with the newer one of the female citizen—would that transformation take place.

This discussion among men does not suggest an invisible and never-discussed sexual contract; it was, on the contrary, a source of much open pleasure and self-satisfaction to the men who ran Virginia to note, again and

again, that on this matter, at least, they and nature and God were in agreement.[30] Notice that there is very little open ridicule of women in all this, although we should also observe that those who were most admiring of women's capabilities were also most strongly opposed to granting the suffrage to propertyless men. Indeed, no one even squeaked, at least publicly, when Barbour asserted that women were not "excluded for the want of *capacity*."[31] The practice of insulting women's intelligence, patriotism, virginity, marriageability, ability to take on the duties of citizenship, or choice of bonnets would await a day when the possibility of granting women the vote itself was subject to real debate. Only by the post–Civil War period, when a number of historical changes (including a woman suffrage movement and the expansion of citizenship rights to black men) produced a discourse within which women could both vote and embody Christian virtue did the threat of female citizenship become serious enough to evoke a defensiveness and viciousness missing in the earlier discussions.

In 1820, embedded in heated debate over who *did* have the right to vote, delegates expressed a cozy unanimity both that "all women and all minors, without exception, ought to be excluded from the polls" and that "no man entertains the opinion, that there is not a single woman, that there are not many, very many women, fully equal to the most meritorious of the other sex, in intelligence, in public spirit, and every other quality that constitutes a good citizen." Rather than limiting the notion of women's citizenship ("the wife and the daughters of such a voter . . . are not the slaves of their husbands or fathers; they are free-born citizens of this Commonwealth"), delegates held women up as the prime example of full citizens who were nevertheless deprived of the privilege of voting. Arguments about the absurdity of women's voting sustained delegates when they sought to limit the political rights of other groups as well, notably ministers, who were themselves closely aligned with women's perceived interests. Thus, the "indecency" of permitting ministers to run for political office was linked to women's respectability, as, according to John Randolph, "If ladies will plunge into the affairs of men, they will lose the deference they now enjoy; they will be treated roughly— like men. Just so it is with priests. They lose all the deference which belongs, and which is paid to their office, (whether they merit it or no)."[32]

In the 1846 New York constitutional convention debates, assumptions about the absurdity of women's independent citizenship (defined at least in part by the ability to own and trade property) were showing signs of wear in debates over the proposed married women's property act; nevertheless, they were hauled out to demonstrate that black men must not be permitted to

vote in significant numbers. Again, the issue of women's suffrage arose in debates over men's suffrage; the very "absurdity" of the notion of women voting was presented primarily as "evidence" that suffrage was not a natural right that had to be granted regardless of *race*. And, here again, those most flattering to women were those most committed to a limited male suffrage. Delegate John A. Kennedy, anxious to assure his colleagues that he "did not design to be understood as advocating any farther extension of the elective franchise," noted nonetheless that white women, "our own flesh and blood," should rightfully receive the vote before "the Ethiopian race." As for the notion of so extending the suffrage to black men, he declared, "Nature revolted at the proposal." A supporter of expanded suffrage, David S. Waterbury, disagreed, insisting that granting the suffrage to black men did not necessarily open the door to women: "the wives and children of all white citizens were protected in their rights and privileges by husbands and brothers," he asserted. "Where do you find any one to stand up for the colored man? Not one." If suffrage were indeed a "right," then logically it belonged to all: "Wherefore the qualification of 21 years of age?" cried delegate Stow as "proof" that the suffrage was, instead, a privilege. "Why not allow it to all of both sexes, and all conditions and ages, whether alien or citizen, if it was a matter of absolute right?"[33] Why not, indeed?

How, then, did it become less unthinkable to consider that universal suffrage might include women? When did the absurdity of female suffrage come to seem itself absurd? Although a precise date is elusive, one nevertheless hears in mid-nineteenth-century political discussions the breaking down of older assumptions—and the urgent desire to refix familiar categories with the least possible damage. In 1846, it may still have been shocking to delegates' tender ears when six women from Jefferson County, New York, petitioned the constitutional convention for woman's suffrage, and expressed confidence that "a self evident truth is sufficiently plain without argument."[34] Yet perhaps in 1853, when the *Maine Age* predicted that before the twentieth century, women would serve in legislatures and on judicial benches, they could expect a knowing chuckle: "We deprecate it," the paper reported, "yet we perceive its inevitability, and await the shock with firmness and composure."[35]

Certainly by the 1872–73 constitutional convention in Pennsylvania, faced with a woman suffrage movement and with the reality of enfranchised former male slaves, no politician could pretend not to have *heard of* the suggestion that women vote; many had to agree, at least privately, with one self-described "original woman suffrage man" that "these latter days have taught

us to admire many things that were repugnant to our prejudices in days gone by." (One does sometimes catch the bitterness of those who, forced to accept change, could not admire it, as when Mr. Boyd, a sarcastic and vociferous opponent of woman suffrage, remarked that he had "always thought it rough for certain gentlemen to give the ballot to Africa before they gave it to female America.") Mr. W. H. Smith's claim to have been "as much astonished as pained, to find that this startling innovation, this pernicious heresy of woman suffrage, should find any one to propose it" was doubtful at best. So was the declaration of Mr. McAllister from Centre County, the chair of the committee on suffrage, that if women were granted suffrage "She would have to assume the Bloomer costume." I cannot help but wonder whether he meant it. Did his claim that woman suffrage would "throw an element of discord into this sacred relation [of marriage]" seem *reasonable*? Or had suffrage even in 1872 begun to seem inevitable, making ridicule the last argument against it? Were arguments about sexual respectability made to so clutter the time of the prosuffrage delegates that the opposing arguments would be buried in a sea of self-defense? It is hard to think otherwise when a dignified and thoughtful delegate to the convention, one who supported retaining the word "male" in the constitution, nevertheless spent some minutes arguing that "we do not think that a trailing dress unfits woman for many other duties which . . . are quite as difficult to perform as the acting of voting."

Henry Palmer for one recognized this kind of rhetoric as a distraction. "The calling of hard names is not precisely argument," he reminded his colleagues. "Radical reformers, fanatics! These are familiar words. We heard them in 1860, when the southern slave driver cracked his whip over the backs of northern dough-faces in the halls of our national Congress. . . . Welcome the name. The car of human progress was never advanced so much as one poor inch by any other than a radical, a reformer, a fanatic."[36] That the opponents of woman suffrage had grown shrill and belittling signaled to men like Palmer that woman suffrage—like black male suffrage—had become inevitable. That opponents continued to draw upon the commonly accepted images of sexual and religious deviance in fighting woman suffrage describes the potency of the terms that supporters of women's rights would have to accept to make female citizenship possible.

Reading the words of these delegates, trying to take seriously their professions, for instance, that they had always and forever believed in the justice and inevitability of black men voting, makes even more striking, and more ironic, the insistence of some that women's suffrage remained as unthinkable as ever. Certainly the middle ground had shifted; Mr. MacConnell argued

for letting voters decide on woman suffrage, a question, he noted resignedly, that "has been agitated for years, and . . . will have to be met some time." Mr. Carter, an opponent of woman suffrage, considered it "not a question of right" but "a question of time," though some, like Mr. Alricks, held for "an eternal fitness in things." The viewpoint of those we might call liberals had shifted as well. John Broomall, a Quaker delegate and longtime abolitionist from Delaware County, made arguments for woman suffrage that anticipated nearly every one that would appear from the 1870s through 1920; most astonishing was his assertion "That a man, that I, with the right of suffrage, should go to the polls and say that my wife should not exercise the same right, is simply monstrosity." [37] Only a few years earlier, standing as a congressional representative from Pennsylvania, Broomall had defended black men's need for the vote as vastly different from women's, who were, he claimed, represented by the male heads of their household. "By common consent or common submission," he averred, "whether founded upon reason and justice or not, is not material to the argument, the adult males are supposed to represent the family, and the government is not bound to look further." [38] With the enfranchisement of other groups against whom the notion of a virtuous citizenry had been used, the assumptions about female suffrage and female dependence that were inherent in notions of female respectability seemed themselves more open to question or, at least, revision.

Over the course of so little time, women's dependence on male representatives could be described as *monstrous*. Indeed, delegates to the 1889 Wyoming Constitutional Convention wanted only the assurance that their appeal for statehood would not be denied on account of the women of the state having the vote. One Mr. Baxter (who "yield[ed] to no man in the homage and adoration which I feel and which . . . I gladly pay to a pure and lovely woman") expressed great satisfaction that "there is no serious division among us on this question" of the male delegates granting the vote to "their wives, their mothers and their sisters," and thus "secure to every citizen within her borders . . . the absolute and equal enjoyment of every right and privilege guaranteed under the law to every other citizen." Mr. Coffeen agreed, stating firmly his unwillingness "to stand here and by vote or word or gesture disfranchise one half the people of our territory, and that the better half." Mr. Hoyt regretted that any discussion of the subject take place, noting that since woman suffrage had been passed in Wyoming territory, "There has been no disturbance of the domestic relations, there has been no diminution of the social order." Even without discussing the political differences be-

tween eastern and western states on this matter, it is clear that by 1889, at least, what had once constituted the most serious of threats had become, for many men, safe.[39]

The words that connote the rights attendant on full citizenship in a liberal nation—words like independence, sovereignty, and self-ownership—remained problematic when applied to women. If independence for women was neither the ownership and control of a household nor a right to control her own sexuality nor mere prostitution, then what was it? Citizenship implies a commitment to something bigger than one's household or property, although one often acts politically on behalf of both. If nineteenth-century politicians believed that women should focus only on their households, the suggestion of woman suffrage held up a mirror in proposing a version of female citizenship that involved a wider lens with which to view the world and one's duties. We might follow Linda Kerber here in emphasizing the *duties* rather than the *rights* of citizenship in order better to understand men's—and many women's—hostility to granting it to women. It is women, not men, after all, who are assumed to have difficulty balancing their responsibilities—between children and paid work, between home and the world, between the universal and the particular—and suffrage threatened that; it was antisuffragists who would argue that "The ballot is not a right denied; it is a burden removed."[40] As Kerber has noted, the notion of female respectability (ladyhood) itself has involved "being *excused* from civic obligation": "so long as married women were understood to owe all their obligation to their husbands, they could make no claims of rights against the political community."[41]

Formulating a notion of female citizenship that could still insist on women's "primary" duties as wives and mothers became a central project of those who supported woman suffrage, most especially the Woman's Christian Temperance Union with its motto of "home protection." Because the shift in the discourse over women's citizenship never substantively questioned the constellation of values at the heart of the notion of female respectability, achieving woman suffrage also did not undermine that constellation: women's citizenship remained deeply gendered.

In a wide array of contexts, individuals and groups have been marginalized as citizens through a rhetoric of sexual respectability and fears of sexual chaos. Thus in democratic nations that claim universal citizenship, we find women appealing to the state or seeking to represent voters "as mothers," praying to political authorities on behalf of their children, staking their claim

to representation and resources on the basis of a greater, feminine influence. Nineteenth-century writers were well armed with the rhetoric of marginalization and isolation on those occasions when women or men spoke out in behalf of any challenge to traditional sexual behavior, including divorce and, especially, birth control. In the antebellum years, even the mildest assertion of nonbelief in eternal damnation was damned by its association with sexual license.

In our own time, we express our concerns with drawing boundaries differently, of course, but we do express them. Consider, for example, the movement to expand the benefits of marriage—and legal marriage itself—to gay and lesbian couples and their children. While acknowledging the profound impact of the gay and lesbian movement on Americans' notions about family, commitment, privacy, and children's interests, among other issues, I would argue that by demanding full citizenship rights as married people, as domestic partners, and as parents, the movement for gay and lesbian rights limits its claims to full citizenship to those terms. As George De Stefano has recently written, "Gay men and lesbians are now being offered limited tolerance and some real but circumscribed social gains provided they ostracize the sexually and politically unorthodox in their communities."[42] To those who can recall the battle over the Equal Rights Amendment (where the charge that ERA would lead to "homosexual marriages" provoked a defensive "Will not!") the dangers of this should be obvious. Rather than embracing the broadest possible notion of citizenship, Americans insist that a particular plea for inclusion will be the last, that it portends no further demands, no drastic reworking of traditional religious and sexual hierarchies. We continually make the qualifications for membership dependent on notions of moral and sexual respectability that were designed to insulate women, to enforce middle-class domesticity, and to maintain categories of exclusion. Perhaps we have learned our historical lessons too well, as we anxiously establish our own respectability in the context of making political claims—and thus deny full citizenship, full personhood, to those whose own claims seem marginal at the moment.

Notes

As always, I am grateful to friends and colleagues for their support and assistance. First, the Webb Lecture Series at the University of Texas at Arlington provided an extraordinary opportunity to share and explore the ideas presented here. I want especially to thank Stephanie Cole, Alison Parker, Steven Reinhardt, Kathleen Underwood, and the rest of

the UTA history department, as well as Sarah Barringer Gordon, Stephanie McCurry, and Elizabeth Varon, for that experience. I also want to thank Gail Bederman, Jeanne Boydston, Joanne J. Meyerowitz, and Joel Steiker for help at various stages of writing this essay.

1. *Proceedings and Debates of the Virginia State Convention of 1829–30* (Richmond: Samuel Shepherd & Co., 1830), pp. 383–84, 438.

2. The list of historical works on the broadly conceived political history of women—and the political meanings and uses of gender—is expanding enormously. Among them see Paula C. Baker, "The Domestication of Politics: Women and American Political Society, 1780–1920," *American Historical Review* 89 (June, 1984): 620–47; Mary P. Ryan, *Women in Public: Between Banners and Ballots, 1825–1880* (Baltimore: Johns Hopkins University Press, 1990); Elizabeth R. Varon, *We Mean to Be Counted: White Women and Politics in Antebellum Virginia* (Chapel Hill: University of North Carolina Press, 1998). For a discussion of rights talk in the post-Revolutionary period, see Rosemarie Zagarri, "The Rights of Man and Woman in Post-Revolutionary America," *William and Mary Quarterly*, 3rd series, vol. 55 (Apr., 1998): 203–30.

3. Linda K. Kerber, "The Meanings of Citizenship," *Journal of American History* 84 (Dec., 1997): 837. On the question of the gendered nature of immigrants gaining citizenship ("naturalization"), see Nancy F. Cott, "Marriage and Women's Citizenship in the United States, 1830–1934," *American Historical Review* 103 (Dec., 1998). It is worth pointing out that for much of this nation's early history, civic status itself—for men as well as for women—was largely determined on the state level.

Several other academic discussions have paralleled this one. One consists of studies in legal history, most notably William J. Novak, *The People's Welfare: Law and Regulation in Nineteenth-Century America* (Chapel Hill: University of North Carolina Press, 1996); Michael Grossberg, *A Judgment for Solomon: The D'Hauteville Case and Legal Experience in Antebellum America* (New York: Cambridge University Press, 1996); Hendrik Hartog, "Abigail Bailey's Coverture: Law in a Married Woman's Consciousness," in *Law in Everyday Life,* ed. Austin Sarat and Thomas R. Kearns (Ann Arbor: University of Michigan Press, 1993), pp. 63–108; Laura F. Edwards, "'The Marriage Covenant is at the Foundation of all Our Rights': The Politics of Slave Marriages in North Carolina after Emancipation," *Law and History Review* 14 (spring, 1996): 81–124; Amy Dru Stanley, "Conjugal Bonds and Wage Labor: Rights of Contract in the Age of Emancipation," *Journal of American History* 75 (Sept., 1988): 471–500; Norma Basch, "Review Essay: The Emerging Legal History of Women in the United States: Property, Divorce, and the Constitution," *Signs* 12 (autumn, 1986): 97–117.

Another field with important implications for understanding ideas about citizenship, the state, and gender consists of works in medieval and early modern Europe about boundaries, otherness, and the defining of nations; here, I believe, we find arguments for how those not considered full citizens—Jews, for instance, or sexually unrespectable women—might provide clues to boundary-drawing in far different contexts. I am by no means an expert in these fields. I have, however, been intrigued by a number of works on the subject, including Barbara A. Hanawalt, *"Of Good and Ill Repute": Gender and Social Control in Medieval England* (New York: Oxford University Press, 1998), and R. I.

Moore, *The Formation of a Persecuting Society: Power and Deviance in Western Europe, 950–1250* (New York: B. Blackwell, 1987). I have also found useful works in the history of both the Jewish and the Islamic worlds, including Leila Ahmed, *Women and Gender in Islam* (New Haven, Conn.: Yale University Press, 1992); Margot Badran, *Feminists, Islam, and Nation: Gender and the Making of Modern Egypt* (Princeton, N.J.: Princeton University Press, 1995); Alicia Suskin Ostriker, *The Nakedness of the Fathers: Biblical Visions and Revisions* (New Brunswick, N.J.: Rutgers University Press, 1994).

4. Carole Pateman, *The Disorder of Woman: Democracy, Feminism and Political Theory* (Stanford, Calif.: Stanford University Press, 1989), p. 14. See also Anne Phillips, *Engendering Democracy* (University Park, Pa.: Penn State University Press, 1991). Feminist legal theorists have played a major role in this debate, as they try to accommodate the material realities of most women's experience of gender with a commitment to the universal rights and obligations of a liberal democracy. See, for example, Zillah R. Eisenstein, *The Female Body and the Law* (Berkeley: University of California Press, 1988); Martha Albert Fineman and Nancy Sweet Thomadsen, eds., *At the Boundaries of the Law: Feminism and Legal Theory* (New York: Routledge Press, 1991); Deborah L. Rhode, *Justice and Gender: Sex Discrimination and the Law* (Cambridge, Mass.: Harvard University Press, 1989).

5. Carole Pateman, *The Sexual Contract* (Stanford, Calif.: Stanford University Press, 1988), p. 180. My own historical work has been deeply engaged in this dialogue, both among historians and with feminist scholars in other fields. In *Women and the Work of Benevolence: Morality, Politics, and Class in the Nineteenth-Century United States* (New Haven, Conn.: Yale University Press, 1990), I argued that benevolent work and the rhetoric of female influence were vehicles for the emergence of a new middle-class political culture. In so doing, that book made explicit the ways in which the ideology of domesticity obscured elite and middle-class women's actual access to that culture.

6. Grossberg, *Judgment for Solomon,* p. 100.

7. I believe that politically active women as well as men turned to the legal system for both rights and definitions of those rights. Nevertheless, in their legal consciousness they would have had to grapple with such claims as Antoinette Brown Blackwell's that "The law is wholly masculine; it is created and executed by man. The framers of all legal compacts are restricted to the masculine stand-point of observation, to the thought, feelings, and biases of man. The law then could give us no representation as woman, and therefore no impartial justice even if the present lawmakers were honestly intent upon this; for we can be represented only by our peers." In Elizabeth Cady Stanton, Susan B. Anthony, and Matilda Joslyn Gage, *History of Woman Suffrage* (1881; rpt., New York: Arno Press, 1969), vol. 1, p. 524.

8. Elisha P. Hurlbut, *Essays on Human Rights, and Their Political Guaranties* (New York: Fowlers and Wells, 1848), pp. 144, 148.

9. Ohio General Assembly, Senate, *Report of the Select Committee of the Ohio Senate, on Giving the Rights of Suffrage to Women* (Columbus, Ohio: [ca. 1860?]), p. 3; Walker quoted in Stanton, Anthony, and Gage, *History of Woman Suffrage,* vol. 1, p. 107.

10. Lori D. Ginzberg, "'The Hearts of Your Readers Will Shudder': Fanny Wright, Infidelity, and American Freethought," *American Quarterly* 46 (June, 1994): 195–226.

11. Here it is worth recalling Aileen Kraditor's point in *The Ideas of the Woman Suffrage Movement, 1890–1920* (Garden City, N.Y.: Doubleday, 1965) that suffragists moved from an argument based on justice to one based on expediency. This accommodation, however, was not merely tactical but a widely shared ideological framework for demanding women's citizenship.

12. *Atwood v Walton,* quoted in *American Jurist and Law Magazine* 3 (Apr., 1830): 389. Also vol. 4 (July, 1830): 79, citing *Jackson v Gridley,* for the proposition that "infidels who do not believe in a God, or who, believing in a God, do not think he will reward or punish them *in the world to come,* is not a competent witness." See also vol. 5 (Apr., 1831): 314, citing *Wakefield v Ross,* and vol. 6 (July, 1831), 173, citing *Norton v Ladd.* I am indebted to Sarah Barringer Gordon for first bringing several of these cases to my attention and for help in developing this analysis.

13. David Lawton, *Blasphemy* (Philadelphia: University of Pennsylvania Press, 1993), p. 29.

14. *People v Ruggles* (1811), quoted in Sarah Barringer Gordon, "Blasphemy and the Law of Religious Liberty in Antebellum America" (unpublished manuscript, 1999, in the possession of the author).

15. Samuel Gridley Howe, "Atheism in New-England," *New England Magazine* 7 (1834) and 8 (1835). Quotes are in vol. 8, pp. 58, 61, 66. Murray case quoted in the *Franklin Gazette,* Nov. 17, 1818, p. 2.

16. *Updegraph v Commonwealth of Pa.,* 11 Serge. and Rawl. 394, 398–99, 408. See Gordon, "Blasphemy," pp. 15–16.

17. *Report of the Arguments of the Attorney of the Commonwealth,* in *Blasphemy in Massachusetts: Freedom of Conscience and the Abner Kneeland Case: A Documentary Record,* ed. Leonard W. Levy (New York: Da Capo, 1973), pp. 214, 257, 262, 268.

18. The phrase is Perry Miller's, in *The Life of the Mind in America* (New York: Harcourt, Brace & World, 1965), p. 40.

19. Jean V. Matthews, "Consciousness of Self and Consciousness of Sex in Antebellum Feminism," *Journal of Women's History* 5 (spring, 1993): 62.

20. William Craig Brownlee, *A Careful and Free Inquiry into the True Nature and Tendency of the Religious Principles of the Society of Friends, Commonly Called Quakers* (Philadelphia: John Mortimer, 1824), pp. 198, 207.

21. The "Pastoral Letter of the General Association of Massachusetts (Orthodox) to the Churches under their Care" (1837) is in Stanton, Anthony, and Gage, *History of Woman Suffrage,* vol. 1, pp. 81–82.

22. On this petition see Jacob Katz Cogan and Lori D. Ginzberg, "1846 Petition for Woman's Suffrage, New York State Constitutional Convention," *Signs* 22 (winter, 1997): 427–39.

23. The current unpopularity of antidemocratic arguments (and the need of politicians to attract voters) should not obscure the fact that universal white male suffrage was not unanimously embraced even long after the fact. In her recent book, Susan E. Marshall notes that antisuffragists continued a long history of aristocratic hostility to broad suffrage. In addition, Marshall points out, accommodation to an expanded suffrage frequently involved the drawing of new boundaries, such as when "antisuffrage newspapers like the *New York Times* grudgingly accepted the new female electorate but drew a new line in

the sand against female office seeking." See *Splintered Sisterhood: Gender and Class in the Campaign Against Woman Suffrage* (Madison: University of Wisconsin Press, 1997), p. 217.

24. *Report of the Debates and Proceedings of the Convention of the State of New-York by L. H. Clarke* (New York: J. Seymour, 1821), pp. 98 (Ross), 102 (Kent), and 126 (Williams). Recall Justice Kent from the Ruggles Case in 1811.

25. For further explication of how women's subordination was used as "proof" of the naturalness of other forms of inequality, see Stephanie McCurry, *Masters of Small Worlds: Yeoman Households, Gender Relations, and the Political Culture of the Antebellum South Carolina Low Country* (New York: Oxford University Press, 1995), ch. 6; Stanley, "Conjugal Bonds and Wage Labor."

26. *Proceedings and Debates of the Virginia State Convention, of 1829–30* (Richmond: Samuel Shepherd & Co., 1830), pp. 67–68 (Upshur).

27. Ibid., p. 55.

28. Ibid., pp. 92, 97.

29. Ibid., pp. 300 (Stanard), 226–27 (Moore).

30. Occasionally the logic of all this seemed to worry delegates, and they did raise other specters. For example, William Giles noted that a logical condition of "universal" suffrage was a fearful trend toward "agrarianism," as epitomized in New York by "Miss Fanny Wright's party," or the Working Men's Party. Ibid., p. 241.

31. Ibid., p. 92.

32. Ibid., pp. 400, 438, 459.

33. William G. Bishop and William H. Attree [reporters], *Report of the Debates and Proceedings of the Convention for the Revision of the Constitution of the State of New-York. 1846* (Albany, N.Y.: Evening Atlas, 1846), pp. 1027, 1031.

34. Quoted in Cogan and Ginzberg, "1846 Petition," p. 439.

35. Quoted in Stanton, Anthony, and Gage, *History of Woman Suffrage,* vol. 1, p. 247.

36. *Debates of the Convention to Amend the Constitution of Pennsylvania: Convened at Harrisburg, November 12, 1872* (Harrisburg: Benjamin Singerly, 1873), pp. 573, 574 (Palmer), 609 (Boyd), 540 (Smith), 528 (McAllister), 539 (Mann), 576 (Palmer).

37. Ibid., pp. 537 (MacConnell), 583 (Carter), 585 (Alricks), 545 (Broomall).

38. *The Reconstruction Amendments' Debates. The Legislative History and Contemporary Debates in Congress on the 13th, 14th, and 15th Amendments,* ed. Alfred Avins (Richmond: Virginia Commission on Constitutional Government, 1967), p. 299.

39. *Journal and Debates of the Constitutional Convention of the State of Wyoming* (Cheyenne, 1893), pp. 348, 349, 350, 354. Wyoming had had woman suffrage for some twenty years as a territory, and little opposition to it was expected at the convention. What opposition there was proposed merely to have woman suffrage submitted in a separate referendum to the voters; this amendment was defeated easily. Most of the convention's delegates seemed to agree that such a referendum would constitute, as one delegate put it, "submitting to a vote whether we shall take away from one-half of our citizens . . . a certain right, and increase the rights of the other half by so doing" (p. 351). The extent of Wyoming's acceptance of women's political equality is illustrated in the 1889 constitution: "Both male and female citizens of this state shall equally enjoy all civil, political and religious rights and privileges."

40. Grace Duffield Goodwin, quoted in Marshall, *Splintered Sisterhood,* p. 98.

41. Linda K. Kerber, "A Constitutional Right to Be Treated like American Ladies: Women and the Obligations of Citizenship," in *U.S. History as Women's History: New Feminist Essays,* ed. Linda K. Kerber, Alice Kessler-Harris, and Kathryn Kish Sklar (Chapel Hill: University of North Carolina Press, 1995), pp. 18, 23.

42. George De Stefano, "HIV as Retro Virus: Review of *Dry Bones Breathe* by Eric Rofes," *Nation,* July 20, 1998, p. 33.

Contributors

CATHERINE ALLGOR is assistant professor of history at Simmons College, in Boston, Massachusetts. Her book, *Party Politics: Women, Society and Power in Early Washington City*, will be published by the University Press of Virginia.

STEPHANIE COLE is assistant professor of history at the University of Texas at Arlington. She is currently revising a manuscript entitled "Servants and Slaves: Domestic Service in the North/South Border Cities, 1800–1850." Her essay on domestic violence, "Keeping the Peace: Domestic Assault and Private Prosecution in Antebellum Baltimore" recently appeared in *Over the Threshold: Intimate Violence in Early America*, edited by Christine Daniels and Michael V. Kennedy (Routledge, 1999).

JANET L. CORYELL is professor of history at Western Michigan University in Kalamazoo, where she also serves as Director of Graduate Studies. She is the author of *Neither Heroine Nor Fool: Anna Ella Carroll of Maryland* and has edited numerous works in women's and nineteenth-century history.

LORI D. GINZBERG is associate professor of history and women's studies at Pennsylvania State University. She is the author of numerous articles as well as *Women and the Work of Benevolence: Morality, Politics, and Class in the Nineteenth-Century United States* (Yale University Press, 1990), which was a co-winner of the 1991 National Historical Society Book Prize in American History.

SARAH BARRINGER GORDON teaches in the Law School and the History Department at the University of Pennsylvania. Her work focuses primarily on the legal history of church and state, the west and women. Her book, *Antipolygamy: Law, Religion, and Marriage in Nineteenth-Century America*, is forthcoming from the University of North Carolina Press.